ON&BY

ON&BY CHRISTIAN MARCLAY

Edited and introduced by Jean-Pierre Criqui

Whitechapel Gallery, London
The MIT Press, Cambridge, Massachusetts

Co-published by Whitechapel Gallery
and the MIT Press

First published 2014
© 2014 Whitechapel Gallery
Ventures Limited
All texts © the authors or the estates
of the authors, unless otherwise stated

Whitechapel Gallery is the imprint of
Whitechapel Gallery Ventures Limited

ISBN 978-0-85488-230-4 (Whitechapel)
ISBN 978-0-262-52661-6 (The MIT Press)

A catalogue record for this book is available
from the British Library

Library of Congress Cataloging-in-
Publication Data

ON&BY Christian Marclay / edited by Jean-
Pierre Criqui.
 pages cm. – (Whitechapel: on & by)
Includes bibliographical references and
index.
ISBN 978-0-262-52661-6 (pbk. : alk. paper)
1. Marclay, Christian–Written works. 2.
Marclay, Christian–Criticism and
interpretation. I. Criqui, Jean-Pierre, editor
of compilation. II. Marclay, Christian.
Essays. Selections. III. Title: On and by
Christian Marclay.
N6537.M3635A35 2014
709.2–dc23
 2014010623

10 9 8 7 6 5 4 3 2 1

Series Editor: Iwona Blazwick
Commissioning Editor: Ian Farr
Project Editor: Sarah Auld
Design by SMITH
Allon Kaye, Justine Schuster
Printed and bound in China

Cover (*front*): Annotated and prepared
record by Christian Marclay, *c.* 1990.
(*back*): Christian Marclay performing at
The Kitchen, New York, 1985. Photograph
by Fred de Vos.

Whitechapel Gallery Ventures Limited
77–82 Whitechapel High Street
London E1 7QX
whitechapelgallery.org

To order (UK and Europe) call
+44 (0)20 7522 7888 or email
MailOrder@whitechapelgallery.org
Distributed to the book trade (UK and
Europe only) by Central Books
centralbooks.com

The MIT Press
MIT Press books may be purchased at
special quantity discounts for business or
sales promotional use. For information,
please email special_sales@mitpress.mit.edu

ON&BY is a series that combines the writings of an internationally significant artist of our time with key texts on his or her work by leading scholars, critics, curators or fellow artists. Each volume provides an overview of the ideas that inform and emerge from the work from the viewpoints of both producer and receiver. Since early modernism, discourse has become intrinsic to the practice of many artists, engaging art in critical reflection on all aspects of culture and society. In this series the artist's perspective on the world and the world's perspective on the artist meet in the shared pursuit of writing.

Series Editor: Iwona Blazwick; Commissioning Editor: Ian Farr; Project Editor: Sarah Auld; Editorial Advisory Board: Dawn Adès, Tamar Garb, Keith Hartley, Jennifer Mundy

In a way immateriality is the perfect state, it is the natural outcome of the ephemeral. In music this aspect of immateriality is very liberating. Ideally I would like to make art that is invisible

In Conversation with Bice Curiger, 1997

BY CHRISTIAN MARCLAY

ON CHRISTIAN MARCLAY

Words without Songs
Jean-Pierre Criqui

Ideally I should not have 'written' a single sentence of this introduction, but instead placed end to end a variety of fragments gleaned here and there, convinced as I am that – as Borges says in a story the title of which I prefer not to remember – language is a system of quotations, and also that critics should sometimes know when to stop commenting on artists, at least those they admire, in order to adopt their methods. It would have been a truly Homeric task, like that of the rhapsodist sewing together snatches of song so as to invent his own, or to claim as much. Haunted perhaps by some fear or sense of guilt (but why?), I have retreated, in part, and on the face of it, from the ideal set before us by Christian Marclay, whose *haute couture* of the already-there, real or virtual, extends from assemblages of two elements (such as record covers, in the case of the head and torso of Herbert von Karajan above a pair of naked female legs, unabashedly echoing a distant *Bicycle Wheel* among many other things – rebuses, metaphors and slips) to montages of thousands of cinema excerpts. Ultimately the same process is at work in the present anthology, but in simpler, less surgical form – 'Making a book is a craft, like making a clock', said Jean de La Bruyère in the late seventeenth century, never imagining that one day the world would have *The Clock*.

'Immature poets imitate; mature poets steal', as the well-known maxim has it, often cited in rather approximate fashion.[1] Let us recall in passing that this is a slogan in support of the classical tradition, even if it readily lends itself to appropriation by various avant-gardes. The French language, my native default, unsettlingly features a homophonic confusion between the action of a pickpocket and that of a bird soaring above human beings envious of its freedom.[2] But we do not need this to feel unsettled – the handful of letters in our alphabets, whose combination contains everything we say, makes all speakers' heads spin when they consider the limitations of their toolkit (languages founded on non-alphabetic principles have a similar head-spinning potential). To speak or write is primarily to repeat (oneself). Some are even persuaded that there are words lurking 'under words', as when Saussure took it into his head to uncover anagrams in Latin poetry.[3] Should we be willing to strip it of its Shakespearian underpinnings, Alexandre

Dumas' quip 'Tibi or not tibi' would gain in pertinence, reworded as 'Tibi is not tibi'. So let us abandon all pretence at saying anything personal and use the space available to deploy a few extracts from the library.

There is more business in interpreting interpretations than interpreting things, and more books on books than on any other subject: all we do is gloss each other. All is a-swarm with commentaries: of authors there is a dearth.
– Michel de Montaigne, *The Complete Essays*, trans. M.A. Screech (1993) bk 3, ch 13.

Let no one say that I have said nothing new: the arrangement of the material is new. When playing tennis, both players hit the same ball, but one of them places it better.
– Blaise Pascal, *Pensées and Other Writings*, trans. H. Levi (1995) 132.

I asked for an exercise-book and a bottle of violet ink, and wrote on the cover: 'Exercise-book for novels.' I called the first one I completed *Pour un papillon* (for a butterfly). A professor, his daughter and a young, athletic explorer were going up the Amazon in search of a precious butterfly. I had borrowed the plot, the characters, the details of their adventures, even the title from a story in pictures which had appeared during the previous term. This deliberate plagiarism released me from my final qualms: it must all be true because I had invented none of it. I had no ambition to be published but I had arranged it so that I was printed in advance and I did not set down a line that was not to be found in my model. Did I see myself as a plagiarist? No. As an original writer: I touched up and renovated; for instance, I had taken care to change the names of the characters. These minor alterations enabled me to blend memory and imagination. New and complete sentences formed in my head with the unwavering certainty attributed to inspiration. I transcribed them and, before my very eyes, they acquired the solidity of objects. If, as is commonly held, an inspired author is, deep down, something other than himself, I knew inspiration between the ages of seven and eight.
– Jean-Paul Sartre, *Words* (1964); trans. I. Clephane (1967) 91.

Henceforth, what is called the speaking subject is no longer the person himself, or the person alone, who speaks. The speaking subject discovers his irreducible secondarity, his origin that is always already eluded; for the origin is always already eluded on the basis of an organized field of speech in which the speaking subject vainly seeks a place that is always missing. This organized field is not

uniquely a field that could be described by certain theories of the psyche or of linguistic fact. It is first – but without meaning anything else – the cultural field from which I must draw my words and my syntax, the historical field which I must read by writing on it. The structure of theft already lodges (itself in) the relation of speech to language. Speech is stolen: since it is stolen from language it is, thus, stolen from itself, that is, from the thief who has always already lost speech as property and initiative.
– Jacques Derrida, *Writing and Difference* (1967); trans. Alan Bass (1978) 224.

And, of course, that is what *all* of this is – all of this: the one song, ever changing, ever reincarnated, that speaks somehow from and to and for that which is ineffable within us and without us, that is both prayer and deliverance, folly and wisdom, that inspires us to dance or smile or simply to go on, senselessly, incomprehensibly, beatifically, in the face of mortality and the truth that our lives are more ill-writ, ill-rhymed, and fleeting than any song, except perhaps those songs – *that* song, endlessly reincarnated – born of that truth, be it the moon in June of that truth, or the wordless blue moan, or the rotgut or the elegant poetry of it. That nameless black-hulled ship of Ulysses, that long black train, that Terraplane, that mystery train, that Rocket '88', that Buick 6 – same journey, same miracle, same end and endlessness. [...] Inhale one vision, exhale another. To steal consciously is the way of art and craft. To steal through breath is the way of wisdom and of art that transcends.'
– Nick Tosches, *Where Dead Voices Gather* (2001) 135–6, 137.

In what was clearly a sign of naïve confusion, I had hoped for a moment that the title of this introduction would be entirely new. Firstly, no doubt, because it inverts another title, as magnificent as the music it designates: Felix Mendelssohn's *Lieder ohne Worte*, a series of pieces for piano composed between 1829 and 1845 and published in eight volumes, each containing six songs. Paul Verlaine used the French version of that title in 1874 for his poetry collection *Romances sans paroles.* But nothing is forgotten in the inverted world, and a quick check revealed that Theodor Adorno had got there long ago, calling an early article 'Worte ohne Lieder'.[4] This did not deter the British composer, poet, artist, calligrapher and cabinetmaker Thomas Pitfield – had he ever read Adorno? – from publishing a short book of poems entitled *Words without Songs* in 1951, with a preface by Walter de la Mare. For those who find this subject interesting or intriguing, we should undoubtedly

also mention *Words without Songs: A Musicological Study of an Early Ottoman Anthology and its Precursors* by Owen Wright, published in London in 1993. There are of course other occurrences, but I will conclude the present list with another avatar of Mendelssohn's title, Hugo Ball's *Verse ohne Worte*. These onomatopoeic poems were first 'performed' – because it was more than a simple reading – by the author at the Cabaret Voltaire in Zürich on 23 June 1916.[5] Ultimately it does not matter that the phrase 'words without songs' is not making its first appearance here, even in printed form. It merely seeks to evoke the world of sound, and indeed music, that means so much to Christian Marclay, its absence providing a backdrop to his words and to commentaries on his work, while his work in turn obliges those who write about it to gauge its effects on their own undertaking.[6]

1 T.S. Eliot, 'Philip Massinger', *The Sacred Wood* (1920). The edition I am using is *Selected Prose of T.S. Eliot*, ed. Frank Kermode (London, 1975) 153.

2 On *voler* 'to fly' and *voler* 'to steal', see Émile Benveniste, 'Problèmes sémantiques de la reconstruction' (1954), *Problèmes de linguistique générale*, 1 (Paris, 1966) 290–91. The ambiguity is maintained in the two verbs' only shared derivation, the word *vol* ('flight' or 'theft').

3 On this, see Jean Starobinski's book *Les mots sous les mots. Les anagrammes de Ferdinand de Saussure* (Paris, 1971). Daniel Heller-Roazen returns to this question in his fine recent work, *Dark Tongues: The Art of Rogues and Riddlers* (New York, 2013).

4 *Frankfurter Zeitung* (14 July 1931). This piece appears in Adorno's *Gesammelte Schriften*, ed. Rolf Tiedemann, et al. (Berlin, 1997) vol. 20 (2) 537–43.

5 Talking Heads set Ball's 'Gadji beri bimba' to music in the song 'I Zimbra', which features on their album *Fear of Music* (1979). There is no reference to this borrowing on my copy of the record.

6 In addition to the writings reprinted below and cited above, this anthology was compiled in the light of other readings and re-readings. It is a pleasure to provide a brief, arbitrary list of them here: Harold Bloom, *The Anxiety of Influence: A Theory of Poetry* (Oxford, 1973); Luciano Canfora, *Il Copista come autore* (Palermo, 2002); Antoine Compagnon, *La seconde main ou le travail de la citation* (Paris, 1979); Rosalind E. Krauss, 'The Originality of the Avant-Garde: A Postmodernist Repetition' (1981), *The Originality of the Avant-Garde and Other Modernist Myths* (Cambridge, Massachusetts, 1985); Jean-Claude Lebensztejn, 'Une rêverie émanée de mes loisirs' (1992) and 'Vols' (2002), *Déplacements* (Dijon, 2013); Jonathan Lethem, 'The Ecstasy of Influence: A Plagiarism' (2007), followed by 'The Afterlife of "Ecstasy"', *The Ecstasy of Influence* (London, 2012); Gary Saul Morson, *The Words of Others: From Quotations to Culture* (New Haven, 2011); Ann Moss, *Printed Commonplace-Books and the Structuring of Renaissance Thought* (Oxford, 1996); Michel Schneider, *Voleurs de mots* (Paris, 1985).

When a record skips or pops or we hear the surface noise, we try very hard to make an abstraction of it so it doesn't disrupt the musical flow. I try to make people aware of these imperfections, and accept them as music. The recording is a sort of illusion; the scratch on the record is more real

In Conversation with Jan Estep, 2001

ON&BY CHRISTIAN MARCLAY

Early Years: In Conversation with
Douglas Kahn
2003

Douglas Kahn What were your record-listening habits, growing up?

Christian Marclay That's the interesting part: I was a pop culture virgin. My colleagues here in New York had a totally different experience growing up. They listened to a lot of music, and did a lot of drugs. Music was very important; it was a soundtrack to what they were doing. But I grew up in a vacuum. My parents rarely listened to music. Around Christmas, my mother in all her nostalgia would bring out her Bing Crosby records and other Christmas music. I hated Christmas music, and I really couldn't stand listening to the same five records over and over again. My mother, being an American, liked to watch old musicals. Of course, they were dubbed in French, except for the songs. All of a sudden they'd start singing for no reason whatsoever, which is strange enough, but then they sang in English. I have always liked musicals because they are such a surreal genre.

When I was 14 years old, I went to a strict Catholic boarding school in Switzerland where we weren't allowed to listen to music. They didn't think pop culture should be part of our life and there was no time to listen, given our day-to-day routine. It would be interesting to know what kind of pop music was happening at the time, but I was reading Baudelaire, Verlaine, and I was listening to classical music, smoking a pipe and being totally out of touch with the culture. No drugs. Just pipe tobacco.

I organized a 'classical music appreciation evening' at the boarding school. (*laughs*) This is embarrassing. I had a genuine interest in classical music. We would meet once a month, listen to classical music, and then one of the teachers, a priest, would give us a little bit of theory. This was an all-boys school. We were very interested in girls and there was another boarding school for young women not so far away. We had already organized afternoons where we would 'share our poetry'. I thought that maybe music would be another way to get the girls to come over. They allowed this under the culture and literature umbrella.

I would listen to music when I got out on the weekends to see family and hang out with friends. The first record I bought was Creedence Clearwater

Revival, and someone gave me the Moody Blues, who were a big hit in Europe, as a gift. I listened to them quite a bit, and my sister, who was much older, had a number of 45-rpm records: Elvis Presley, Paul Anka, Johnny Hallyday, rock 'n' roll ballads.

But I really didn't listen to that much. However, there was one record. I had a friend who was not locked up at boarding school and had records. His father was an amateur jazz clarinetist. He came up and said, 'I have this record.' It was the *White Album* by the Beatles. When 'Revolution No. 9' came on, I wondered, 'Wow, what is this?' It was so different from anything I had ever heard. It was the most experimental thing I had ever heard. At the 1964 Exposition Nationale in Lausanne I had seen one of Jean Tinguely's giant machines that was very loud, with all its mechanical parts, and that blew me away. But I don't remember feeling anything more surprising than hearing that Beatles song, that collage.

Kahn How did you end up at MassArt? [Massachusetts College of Art & Design]

Marclay At the time, there was a lot of anti-American sentiment, with Vietnam and so forth. I had mixed feelings about my being American and wasn't so eager to go there. After my secondary schooling, my mother wanted me to learn English, so they sent me for a summer course at Harvard. I never took an English course proper there; instead I took a summer course with a crazy guy named Lowry Burgess, a conceptual artist who was talking about changing the axis of the earth. I remember reading Gaston Bachelard on space. Lowry told me about MassArt and helped me get in. That must have been 1976, because it was the bicentennial and there were American flags *everywhere*.[1]

The next summer I rented the room in the 'Love Story' apartment on Oxford Street where they had shot the movie *Love Story*. They had shot some scenes in the room I rented. Down the street was the 'Love Story Laundromat' where I did my laundry, because of the Laundromat scene in the movie. For me, culturally, it was surreal.

I spent fall 1977 in New York on a 6-month exchange programme at Cooper Union. My teacher was Hans Haacke, who was teaching sculpture. 'Sculpture' for him meant whatever you wanted to do. Every Friday when the class met, someone would pin something on the wall and there would be a

class discussion. It was more conceptually oriented and not very object oriented. Also, I went to a lot of clubs. For me what was going on in the New York clubs was much more interesting than what was happening in the galleries or museums. There was music – punk rock, no wave, [the no wave band] DNA – and then once in a while there were artists doing things in the clubs that weren't necessarily music, but more performances. I'd see Sid Vicious do something one night at Max's Kansas City, and then Dan Graham the next night at the Mudd Club, or things by Laurie Anderson. There was a very interesting mix between club culture with some art events and punk rock.

I had such a cheap apartment in New York that I decided to stay the whole year, so I took the rest of the year off. Then I came back in the fall of 1978 to Boston, because I felt like I should finish my schooling at MassArt. The trouble came when I went back. The sculpture department did not like my new interest in music and performance art, so they kicked me out, and I went into the Studio for Interrelated Media. I was really interested in punk music.

Kahn How did you get into your own music?

Marclay In 1978, I wanted to do a short movie, a weird little all-singing, all-dancing musical. I liked the idea of actors all of a sudden singing, but it wasn't going to be a musical in the way we know it. I wrote a few songs and I asked around school for someone who played music. Kurt Henry, one of my classmates, was a guitar player. I said, 'Can you write something basic for these lyrics because I want to do this film?' and he said, 'All right, but who's going sing them?' I had never sung, except maybe in kindergarten, and he said, 'Why not you?' We recorded these songs on a cassette player. I never made that film. This is as close as I have ever got to a musical. At that time, film was expensive, video was just starting and was not very accessible.

Kurt and I eventually formed the band The Bachelors, Even. We did some performances that involved destroying televisions with a bowling ball, not just songs. We'd roll the balls. We did this crazy performance once where we would break mirrors and televisions with bows and arrows. It was fairly dangerous. We didn't know whether the arrows were going to bounce back. I held a piece of glass up and he broke it with a hammer. It was lucky I didn't get hurt. Then, in a kind of Beuysian way, we displayed the relics of these performances as our art as part of our final project at MassArt, and got away with it. (*laughs*) I had seen the Joseph Beuys retrospective at the Guggenheim

on a weekend trip to New York in 1979. I was interested in performance, of course, but also with everyday life, what Beuys called 'social sculpture'.

Kahn Could you tell me how you began making art and music with records?

Marclay At the time I was already thinking about sound; this was 1978 and I was living in Brookline [Boston]; while walking to school on a heavily trafficked street a block away from my apartment I found a record on the pavement. Cars were driving over it. It was a Batman record, a children's story with sound effects. I borrowed one of the turntables from school to listen to the record. It was heavily damaged and skipping, but was making these interesting loops and sounds, because it was filled with sound effects. I just sat there listening and some kind of spark happened.

Kahn How did you go from organizing evenings of classical music appreciation to picking up a Batman record off the street?

Marclay Just the fact that I picked it up was significant of that cultural difference. If I had grown up in the US, I wouldn't have thought twice about seeing a record on the street. That's what surprised me about American culture: its excess, the prevalence of so much waste. When I first came to the United States, it was a common sight to see broken records on the street. It took away the preciousness of the object. I grew up always taking very good care of my books, whereas here everyone was underlining all their books, scribbling things on the book itself. When there is excess, when there are thrift stores filled with books and records that are 25 cents apiece, it makes you think about objects differently.

I probably felt more inclined to pick up the Batman record off the street because of that. Just the fact that it was there was such a surprising sight. What is it doing there on the street? I don't remember picking it up thinking, 'I'm going to listen to it.' Instead, it was probably, 'Oh, this is an interesting artefact, this scratched-up record on the street!' I always liked found objects. Since very early on, I have tried not to make a distinction between pop culture and high art. Duchamp with the readymade influenced me in this respect, but also the Nouveaux Réalistes, French pop art.

Kahn How did you start using records in performance?

Marclay Kurt and I got an opportunity to perform at the Boston Film and
Video Foundation. We developed a performance that was as much visual
as it was musical. There were slides. To create a rhythm I would chop wood,
or break things. We were dealing with simple things, and my singing was
more like speaking. Then I would use skipping records to record loops
on the cassette recorder and those became the rhythms for the band.

The use of the synthesizer started first, before the records. At MassArt
there was a place called the Cage, which was a copper cage with a synthesizer
and a sound-recording device donated by the US Army. The copper cage
stopped the radio signals from interfering with the sound equipment. No
one would ever use this studio. Kurt, who already had knowledge about
sound, introduced me to all this technology. Some of our back-up tracks
for The Bachelors, Even, were made with this old analogue synthesizer;
we'd put them on cassettes.

We had a piece called 'Joni James' where we used loops produced by
skipping records recorded onto audiocassette. That was our rhythm track;
we would lay our live music on top of it. With another song, we'd put on
another cassette. I would find an interesting sound on a record and glue
things, little stickers to create the loops, to make it skip. Some good loops
would deteriorate quickly. I'd get depressed, 'Oh, that good loop, it's gone!'
(*imitates the sound of a loop deteriorated into nothing but noise*) The heavy
tone arms would make loops fade away quickly.

Then I thought, why don't I just use the records on stage? Then it became
more about playing the record on stage. I might have a cassette still going,
but then I would play certain fragments of records. I would use the stickers
to indicate where something would start. That hasn't changed; I still do the
same. But that's when I started cutting up the records. I had the idea and
was so excited about it I had to go do it right away. Shortly after that, while
I was planning the festival Eventworks, I got in touch with Boyd Rice and he
sent me a 7-inch record in the mail, and it had two holes, a regular one and
off-centre one. It was so simple and such a great idea. I felt that there was
a huge potential there in just using records.

Kahn What were you using for turntables?

Marclay In the audio-visual department at MassArt there were some
Califones.[2] No one was using them, so I appropriated them. The school

had two or three, I can't remember. I got those and then I would buy them every time I saw them. People have strong memories attached to these things, but I felt comfortable with them because they had no meaning for me. They're just industrial, solid, take a lot of abuse and already have four speeds: 16, 33, 45, 78. I usually take the speaker out; that way they're easier to carry. The most sophisticated Califones came with pitch control. Some of the same turntables I'm still using today.

I've never used Technics. I can't do certain things with them. They only have two speeds: 33 and 45 rpm. They have pitch control, but it only allows you about 10 per cent pitch shift. But now, which is interesting, because of the DJ culture and the turntablists, certain companies have started making turntables that go backwards, that have more of a pitch control and some gimmicks. It allows you to do more things.

Kahn When did you become aware of some of your precursors in performing and manipulating records?

Marclay At that time I had never heard of Milan Knizak. I thought I was so original! Over the years, I found out more about Knizak. When I heard his stuff, I realized it was not very musically developed. Supposedly, when Knizak would perform, he would just play one broken record at a time. Nam June Paik also did things with records. He broke records, made them play slower or faster. If we look back historically, the minute the record was invented, people said, 'What else can we do with this?' Pierre Schaeffer used records to make his *musique concrète* in the late 1940s and early 1950s, before moving to tape recorders.[3]

As for hip hop, I started performing with records in 1979, and *The Adventures of Grandmaster Flash on the Wheels of Steel* and *The Message* came out in 1981. That's when people started becoming aware of hip hop, that is, white middle-class kids like me. I knew about John Cage. I bought my first John Cage record in Boston at the Harvard Co-op, a percussion thing just using glass. I remember listening to it while washing the dishes and it made total sense because I was creating similar sounds in the sink.

1 The summer class was at the Carpenter Center and included lectures on 'The Metaphysics of Space'. Lowry Burgess is now Professor of Art at Carnegie Mellon University.

2 Rheem Califone 1450B. These turntables have nostalgic value for Americans because they were used for playing records in classrooms.

3 For background on artists' use of records, see Germano Celant, *The Record as Artwork: From Futurism to Conceptual Art*, exh. cat. (Fort Worth, Texas: The Fort Worth Art Museum, 1977) and Ursula Block and Michael Glasmeier, *Broken Music: Artists' Recordworks*, exh. cat. (Berlin: Daadgalerie, 1989). In 1958 Arthur Köpcke used abused records for performance in *Music While You Work,* and circa 1963 Milan Knizak cut up and reconfigured records for exhibition and performance as *Broken Music*. The most notable literary early use of a gramophone can he found in Alfred Jarry's 'Phonograph' section in *Les Minutes de sable memorial* (1894). For an introduction to the music scene in New York in the latter half of the 1970s, see Bernard Gendron, *Between Montmartre and the Mudd Club* (Chicago: University of Chicago Press, 2002), especially 'Section C: New York: From New Wave to No Wave (1971–1981)'.

Christian Marclay and Douglas Kahn, 'Christian Marclay's Early Years: An Interview', *Leonardo Music Journal,* vol. 13 (2003) 17–21.

**In Conversation
with Bice Curiger
1997**

Bice Curiger [...] Do you play an instrument?

Christian Marclay Turntables and records are my instruments. I've never
really studied music, and I don't play a traditional musical instrument.

Curiger I'd like to discuss a certain notion of material, or materiality, in
music because I have always been fascinated by a term used by musicologists.
In German, *musikalisches Material* is used when speaking of certain
chords and harmonies, which is for us so absurd because music is not
really material in the common sense, yet sometimes I think you suggest
the opposite.

Marclay Well, in a sense it is; music is material. Recording technology
has turned music into an object, and a lot of my work is about that object
as much as it is about the music. The ephemeral and immaterial vibrations
that make music have become tangible objects – records, tapes, CDs. This
transmutation is very interesting to me. One doesn't necessarily think of
music as a physical reality, but it has physical manifestations. It can also
be an illustration, a painting, a drawing. In a performance you have the visual
presence of someone producing sound. In my work I'm constantly dealing
with the contradiction between the material reality of the art object as a thing
and its potential immateriality. In a way immateriality is the perfect state, it is
the natural outcome of the ephemeral. In music this aspect of immateriality
is very liberating. Ideally I would like to make art that is invisible.

Curiger So a record is a medium not only for transporting music, but also
for many things.

Marclay Yes, it serves other roles. The record has become an icon,
a symbol for rebellion, for fun, for pleasure. Think of how records were
used to advertise this kind of freedom – make your own choices, buy
your own music, discover it in the privacy of your own home. It offers

a very individualistic freedom. A live concert has much more to do with
social interaction.

Curiger Right. What fascinates me in your work is that you deal with
potentialities. A musical instrument, a cello for instance, is an object
that has a potential to make people melt. This brings me to resonance.
In German we have the word *Resonanzkörper*.

Marclay Resonating Body?

Curiger Yes, for me the word 'body' is interesting. It also comes up in the
German expression *Klangkörper*, used in connection with orchestras.

Marclay A body of sound?

Curiger Yes, a body of sound. When a conductor speaks of the *Klangkörper*
of the orchestra he'll be working with, he's talking about the collectivity of
people as one body, which can make sound.

Marclay Music has a way of magically bringing people together. Not only
in the making of music but in listening too. I'm interested in the ritual aspect
of live music as much as in the private experience of listening to records.
Records imply a more passive and domestic relation to the music, whereas
every performer will tell you that the audience plays a role; they're participating,
they create an atmosphere, they reflect what's happening on stage and
influence it in some way.

Curiger It's quite obvious that some musical events, regardless of their
quality, can touch people more directly. For example, I remember a group
of children playing instruments poorly and adults being moved to tears.

Marclay If you were listening to the recording of that same event, it would
have a different impact, a different meaning; that difference is important
to me. The physical presence of a performer is rare; more than ever we
experience music as recordings. We hear recorded sounds all day long,
wherever we go, in the street, in the car, at the supermarket. The live
performer has been replaced by an inanimate object, a disembodied

recording. Records are about dead sounds, but when I bring records into a performance and play with them, I change my role from a passive listener to an active player; the same is true for the audience. I give a new life to these dead sounds. That situation is a lot more interesting to me than the passive one. More and more kids are becoming DJs. They are pointing towards a future that will be a lot more interactive with information, given the digital technology, the internet and so on.

Curiger Coming back to performance, if you watch someone making a drawing it can never be as affecting as someone playing music, even if it's bad music.

Marclay This is an interesting comparison, because a drawing is a recording of some sort, and a record is a kind of drawing; the groove is like an etching, but the difference is the extra dimension of sound, the sound transcends the object. The elusive vibrations of that spiral drawing need to be decoded by a turntable. This type of drawing needs a machine to make it vibrate into life. Or if it's a score, it needs a performer to interpret it. But when you watch someone drawing or playing music you can still identify with their physical presence.

Curiger We listen with the body as well.

Marclay Yes, and unlike a drawing, a sound recording can affect your whole body, it's a more complex physical experience. That's what I love about loud music, you can feel it vibrating through your whole body. It becomes something very tactile, very physical, like a presence, a substance that surrounds you but that you can't touch.

Curiger You are creating many objects which are also like bodies, or parts of bodies, like the telephone receivers becoming bones [*Bone Yard*, 1990]. Your work revolves around the idea that everyday objects have fantastic possibilities for metamorphosis or that they are hiding something. Sound is absent and yet it's the most present thing. In the stool pieces with the wind instruments, no one wants to sit on them, because one thinks about a bodily sound that is embarrassing. In another work, *Chorus* (1988), we see images of people singing but we can't hear them.

Marclay That absence is a void to be filled with one's own stories. I find silence is much more powerful because we are always surrounded with sounds, and in silence we can think about sound. Silence is the negative space that defines sound.

Curiger And seeing an image of music, or of something that could potentially make a sound, draws your attention to the absence of sound.

Marclay That difference, between the presence of an object and the absence of sound, is what interests me. [For the Kunsthaus Zürich exhibition, 'Arranged and Conducted by Christian Marclay'] I've selected from the Kunsthaus permanent collection images of people playing music. I've chosen figurative works because I think people will more easily identify with these images and project sound onto them. I am less interested in abstract synaesthesia. Synaesthesia is too subjective, it's not universal. Music has always had a privileged place in Western culture, but why should it be the primary way that one deals with sound. I want my work to be about the aural, but it doesn't necessarily have to be about music ...

Curiger ... or even make sound necessarily. You work a lot with the imagination. I always feel you only give a little bit and you know the spectator will add the rest.

Marclay That's a lesson I've learnt from Duchamp. I like to get people involved with the work in one way or another. Music is a very popular experience that anybody can relate to. It's a lot more popular than painting. I am also interested in how music has been transformed by the media. How sound becomes something else: an object, a groove, a set of numbers, an image.

Curiger A musical instrument like the piano can be a symbol for bourgeois culture. In Fribourg, at Fri-Art you once did a piece with a mirror inside a piano and another under the piano lid. I saw it as the abyss of bourgeois culture, its inner world.

Marclay The idea of the infinite is reflected in the mirrors. You can see a virtual tunnel created by the reflection of the mirrors echoing off each other.

Recorded music is seen as repetition, as infinitely reproducible. To change the nature of sound from ephemeral to permanent seems like a futile desire for eternity. In another piece, *Feedback* (1994), I used mirrors covered with CDs and mounted on opposite walls. You can never see the end of this virtual tunnel because your body is always in the way, blocking the endless reflection. Mirrors are a form of recording, but a transient one. Records and CDs slowly deteriorate; in their fragility and weakness I find something interesting, more than in their permanence. It's in the scratches, the wear and tear of recordings, that something expressive happens. It's not an idealized reflection, and it's less about infinite duplication than the finite. Death and decay are the only realities we can be sure of. So the resonant body of the piano has a different resonance once I've emptied it and put mirrors in it. It's also something you have to experience, a very hard piece to photograph, because it's an optical illusion about an aural illusion.

Curiger Tell me about the work *White Noise* (1993). What is 'white noise'?

Marclay 'White noise' is the over-saturation of sound information, or static on the radio or telephone. Visually it can be the 'snow' of television, where you have no distinction between the frequencies, or mixing all the colours of the spectrum which results in white. There is no distinction between the elements, so it can be perceived as an interference or as a perfect state of harmony. If you look at the actual pictures, you can only experience their banality. We all have the same pictures at home – weddings, babies, parties, people sitting around drinking, holidays, etc. The more I looked at them the more they became anecdotal. So by turning them over they were still photographs – everybody recognized them as such – but they lose their subjective quality. In a way they have been mixed or distilled into their essence as photographs. They are still loaded, they still have this 'hum' or 'buzz', this feeling that a lot of things are going on behind them, like a recording waiting to be played.

Curiger You bring back an aura to the photos, which is probably more effective here than if you would just be showing their subject.

Marclay Photos are visual recordings. Walter Benjamin said that a photograph has no aura or what is mechanically reproduced doesn't

have the aura of handmade objects, but in fact with time things get a patina, they get damaged. The technology evolves, things become obsolete. A yellowed photo or a broken record can often be more expressive than the subject represented or recorded on them; the medium is the message, and the incidental traces of time are very expressive.

Curiger Tell me about your performances. You use records to produce a wide range of sounds, sometimes without even using a turntable. You also use many different styles of record. What kinds of performance have you done recently?

Marclay I've been doing fewer turntable performances in the last few years. When I started in 1979, the relation we all had with records was different, vinyl records were contemporary, but with the advent of CDs, records are becoming obsolete. But it's interesting again right now because every kid on the block wants to become a DJ. When I was starting to play music, everybody wanted to be a guitar player, that was the cool instrument. Now it's the turntable. Because of this renewed interest I'm playing a little more. Younger DJs are interested in what I'm doing, and I get to perform with them. Recently I've been more interested in doing performances involving live performers, mixing live musicians like I would mix records.

Curiger Like the performance *The Sound of Money* (1991), which you did with the Appenzell people playing the Tallerschwingen, a traditional Swiss instrument, where a coin is spun inside a bowl to produce a tone?

Marclay Yes, or *Berlin Mix* (1993), or *Swiss Mix* (1996). In these performances I bring people together, audiences and musicians from very different backgrounds, who play different kinds of music, and who under normal conditions would never play together. I like forcing a mix, not only with the music but with the people; music is only one part of the event. The important part is having all these people under the same roof making sounds together. Music is not the only purpose of the performance, the social gathering is as important.

Christian Marclay and Bice Curiger, extract from interview in *Arranged and Conducted by Christian Marclay* (Zürich: Kunsthaus Zürich, 1997) n.p.

In Conversation with Michael Snow
2000

Michael Snow As you know I've been involved with free improvisation for a long, long time. It's one of the major rediscoveries in art and music in the last hundred years, and really revolutionary in some ways. For me it came partly from jazz. I wondered how you started to improvise, using discs and so forth? There's a jump there, starting out with a respect for supposedly composed music, then finding out that you can make some gestures that open up a lot of things.

Christian Marclay It took me a while to really believe in improvisation. It didn't happen right away. I felt like I had to have a certain amount of control or have an idea before I played. But working with improvisers was liberating. John Zorn, for instance, introduced me to a lot of musicians. For them – they'd pursued music their entire lives, practised eight hours a day – my approach was really refreshing. They gave me a lot of encouragement because they envied my ignorance and I, of course, envied their knowledge. It was weird. It took me a while to understand that I brought something to the mix that they didn't have.

Snow It's an interesting thing. I've only heard one performance of yours, in Lyon, which was very beautiful. But I recognized that the system, if you can call it that, was exactly what my band the CCMC does. We just play. There really isn't any thought, in a sense, because you can't think fast enough. It's all about gesture. As soon as you hear something you recognize, but not in a conscious way, it's happening. Improvisation really is an art of living.

A group called The Artists' Jazz Band started in Toronto in 1962. They were friends of mine, painters mostly, who just got instruments, didn't learn anything and started playing. I thought it was kind of a joke, because I'd been a professional musician before that. But I soon found out that it wasn't a joke at all. It was fantastic. When these guys got stoned enough, the music was really amazing. I have tapes of them attempting 'Mood Indigo' or 'Joy to the World' (which is a scale) and nobody could play it. But the result is incredible. Incompetence in relation to a 'legitimate'

playing of the instruments was actually a means of making variations.

Recently there was a night of guitar duets in Toronto. There are a lot of interesting young free guitarists there. A composer, Martin Arnold, asked me to play with him. Although I really know nothing about guitar, we played. The audience, basically of guitarists, all thought it was great. I played OK but I don't know what I'm fucking doing. I tune it any way at all.

Marclay Because of your knowledge of the piano, you can read notes, recognize keys, you have an understanding of music that is never going to be the same as mine. Yet there's a common understanding of Western music, because of listening habits that allow most people to recognize if something sounds good. It's not so much a question of exact pitch or anything learned, but perhaps because it is the music that we've been nurtured in, we understand when something is right or wrong. We recognize when musicians are in sync.

Snow That's an interesting point. The background of a culture makes things right or wrong. You work with found sounds. They're all sources that exist on records.

Marclay Working with found material is due to my inability to play instruments. I take found sounds and transform them to the point where I feel that they're mine.

We have something in common, in that we never take the medium we work with for granted. You always foreground the process of film. I allow the recording medium to be heard. We acknowledge the existence of our tools and machines. We are suspicious of illusion. Sometimes I wonder what in my development made me want to make music with records. Duchamp and the idea of the readymade was probably key. Finding something that's already out there was always more interesting to me than making something from scratch. Isn't that close to improvisation in a way? Improvisation is about dealing with the moment instead of preparing something ahead of time.

Snow Finding something intuitively rather than planning.

Marclay With the readymade, the decision to remove oneself from the selection process is close to improvisation. When you're improvising you

try to be as innocent, as spontaneous as possible, although you can't help but to put in everything you know.

Snow You make what I think you have to call compositions out of found material.

Marclay It ends up being sort of a composition.

Snow A composition could be identified as a process susceptible to afterthoughts. You put this with this, that with that, you decide something doesn't fit and you change it. You can't do this in improvisation, at least in real time. You can't go back again. It seems to me that composition has to do with the possibility to go back.

Marclay Today the studio is a composing instrument. You can go back, edit and alter things. Most of my work is live. I do many more live performances than recordings. It's hard to translate a live event on tape. The recording makes it final, like a composition. And it removes the visual experience and the social interaction.

Snow Some artworks you've done, like the *Moebius Loop* (1994) or *The Beatles* pillow (1989), are, strictly speaking, traditional sculpture. But the materials themselves have this personal source. You have a way of finding sound artefacts and making things with them. I like that quite a bit because it's something about the facts of objects. Even when you use images there's an object aspect, something I try to do with my own photography. It isn't only something you look through to see the image. It's also a surface of coloured stuff, which has a material or object aspect. It's very interesting that you say that the finding of a readymade is a kind of improvisation.

Marclay I don't think it's exactly the same, but a similar kind of awareness. You can access new things in that way and not always have to be in control of the choices that you make. When you select a group of people to play with, that's given. You play for an hour and the music that comes out will always be different than with another group. When I was listening to recordings of the CCMC, what impressed me was how varied it was, even though you were working with the same group. Often, especially with large

groups of improvisers, it's really hard to achieve changes in dynamic that are not just loud and quiet, crescendo and decrescendo.

Snow That's very true.

Marclay There were lots of subtle changes. The form of the recording, if we don't want to call it a composition, ended up being quite varied. It has to do with practice also. You've been working with these people for so long. There is all that knowledge, previous experience, and knowing what the group is able to do, even though it's improvisation.

Snow It keeps on expanding in an individual sense, as if we were each composers except that we play together. I'm really happy to hear that you like the variety that we have.

Marclay It almost feels composed, in a positive way.

Snow (*laughs*) There have been many great compositions.

Marclay There are parallels between our work. With my *Record Without a Cover* (1985/99) you can't ignore the medium. You can't ignore that you are listening to a recording. There is confusion between what is intentionally recorded and what is damage to the surface of the disc. There's a push-and-pull between the reality and the illusion. You have to stay alert. Your film *Wavelength* (1967) is much like that too. In a lot of your film work, you constantly keep the viewer alert, aware of his or her thought process and the medium behind the experience. There's a tension between being fooled and being aware of the Illusion. That's something that I've been interested in too.

Snow That's what I meant about the sculptural aspect of what you do – the recognition that there is an object besides the illusion. Of course the illusion is convincing. We see a representation of a guitar and we all agree that 'it's a guitar'. But it isn't. So if it isn't a guitar, what is it? That's something I like to get people involved in: What is the transformation that takes place? It's so common that we read images, yet isn't it pretty mysterious that we can make that out and say, 'That's a guitar'?

Marclay This desire to be aware that everything has a meaning – if you use a camera or a paintbrush or a guitar, each of those tools has meaning beyond what you do with it. Duchamp said that when you use paint, you use a readymade because it comes out of a tube. This awareness and suspicion of the illusion and the fictional are important to me.

At some point in my development *Wavelength* played an important role. I first saw the film when I was an art student in Boston in 1977 or 1978. However, when I read about it recently in your catalogue, I realized I could not remember the soundtrack.

Snow The sine wave or the sync sound?

Marclay I had no conscious memory of the sound.

Snow That's interesting actually, that it would disappear, because the sound really is a pretty distinctive thing, the long glissando.

Marclay I know. It probably was part of my appreciation of the film that the sound became one with the image and connected with the zoom. There's a strong relationship between those two movements, the slow change in pitch and the slow close-up.

Snow I wanted to make them equivalent. The real equivalent of a zoom would be a crescendo or diminuendo, but since over that length of time it couldn't be controlled, I decided on going from as low as you can hear to as high as you can hear. I had the idea to use an instrument like a violin or a trombone, which has built-in glissando, and try to edit it all together on a tape. Then someone told me I could do it electronically. Well, I hadn't thought about that. Electronic music existed then but there weren't synthesizers. I met Ted Wolf, who worked at Bell Labs in New Jersey and said, 'I want to make this 40-minute glissando.' He said, 'Oh yeah, you can use a sine-wave generator.' That's how it happened.

Marclay I thought it was really strange that I didn't remember the sound, but I tend to be a more visual person. I can't hum a tune.

Snow That's why you're a good improviser.

Marclay I'm not very good at memorizing sound. It's very strange. I do remember being totally hypnotized by *Wavelength* and *La Région centrale* (1971), quite unable to let go and constantly being surprised.

Snow There's also kind of an imminence. It's directed.

Marclay Right. You sense that you know where you are going, but all these elements come in to disrupt your expectations.

Snow *Wavelength* is really constructed in frames and very, very, uneven. It was done by hand. What gives the impression of a continuous mechanical zoom is the evenness of the sound, because the sound has no frames.

Marclay Sound informs image so much. It really influences the image completely and reinforces the illusion. The soundtrack in a film is always more subliminal, I've found.

Snow Often on plane flights I watch movies without the sound because I find that much more interesting. The sound is always so coercive in feature films. It tells you this is happy, this is sad; now get excited, now don't get excited. You see the mechanics of fiction film construction much better if you see it without sound. This brings up what you're doing with film actually – exchanging soundtracks and all that.

Marclay In my video *Up and Out* (1998), you watch one film while listening to another. You're never sure of what's going on. The sound from the other film informs you in confusing ways. Suddenly, a very banal situation can become dramatic. At other times you can focus on the image without the sound overpowering it. You become aware of the editing points, like moments of intensity. It reveals otherwise hidden dynamics. It's interesting to think in retrospect about a film, trying to remember a scene. I tend to remember the image and have an idea of the dynamics, but I forget exactly what the soundtrack was.

Snow But that's because all fiction films are sync sound, naturalist sound. Mouths move so you think they are speaking. You forget that the sound is coming out of a loudspeaker. It just becomes part of the realism that they

talk. The music, if it's successful, enhances moods or reinforces moods, so you don't think of that either. Because it's the mood that you experience.

Marclay Plus we are so used to hearing this underpinning of emotion through the sound. It's almost as if we can't deal without it now, it is so much part of the film grammar.

Snow Personally it's something I've been opposed to in my own work ever since I started making films. I don't want that.

Marclay You want us to be aware of sound as an independent entity. Godard also made me aware of the importance of sound and how manipulative it can be. He often deals with that.

Snow Even in his films, there's still a respect for the suspension of disbelief. He can't be completely constructive. He couldn't make a fiction film and decide to cut it up into 20 pieces and patch it together again and have it be interesting. He still respects a certain kind of naturalism or realism.

Marclay But he plays nicely with sound. In *Every Man for Himself* [*Sauve qui peut (la vie)*, 1980], there's a romantic scene. You hear violins. Then the camera pans and you see that the string quartet is right there in the scene.

Snow That's nice. He really can do that ironic playing with expectations.
 I want to tell you about a film I just finished shooting. It's relevant somehow. The Toronto International Film Festival asked ten filmmakers to make little 'preludes' to be shown prior to the main programmes this year. I was surprised to be asked because I'm kind of subterranean. They're to be short. Four minutes is the limit.
 In *Prelude* (2000), I did something I'd done in *Rameau's Nephew* (1974) in a different way. It's a single tripod pan and shot in sync sound. A group of people in a loft are eating in a big hurry because they are trying to get to a festival screening. It starts with them playing very, very loud music (which happens to be the CCMC) and shouting over it. There's a knock at the door; they are waiting for a pizza. This woman rushes to the door. They are all yelling over this sound and finally she says 'Could you turn the sound down a little bit?' And this guy: 'Okay, it's nearly over, I'll turn it off.' Click. That's the end

of the music and an off-screen voice calls cut. Every 30 seconds the voice calls cut but there is no cut in the image. It goes on with them eating. Talk about sex and violence. A woman takes off her blouse. At the end, a guy is standing next to a great big Chinese vase. They're talking about whether there's going to be any violence in the film they're going to see and he says 'Here's some violence now in this film' and smashes the vase. Someone says, 'That takes care of that. Let's go.' And he says, 'No, let's stay and see this movie.'

I'm going to cut and rearrange the sound, not the picture. The last scene's sound gets put against the part where the woman rushes to the door. And the first part goes to the end. I'm shifting it all around. The third part stays in sync. The fifth part is set against the first image, the fourth part against the second image, etc.

Marclay I see. You're only cutting the sound.

Snow You see all this yelling and you hear the crash of the vase. There's obviously no source in the image. This keeps on happening except in the middle, which is a sort of fulcrum, when they're in sync. By the end shot, when the guy actually breaks the vase, you say 'Oh, that's what the crash was.'

It's a short film, just 2 minutes, 30 seconds. And the sound for the section where you saw all the yelling ends with the guy saying 'I'll turn it off.' And it's the end of the sound and the end of the film.

Marclay It's short enough that you can remember the sequence?

Snow I think so. I brought it up because it's an example of doing something with sound that's actually construction, as opposed to using it for mood, character, or any of those methods. It has now become a thing in itself, which is really important to the experience.

Marclay If I try to recall an event, I'll most likely remember the image rather than the sound. But then if I hear a recording of a past event, my memory will be triggered. Sound is a perfect memory trigger. It's so suggestive. I recall the image faster than the other way around.

Snow Which relates to the radio-play kind of image, where you know that

it's a construct of the sound, the image. You believe that they are in such-and-such a place and such-and-such an event is taking place.

Marclay Vision is the dominant sense. We rely on it more. That's why I'm so interested in working with sound, to reverse those habits and try to make us aware of what we hear.

I wanted to ask you about *The Last LP* (1987). You were talking about the notion of abstraction and how music is thought of as a very abstract art. But *The Last LP* is a very figurative, realistic recording where you tried to imitate certain genres of anthropological field recordings.

Snow Well, it's my only fiction film. The recording attempted to indicate locations, like the Tibetan track for which the drones of brass instruments were supposedly recorded in a big, resonant stone hall, whereas 'Si Nopo Da', the African puberty rite, was recorded on a dusty plain, so that there's no echo. The liner notes are a very important part of it. It's picturing but also gives a pseudo ethno-musicological background, which affects your hearing. A friend of mine played *The Last LP* for a visitor, who liked it a lot and asked where she could get it. She became very angry when she found out it was faked. That's the real encounter. What on earth does that mean. Does it change the music?

Marclay It doesn't change the music, but people don't like to be fooled. It is interesting that you think of it in terms of fiction, when the subject of your fiction is realism. The thing about field recording is that you have to forget about high fidelity. Whatever's happening you have to record on the spot, even if there's thunder. You have one track where the tape recorder starts in the middle of the action. You recreate imperfect recording conditions.

Snow A plane goes by on the other African one.

Marclay The genre is documentary, yet you have created this total fiction. *The Last LP* is very descriptive. You try to imagine why the recording is so bad, how you are in the field and the conditions are not optimal.

Snow There's a lot of wind in one of them actually.

Marclay It's the perfect outdoor-recording cliché. Or the birds are too loud. The one I like best is the waterfall, the gurgling one, where the waterfall is just this big hiss in the front and you can barely hear the ritual. That's what always happens when you're recording something in the field. Like we're recording this conversation.

Snow We hope we are. (*laughs*)

Marclay We hope, yeah. And all the ambient sounds that we're not aware of, luckily there aren't so many here. If we were recording ourselves in a restaurant and perhaps not aware of the music in the background, we'd listen later and wonder 'Where did all that music come from?' On tape, background sounds can become just as important as the conversation. Our selective ability to listen to certain sounds and ignore the rest is something the microphone cannot do. In recording, everything occupies the same field. But in film, the image affects aural perception. When you have something to look at, it continuously refocuses your perception of the sound and gives it depth.

Christian Marclay and Michael Snow, 'Michael Snow & Christian Marclay: A Conversation' (4 June 2000, New York), *Christian Marclay: Cinema* (Oakville, Ontario: Oakville Galleries, 2000); reprinted in *Replay/Christian Marclay*, ed. Jean-Pierre Criqui (Zürich: JRP/Ringierl/Paris: Cité de la Musique/Melbourne: Australian Centre for Moving Image, 2007) 126–34.

Words and Music:
In Conversation with Jan Estep
2001

Jan Estep You made a piece in 1996 called *Graffiti Composition*, in which you installed large posters of empty sheet music throughout the streets of Berlin. Passers-by responded with graffiti, personal ads, bits of musical notation and drawings. Most of the posters were consequently destroyed, either torn down or plastered over with other signs, but you photographed some of them and have turned these photographs into a musical score that can be interpreted literally (when there is music written on the posters) or used as a catalyst for a performance. This piece made me think a lot about written and spoken language, and I started seeing that interest throughout your other work: the vinyl record becomes a palimpsest that has a history of layered marks that you can't erase; incidental scratches become a natural part of the piece, not a mistake but integral to its meaning and composition. In *Graffiti Composition* language potentially becomes pure sign, pure marks on a stave. Do you think much about this relationship between writing music, making music, and language in the sense of how we communicate with one another?

Christian Marclay Very much so. I have a strange relationship to language, partly because of my background. I was born in the United States but raised in Switzerland. I was raised speaking French and learned English later. I've always felt like I was between two cultures, between two languages. I think I became an artist because I didn't trust language that much and I was more interested in other types of communication, like visual language or music, things that rely on different signs or perceptions. I don't mean to explain my development in such a simple way, but there is a questioning of language that I've always been very conscious of. Music is such an open-ended way of expressing things; if you try to translate it into language it fails. In 1999 I did a piece called *Mixed Reviews* which is all about this discrepancy. It's a long text that I made by sampling sentences or paragraphs from different reviews of musical performances, records and CDs found in music magazines or the *New York Times*. Every time the writer tried to describe the music, the sounds, I took this description and collaged it with others to create

a seamless text, a continuous flow of words, a rambling sound description.

The challenge for a writer to describe sound is interesting. Music reviews, unlike art reviews where you can describe the object you're seeing, can't really describe the music so easily. You have to use metaphors, comparisons with other known musical forms or performers. Music writers mostly talk about other issues, but once in a while there's an attempt to describe what is heard.

Estep How long is the string of words in *Mixed Reviews*?

Marclay It's about five pages of dense text, about 2,500 words. It then gets translated into the local language where it is exhibited, so it's really a piece about translation. It was first shown in Japan, so the original English text was translated into Japanese. It was also translated into French Canadian, and later it was retranslated into English for a recent show in St Louis.

Estep So this new English version has gone through multiple translations?

Marclay Yes. The translator is always working off the most recent version. The piece will be shown in different locations and will be translated many times, and every time the text will be more and more removed from the original experience of sound that the first writer tried to put into words. This sort of impossibility, this attempt at describing sound interests me. I also made a video version in which I asked a deaf actor, who was born deaf, to translate the text into American Sign Language (ASL). He's not signing every letter, he's visually interpreting sound in a very expressive way, it's all sign and body language. My interest in ASL grew out of a piece I did using the archives of the tenor Enrico Caruso, held in the library at the Peabody Conservatory of Music in Baltimore. I found a news clipping in Caruso's scrapbooks about his meeting with Helen Keller in 1917; it describes how he sang for her and how – being deaf and blind – she felt his voice through touch. He sang a song from the opera *Samson and Delilah*, when Samson is blind and lost in his cell. Their personalities were so completely opposite – Caruso loud and extroverted and Keller a prisoner of her own body, trying to communicate. I had never thought much about how sound could be experienced through touch, this was fascinating.

Estep What was the result of your research?

Marclay An installation, *Keller and Caruso* (2000). It was part of a three-person show called 'Making Sense', organized by the Contemporary Museum in Baltimore. But my piece was installed outside the museum at the Peabody Conservatory of Music nearby. I filled the waiting room of the concert hall with a labyrinth of museum vitrines containing lots of objects and video monitors relating to these two characters. I had a deaf assistant at that time, so it seemed natural to translate *Mixed Reviews* into sign language and include it as a video in the show. I would eventually like to have the video translated back into music, to find a way back from silence to sound again. It will be nothing like the original, but I never knew what the original was anyway, all I know are the printed descriptions that by now have totally lost their original context and memory.

Estep Are you more interested conceptually in what is going to happen to the text over time as it gets further and further away from its referent, or is there some kind of qualitative judgement at work? Will this create something that is musically more interesting, better, or more insightful than the traditionally played original?

Marclay It's more out of curiosity, or an interest in changes and the discrepancies between the signifier and the signified. Also, *Mixed Reviews* is installed as a line of text that goes around the gallery, printed in small type. In order to experience it you have to read while you walk around the space. You either pick up fragments or, if you really want to read the whole thing, you have to move physically through the space. In Japanese it looked beautiful but totally incomprehensible to me, and the small line of text almost disappeared in the large space.

Estep You seem to do this a lot: disrupt people's habitual ways of processing information. In part the project you are discussing is about the difficulty of describing something that is fairly immaterial. We haven't developed a vocabulary to express the subtleties of what we hear and that makes it hard for us to identify non-text-based sound. You disrupt the normal way we might use or understand language, and draw our attention to the gaps in our knowledge. You do a similar thing with music, by emphasizing what's physically possible but often taken for granted; you don't just keep the needle in the groove, you skim the surface of the record, running across it to make sound.

Marclay I'm curious to bring out aspects of things that are just so common we're not even aware of them. With music, I want to disrupt our listening habits. When a record skips or pops or we hear the surface noise, we try very hard to make an abstraction of it so it doesn't disrupt the musical flow. I try to make people aware of these imperfections, and accept them as music; the recording is a sort of illusion, while the scratch on the record is more real. I want to question the recording medium itself, or any medium for that matter, be it a sound recording or a text.

Estep You question the transparency of the exhibition space as well.

Marclay Some of the pieces shown at the Museum of Contemporary Art, Chicago – like the very long accordion and the very tall drum set – were first exhibited in a music shop in San Antonio, Texas, rather than in a gallery.

Estep Can you imagine some parent walking in with a son or daughter and the kid says, 'I want that one.' It was fairly seamless, right?

Marclay Yes. People didn't expect to see art in a store and they might never have recognized it as such, which is the interesting thing, whereas when you come to an art gallery you expect to see something unusual. But in the music shop the instruments almost belonged there, they blended in, and became almost invisible.

Estep Almost, but not quite. You've always managed to be involved in two worlds: to perform and produce music and to exhibit in traditional visual-art contexts, and it doesn't seem like you try to prioritize one over the other. You move back and forth between sculpture, video, sound recording and performance. Why is it important to you to be involved in both realms; why not be just a musician or a visual artist?

Marclay I wish I had more time – two lives – because I don't get to do all the things I'd like to do in music or in art. For instance I'd like to be able to put out a new record every year, but I just don't have the time. I tend to see myself as an artist who does a lot of different things, because with the musician label you're too easily typecast. Artists, at least these days, are allowed to do whatever they want, which is great. So I can make a video, a CD, or have

an exhibition of sculptures, perform in a small club or in a museum. Everything is possible. For a long time I trusted my eyes better than I trusted my ears, but I don't really care so much about that anymore.

Estep Why were you more comfortable making visual art than making music?

Marclay Because of my training I was more confident about making a judgement about something I could see; I could understand it and say why I liked it or not. But with music I didn't feel that I had the proper skills. I had not been trained to listen and to understand music the way most musicians are. But since, I've learned how to trust my untrained approach, and other musicians have helped me trust my intuition. It's like anything, the more you do it the more you are able to trust your judgement. The creative process is a little different: in general I tend to work on my own when I make visual art; music is made in a more social space, where I interact with other musicians and improvise. I like to have the choice to either isolate myself in my studio or to collaborate with other musicians. I don't want to generalize too much because as a visual artist I also collaborate with others a lot, such as fabricators, technicians, curators and art professionals.

Estep But maybe at a different point in the process. Live improvisation is certainly different from any kind of negotiation you might have with a fabricator or curator.

Marclay And there's something so immediate about making music. You just do it. [The turntablist] Toshio Kajiwara and I are going to perform in a duet tonight for the first time.

Estep Will you rehearse?

Marclay We'll do a sound check and get all the technical stuff ready, then we'll just play, and it may gel or it may not. This gives a nice tension to the performance. Music gives me a very direct pleasure from doing something spontaneously, and with improvisation it's understood that sometimes it works and sometimes it fails. When you make an art show you don't want to fail. (*laughs*)

Estep No, severe editing is required. (*laughs*) You mention failure again. Earlier you said there's a way that language fails, or one's expectations of what it can do can fail us, even though we rely on it for communication. It's almost as if you trust the physical more than the conceptual: the breath hitting the cheek as you described it for Helen Keller, rather than the content of the speech, or the sound you create by scratching across the surface of a record rather than the pre-recorded music.

Marclay When we communicate with language we're always looking for the right word, the precise word, the word that will tell the full story. With art and music you still have to be very precise, but the focus is different, it is less about the meaning than the possibilities for interpretation. You can't control how people will read your art and use it. There's not one interpretation, there are as many interpretations as audiences. Art is only a catalyst, it has to be open to multiple interpretations, it has to be used.

Estep You mean to be evocative rather than so specific?

Marclay Yes. All these issues about meaning and trying to express something the best we can are important, but I'm also interested in this idea of failed communication, when something unexpected happens because of a misunderstanding.

Estep Some understanding takes place even if it's 'wrong'.

Marclay Yes. And that could potentially be interesting if it's not destructive. (*laughs*) The mistakes are often very enlightening. The unexpected will lead to new meaning.

Estep Is this openness tied to your willingness to let chance operate in your work, letting the accidental and the incidental become fully incorporated?

Marclay Yes. Allowing myself a kind of distance and loss of control might sometimes be very revealing. I like making pieces that continuously evolve, for instance *Mixed Reviews* will never have a definitive finished version. The same is true of *Graffiti Composition*, it was first a street installation for people to leave markings, now it's a score, and in the future there will

be concerts and recordings by other people. I like these evolving structures where I eventually lose control. With turntables and records, which are mechanical means to repeat captured sounds, you can have malfunctions that will make your record skip or play at the wrong speed, unexpected accidents that will reveal a new dimension; it will reveal something that it wasn't meant to repeat, and that's good too.

Estep Do you think sound affects the body or the psyche differently than the visual, or visual art?

Marclay As with sound, we're affected by colours and light in a physiological way that we don't quite understand. But again, those things are so subjective; you can't create a reliable system around them. I've never been much of a believer in synaesthesia. There are connections between the senses, but they are so personal and subjective that it's not really a science.

Estep Do you think most people have a more developed sense of visual than aural phenomena?

Marclay I'm not sure, but our culture is dominated by visual signs, we're more often visually stimulated, and we also communicate visually through writing and images. We communicate with language but it's still connected to writing. We say 'an image is worth a thousand words' and we tend to trust what we can see and feel more than what we hear. We're always looking at things, watching movies and photographs.

Estep You made a video in 1995 titled *Telephones*, in which you edited together clips from old movies showing people talking on the telephone, creating one long conversation. There's a part near the end where we hear someone talking on the phone say, 'Oh, I wish I could see you, I wish I could talk to you.' She is talking to the person on the other end of the line but there's this momentary confusion in her speech that reveals the feeling that since she can't see the person, it's not adequate, or that she can't trust the information coming across the phone line.

Marclay We like to see whom we're talking to. The actors in *Telephones* are often saying 'I see' to express understanding, even though they are

not seeing their interlocutors. I'm very interested in this sensorial confusion between the eyes and the ears; that's why I'm also very intrigued by people who have hearing or seeing disabilities. *Keller and Caruso* was also intended to be experienced by blind people. All the labels were in Braille and didn't even explain what was in the vitrines. They provided just another layer of information. My ideal audience for this show would have been a group of three people, one blind, one seeing, and one deaf. They would have to share clues, they would need each other to understand certain aspects of the show, but as with the single viewer, they would not be able to get everything. A lot of people go into a contemporary art gallery convinced that they're not going to get it. I wanted to make that frustration real instead of imaginary.

Estep Initially this strikes me as a sweet social message: we need each other, don't take your perceptions for granted, we all have something valuable to contribute because we perceive differently. Meaning is very subjective and is enhanced by dialogue with others. This message is there, but there's also an ornery attitude that says, 'You are going to be frustrated' and 'Don't think you can understand this so easily.' You want people to allow there to be some room for lack and incompleteness. In practical terms, we walk around, we take in information, we quickly categorize it, and we move on. Do you think this practice limits the aesthetic response a person can have to art?

Marclay I don't want people to be lazy and say they can miss some of it. But we live in a culture where there's so much information that you have to accept the fact that you can't take it all in. Most people don't have a problem watching TV while doing ten other things, or watch 20 channels at once. We live with this understanding that we can't know it all, but it doesn't mean we know nothing.

Estep *Keller and Caruso* seems so poetic, about a particular state in which people find themselves in the world. The pieces at the MCA, the adulterated instruments, are much more overtly funny to me: the rubberized and droopy guitar too pathetic to make a vibration, the extended drum kit implying an inflated rock-star ego, the impossible talent a musician would need to perform these instruments. There's a wide range in your work, and both kinds of work were being made roughly at the same time. It's not like you

were doing the funny instruments and now you've moved on to more serious subject matter.

Marclay There's also a lot of humour in *Keller and Caruso*, but maybe it didn't come through in the description I've given you. For example, within the vitrines were incongruous juxtapositions of objects, a mixture of pop culture and historical artefacts. Small monitors with different video clips, one from the pilot episode of *Mission Impossible* showing a record that self-destructs, it smokes and dissolves, and next to it was a Braille musical score for the opera *Samson and Delilah*. Another short clip was taken from a Charlie Chaplin movie, it shows a man trying to speak while only soap bubbles come out of his mouth. My video *Guitar Drag* (2000) – in which a guitar is tied up to the back of a pick-up truck and dragged around – is a serious piece, but it can be interpreted as a fun rock and roll thing or as a totally violent and destructive gesture, it depends on the audience. There is often a certain dose of humour in my work, it helps get people engaged in a non-threatening way. But humour can be serious too, sometimes even nasty, it all depends on how you look at it.

Christian Marclay and Jan Estep, 'Words and Music: Interview with Christian Marclay', *New Art Examiner* (September/October 2001) 78–83.

In Conversation with Philip Sherburne
2005

[...] *In* Shake Rattle and Roll (fluxmix) *(2004), Christian Marclay plunders the Walker Art Center's substantial collection of Fluxus objects, presenting a 16-channel audio- and video installation in which his white-gloved hands shake, rattle and roll (and tap, thump and thwack) dozens of items by George Maciunas, Yoko Ono, Nam June Paik, Joseph Beuys and their peers. [...]*

Christian Marclay [*Shake Rattle and Roll (fluxmix)*] started with this idea I had of doing a project with the Swiss National Collection, taking objects – from an antique chest to an old bicycle – that the government or the historical society deemed worth saving, and using them for their sound. But that project never happened. When the Walker invited me to be an artist in residence I still had this idea kicking around in the back of my mind. And then, when I found out they had a large Fluxus collection, it all made sense because Fluxus was all about doing things in a non-traditional way, reacting to the whole art system of creating collectable objects. They were more iconoclastic, trying to make fun of the whole process, so there's a lot of humour in it. At the same time, there's a delight in the strangeness of objects. I, of course, couldn't just do anything I wanted with them, I had to wear white gloves.

Philip Sherburne They made you do that?

Marclay Well, that's museum policy. The appropriate way of handling objects is with white gloves. So it became this magic show. And that playfulness was so much in tune with what Fluxus was all about. In some cases there are non-musical objects that I use musically, and sometimes there are musical objects that I use differently from their proper function. These are the kind of spoofing, iconoclastic and Dadaist gestures that Fluxus was all about. And to see these objects in a museum, protected – embalmed almost – made no sense. It was contrary to the initial objective of the artists. A lot of art objects end up like that. You can't touch them, even if they're objects

that were made to be interacted with. And so it was about critiquing the institutionalization of the art object, but in a playful and humourous way.

Sherburne I'm surprised to hear that you thought of this project before you had access to the Fluxus collection. So much of it seems tied up in Fluxus, and there's so much of Fluxus in your work in terms of sound, in terms of play, and in the recycling of everyday objects. The show feels like an art mix tape. You're taking these things and throwing them into a mix. It's curatorial, but it's a performative spin on curation.

Marclay Creating an exhibition in a non-museological way has always been something I have been interested in. I did a project in 1995 in Geneva at the Musée d'Art et d'Histoire, which used everything in the collection that had anything to do with music. It's a historical museum filled with everything from antiquities to contemporary art, and I just selected anything that had to do with music, to create these flea-market-like installations. Then I did another installation at the Kunsthaus in Zürich where I was playing with the museum's collection. So, again, these shows are not didactic. They don't inform the viewer about the art object and its historical value; it's more about using the art objects like raw material in playful ways, and it makes you look at the objects differently.

Sherburne When did you first become aware of the Fluxus movement?

Marclay I discovered Fluxus in the mid 1970s when I was an art student in Geneva, through John Armleder and his group Ecart. This group of artists was working in sort of a post-Fluxus mode and restaging some of the performances by Fluxus artists. What struck me about these performances was that many had something to do with sound, but they were more about making fun of classical music rituals and the traditional relationship with the audience. That early exposure to Fluxus was important in my development and was an influence on my later interests in performance art.

Sherburne What do you think about the current vogue for so-called sound art?

Marclay I'd like to think it sort of came out of the whole performance art movement. Maybe it started in 1958 with John Cage teaching at the New School,

and it's just growing out of there through punk and hip hop. The art world had embraced punk at some point, and now there's a need for sound again. The art world is always eager to find new blood, and something else to stifle.

Sherburne All the major museums and galleries have shows devoted to it.

Marclay Well, I think it's great that there is this interest in sound and music, but the overall art-world structures are not yet ready for that, because sound requires different technology and different architecture to be presented. We still think of museum galleries as nineteenth-century galleries, like 'How do we hang this on the wall, how do we light it?' But nobody knows anything about sound – how you hang a speaker, how you EQ [equalize] it to the room. There isn't that kind of knowledge and expertise within the museum world. More and more museums have a lounge-type listening room, but there are still a lot of changes that need to happen before the art world is ready to present sound as art. And you know, it doesn't matter, because there are so many ways for people to enjoy sound these days. Sound is so easily diffused, spread around through the Internet, downloaded to portable MP3 players and walkmans, you name it. Everything is so portable and so easy to share that you don't need an art institution to tell people what to listen to. I think it's in sound's nature to be free and uncontrollable, to go through the cracks, to places where it's not supposed to go.

Sherburne I think sound is often best when it's unexpected in that sense. I heard 'Amazing Grace' today in the subway, and I was really moved. I'm not religious or anything, but it was just one of those moments.

Marclay Well, New York is such a source of unexpected visual and aural stimulation. It doesn't necessarily have to be art for it to touch or transport you. I mean, it is art, you know, an artist singing in the subway, but it doesn't have to be presented in a place where you have to go to get it.

Sherburne Most people know you for your work with records and with vinyl. Have you considered doing something about the download culture and digital distribution?

Marclay Yeah. I would like to. I'm kind of low-tech, not very good with

downloading, but what I like is how sound circulates and how you can produce things and put them on the Internet where it circulates and takes on a life of its own. It is an uncontrollable environment, which is very attractive.

Sherburne But you are such an object-oriented artist, and this new technology is all about dematerialization.

Marclay The whole idea of it is fascinating, and I think that's a revolution in itself – just the fact that you don't really need these big vinyl records; you don't need a big radio with big knobs or all this heavy equipment. There's a speed and lightness to that world that is fascinating and liberating.

Sherburne Let's talk about *djTRIO* (initiated in 1996).

Marclay *djTRIO* is always changing; it's a rotating trio. It's myself with two other DJs. It's very much about the idea of the DJ as an ensemble player rather than a soloist, which is how DJs usually are thought of.

Sherburne It's a very egotistical sort of position.

Marclay And it has become that more and more. The DJ used to be a shadow in the background. He was usually high up, a sort of *deus ex machina* pulling the strings. Now the DJ is like a rockstar, in the foreground, and nobody's dancing anymore; everybody's just watching the DJ. So *djTRIO* is a reaction to that. It's not like a traditional band where you can hear the drummer, you can hear the guitarist, you can hear the vocals. Here, it becomes this homogeneous sound – usually six hands on six records – and you can't really tell who's doing what. It's not about the personality cult of the DJ, and I like that kind of levelling, this egoless music.

Sherburne And you have another DJ performance called *Tabula Rasa*?

Marclay Yes, it's a collaboration with Flo Kaufmann, who is a DJ and specialist lathe cutter. *Tabula Rasa* is a performance we did already twice, and we're going to do it again in London. I bring turntables to the gig, and he brings a lathe.

Sherburne And he cuts the vinyl right then during the performance?

Marclay I start making sounds with my turntables – without any records, just feedback sounds – by shoving the turntable into the monitors and using the tone arm to create a vocabulary of sounds which he cuts live.

Sherburne On an acetate?

Marclay Yes. He hands me the first record and then I start mixing that acetate, changing the speeds, again developing the vocabulary while he's cutting another one. It's this weird process, and within an hour we have about six records. We start with nothing and develop all these sounds. It's great for me because it takes me completely away from the quotation of other records. I can only quote the medium. It's all about the sounds of the turntables and the sound of the lacquer and the needle and the groove. I love it because it's totally improvised. I can't rely on certainties and say, 'I know what this record sounds like', and grab it. There's no safety net. I have to be really on, and I love the challenge. It's kind of like diving without a parachute.

Sherburne (*laughs*) And being ready to crash.

Marclay Right. But I'm really excited about this project, and we're going to do it again on 22 March in London. It will be during my survey exhibition at the Barbican. I'd like to perform it more often, but right now I'm so busy it's hard to juggle the performances and the exhibitions. It would be great if I could multiply myself by sixteen, like in my *fluxmix* video. I could send one of me to London and one of me could stay in New York, and I would still have time for a lot more.

Sherburne Take a lesson from Warhol: just get yourself some interns and factory workers.

Marclay Yeah, but it's more fun doing it yourself.

Christian Marclay and Philip Sherburne, 'Interview – Christian Marclay: This Artist Makes Music Like You've Never Seen before and Art Like You've Never Heard before', *Interview* (March 2005) 162–7.

With some of my videos, many viewers don't really listen, because they're so involved in playing this game of recognition: trying to identify the film clips. It triggers so many memories that the brain goes into overload and they don't pay attention to the musicality. It takes a few viewings to let go and just balance yourself between this recognition and a kind of forgetfulness

In Conversation with David Toop, 2007

In Conversation with David Toop
2007

David Toop I'd like to begin by talking about the relationship between composition, improvisation and recording, as it's an interesting area at the moment. People used to be quite fundamentalist about where they felt they belonged, so if you were a composer you were a composer, if you were an improviser you were an improviser, if you were a video artist you were a video artist, and so on. But now there's much less clarity. Certainly in the area of composition versus improvisation, as some used to think of it, there's a younger generation that feels much less pressure to define clearly, if there is a fence at all, which side they're on. Personally I find that quite healthy, I don't know about you?

Christian Marclay I'm in the odd position of not being a composer in the traditional sense. I'm more of a live performer, mostly improvising. But when a performance ends up being recorded, does it become a composition or just a document? These days there are countless recordings of people improvising, because it's much easier to record and put things out. Maybe there's too much of it – stuff that should only have existed live. This sort of recording has its interest and value as document, but when you go into a recording studio to work on a piece of music – which will then only exist as a recording – is it composition if it cannot be played again, as opposed to traditionally notated music? What makes something a composition? I don't know. I don't know how to 'write' music, and if I had been trained, I probably would never have played with records.

Toop Exactly, yes.

Marclay For me it's a way to make music with the means available. But when you're reworking recordings that already exist, it's an unusual position to be in. I guess you could compare it to composers reworking notes that already exist, or structures ...

Toop Yes, or themes, or sometimes even working with existing material

and making variations from that. I remember buying your *Record Without a Cover* (1985). I was playing with Alterations in France and it was on sale there. I found it very interesting because it was a document but also a record, and an artwork, and also a set of ideas. You could say it was an intangible object because it was just a bunch of implications; it was an idea of what you could do. And so it was quite a complex object: it was a composition because it had a frame. I don't know how you did the record, I'd be interested to know, but it was like a performance that was framed just by the part where you drop on the stylus and then the run-out groove. It was all of these things but it developed in itself, and so over time it changed. That was built into the object itself and the ideas of it, so this continues in parallel with the development of your work. I still have that record and it gets more and more scuffed.

Marclay I remember you described how your cat was sleeping on it.

Toop (*laughs*) Yes, she used to sleep on it.

Marclay It's a beautiful image, this cat sleeping on a record. And poetic, if you think of the word 'cat' as a musician.

Toop (*laughs*) And also 'Kitten on the Keys' and all those pianistic references from cartoons.

Marclay I wanted to make a record that was critical of the medium. In relation to composition, it's an interesting record because it's not fixed. It changes as it gets damaged and these changes become part of the composition. The needle might skip or loop, or the surface might get so damaged that you can't really listen to it, or you'll just hear fragments. These damages will break up the linearity of the original and keep you aware and conscious of the fact that you're listening to a record, and not just to the recording the way it was on the tape when I finished it, but the recording in the groove. And you're never quite sure if the pops, clicks or surface noise were recorded or added later by the wear and tear.

Toop Or earlier, by the pressing.

Marclay So you have this tension between the actual recording and the

unstable medium, never knowing for sure what you are really hearing. It brings the idea of improvisation into the recording because it's open to change, and you can even decide to damage the record or care for it more or less, and that's a kind of participation. You get involved with the medium and the composition, you can affect what your hearing. It's collaborative, even performative: placing the record on the turntable, handling and caring for it, all those audiophile habits are being questioned. But now all that is really obsolete – we're talking about, you know …

Toop … antiques, yes.

Marclay We grew up listening to records, so we have that first-hand experience with these objects. We understand how destabilizing *Record Without a Cover* was then. Now, records don't have the same meaning as they did in 1985. I wasn't just releasing a piece of music, this record was also about impermanence, which is the true nature of music. I like improvisation because it's all about the present, you do it and then it's gone. I love going to a concert that's very good and you know that it wasn't recorded. So you share this live experience with a bunch of people who were present, and it never goes beyond that intimate circle. I think that's magical: this tenuous, fragile thing about live music that is so much about a shared experience, which doesn't translate into recordings.

Toop So that goes back to a pre-twentieth-century condition of listening to music, in a way. And I think the irony is that works like *Record Without a Cover* may have made a whole generation more relaxed about recording. You know, the first generation of improvisers were, well, they weren't *anti-recording*, but a lot of them had a very ambivalent attitude to recording, very similar to what you're describing, and they could be quite militant about it. But I think people now are relaxed about the idea of recording, so they have the tendency just to release a CD of a concert if it was any good. Maybe it's spurious, in a way, but I don't think that relaxation could have happened without works like *Record Without a Cover.*

Marclay Now you can record on a little digital device, put it out on a website, and people can download it in no time. It's easier but less tangible than a 12-inch record. Maybe that's the reason; the digital medium made people

more relaxed about recordings. In the eighties when you made a vinyl disc it was a big production, with the recording studio, designing a cover and all. It was meant to be a real statement. Now a recording is this immaterial digital thing. And after it's out there you don't know how it circulates, which is kind of interesting. This new recording technology affects the way we relate to music. Imagine when the first phonograph records appeared; it really changed the way people thought about music and composition. You can only put a limited amount on a record, so duration was something you had to be very conscious of. Now you don't have to worry about it as much. The early 78 rpm records were so short, maybe the three-minute song that is now so ingrained comes out of this limitation from the early years of the medium, and still defines our attention span for pop music. With hip hop there was this amazing revolution in composition, the idea of the 'remix' and 'extended play'. The fact that you can actually DJ with records and transform their duration is the beginning of a shift. The record becomes a tool rather than documenting one version of a composition, and you also get a B-side with extra sounds made for remixing and changing this piece of music, adapting it to your own taste, transforming it. This idea of putting out a record that is not a finite piece of music – with an immutable beginning and end – to me that's also a really important contribution. The record gives you some of the ingredients, so that you can kind of extend this soup.

Toop (*laughs*)

Marclay It's like the stone soup concept: everybody adds a little bit to it and it develops. The idea of composition as the vision of one person is negated. Today, these notions of authorship are being questioned, the idea of the singular author and copyrights.

Toop There were elements of early hip hop which almost had a sense of group myth. I had this conversation with Tom Silverman of Tommy Boy Records and he said the first time he went uptown to hear Bronx hip hop, just almost by chance, he went to this event where he heard Afrika Bambaataa and people just playing records in a room somewhere. He said they were advertising various acts who were supposed to appear, like Kraftwerk, on the poster. Nobody believed, obviously, that Kraftwerk would appear, or James Brown or whoever, but it was advertised. So it's almost like a sense of myth

that you can invite these people: you don't really invite them but you invite them by the act of advertising them on the poster and then their music becomes *your* music, in a way. To an extent, this is what you do, isn't it? Other people's work becomes your work, so it's almost like you've eaten and regurgitated them. People usually want to talk about copyright and that always ends up in a boring place. But it's something more than that, which is almost mythical, in a way, and I find it really interesting. You're doing that in the video works, as well, of course.

Marclay I've always sort of disguised the material I use – maybe disguised is the wrong word – but manipulate it in the way that it sometimes loses its origin; you can't recognize where the sounds came from. But at other times I make the quotes very clear, like on the record *More Encores* (1988), where I only use the records of one performer or composer to make a new piece, and you may recognize the original source. But when you deal with moving images, then you can't hide the original, because one frame can tell the whole story; you can't hide your tracks. A film still can instantly trigger memories in the viewer. In *Video Quartet* (2002) the viewer is as much a listener, and somehow becomes involved in the composition because you have to make choices, you can't see all four screens at once. And you perceive the music differently, because the image is charged with all this memory. It was also true when I was doing my live DJ pieces, because the audience could see that the music came from recordings that could potentially be recognizable, there was this kind of expectation of wanting to recognize. And sometimes even recognizing things that weren't in the mix, but that you thought you heard, because something was vaguely familiar.

With some of my videos, many viewers don't really listen, because they're so involved in playing this game of recognition: trying to identify the film clips. It triggers so many memories that the brain goes into overload and they don't pay attention to the musicality. It takes a few viewings to let go and just balance yourself between this recognition and a kind of forgetfulness.

Toop There's a real pleasure in that, though, right? I find that *Video Quartet* lives on for me in that sense because, occasionally, I'll be watching a film on television – and just something will come up, somebody's doing something weird with an instrument – and I think, oh, that would be great in *Video Quartet.*

Marclay (*laughs*) Take notes next time and let me know.

Toop Your recent video *Crossfire* (2007) is different: *Crossfire* is a more overwhelming, immersive piece and its development is – well, it's not a development – but it's quicker in the way it moves. But there's still a pleasure in seeing a frame that you recognize and thinking, yeah, I know that, and at the same time, this is counterbalanced by an overwhelming feeling of being in the middle of this gunfire. The memory component is really important in those pieces.

Marclay Because it grounds you, you know where these sounds are coming from. These fragments add up to be something completely different, but you understand the process, there isn't so much mystery. How music is produced is often mysterious, because it's made by experts who have skills, who can play their instrument in unique ways. Or else because of new technology. These days you often don't know how the sounds are generated (*laughs*). Are the musicians actually doing something on their laptops or – as the joke goes – are they just checking their emails?

Toop How does your video work feed into performing or creating music for other performers?

Marclay For me editing a video is like making a sound collage but with visuals attached to it – not a soundtrack to images, but images that have sounds: sound-images. More recently I used video to generate performances, with video scores such as *The Bell and the Glass* (2003) and *Screen Play* (2005). I'm using video for visual cues, devising ways to give musicians instructions. The music is triggered by the projection. *Screen Play* is a montage of old films, all silent and all black and white, on top of which I overlaid these simple and colourful graphic animations: mostly lines and dots, simple forms derived from the staff lines and dots on a traditional score.

We're so conditioned to watching films with soundtracks that film images have the power to trigger sound. There are certain sounds that we now automatically associate with certain images, so I'm playing with this conditioning. The abstract graphics act as potential cues, signals to indicate a duration, a change, or maybe suggest a rhythm or pitch. Because the video is visible, the audience is engaged in the process.

They're seeing what inspired the music. They see the cause and hear the effect. It's not completely improvised, the musicians rehearse, familiarize themselves with the video and learn the cues. The way I've been presenting *Screen Play* is to invite three different ensembles to take turns performing in the same evening. The audience sees the movie three times with three different soundtracks, because sound can affect a scene, and something that might appear to be long with one kind of music will appear to be short with another. And you may notice something visually that you hadn't noticed before, because a sound underlines it differently from one interpretation to the next. You may ask yourself, Am I watching the same film or a different version? Something happens that's different than if you're sitting with your eyes closed, listening to a piece of music, where the score is visible only to the musicians.

Toop Did you have a sense of what you wanted to hear when you were devising this piece?

Marclay I could hear music in my head when editing the footage. I had an idea of what it *could* be, but most of the time I'm surprised with what musicians come up with. It's been performed many times and it's always different. It's basically an open score, only the duration is the same, and even then musicians decide to start a little before and end a little after. I never know what's going to happen and that's great. So in a way the only thing that I can really put my name on, as a composer, is the visuals. That's going to remain the same, but the music will always be different.

Toop But it is your music, to an extent, isn't it, because it wouldn't have happened without you and your method and directions that are intrinsic in the material.

Marclay I'm not sure. These new pieces, like *Shuffle* (2007) or *Graffiti Composition* (2002) offer only possibilities: it's like a social situation that involves musicians and audiences. And whatever happens in that setting, happens. I have no control over what the music sounds like.

Toop Yes, it's your party. It's a party that has certain subtle constraints, or it pushes in a certain direction. There's room for pleasant surprise

and there's room for disappointment. One of the interesting things is how you deal with, say, the disappointment (*laughter*). So many things must have happened at times, where you felt that no, this wasn't what I wanted.

Marclay The party is a good analogy, it's a social event and you never know how it's going to pan out. You try to make everybody happy and provide the food and drinks, but you can't be sure of the outcome.

Toop But you don't want a party to be boring so you bring slightly unsafe people to the party, and with that comes the possibility of a dynamism that may be greater than you expected.

Marclay It's a little bit the same with an improvised gig. You bring different musicians together who you hope can have an interesting dialogue and create interesting music together. Sometimes that fails and other times it's great. That's what I enjoy about it, not knowing where you're going.

Toop Well that's a big shift, isn't it, I mean the romantic composer; you know, the romantic idea of the composer who's in complete control. There was the emphasis in the twentieth century on greater and greater control and then you have this kind of letting go which comes with indeterminacy and improvisation. Improvisation is partly about acceptance that certain things will happen which will make you unhappy. And so this form of composition can't really happen without that sense of acceptance and letting go. The form becomes more open, the narrative can be impulsive, modular, fragmented. One of the interesting things about, say, your video pieces is that they engage with stories by means of these newer ways of making stories. So, you could say that *Video Quartet* is an open-form piece: it makes a big story, or not a story, from all these mini-stories. And you can make stories from it if you want to – it's very open to participation in that way –or you could simply listen to it as a piece of music which is constructed very much in a postwar vein, where there isn't a narrative arc or reconciliation of materials. It's similar to certain methods of composing and improvisation.

Marclay Well, I would say it has a sort of narrative arc, there's a beginning, different movements, and there's an end. In a way it has a traditional form, and the genre is collage.

Toop I thought about it with *Crossfire*, because in a way *Crossfire* seemed to me to be a response partly to an increasing emphasis on gun fights in cinema. In John Woo films you'd have this thirty-minute orgy of gunfire. At some point, he says, okay, forget the story and let's just have guys shooting guns at each other because that's what everybody loves (*laughs*). It's like going to a boxing match and two boxers just knock each other out over and over again. So that, in itself, was a radical intervention into narrative flow when a director says, okay, we've had thirty minutes of nice stuff and now let's just have the guys killing each other. So you pushed this further to the extent where you've got nothing else: you've got the quintessential moment of the gunfire.

Marclay There's a new narrative organized around the handling of guns, a narrative and musical composition that holds things together, creates tension. The new structure is mainly rhythmic, reminiscent of pop beats or dance music. You get this contradiction because the violent action of guns becomes this kind of pop music.

Toop So it's like a kind of techno record.

Marclay One part is about violence and the other is about this kind of partying euphoria and pleasure. It's a mix of contradictory emotions similar to what happens in *Guitar Drag* (2000) where you've got this violent action – the destruction of an electric guitar – that can be read even more violently as a metaphor for a lynching, and at the same time there's this excitement about the sound. It usually triggers very different reactions in audiences; some people just connect to the music as this kind of rock-and-roll aesthetic, heavy metal, intense noise guitar, and don't think of the other possible narrative, which is the dragging of someone behind a truck. Some only see that, for others it is a continuous back and forth. *Crossfire* works in a similar way. It's an interesting thing to observe, some people are very uncomfortable in that room while others are very exhilarated; they just love the tension, the build-up, the shooting and then the rhythms. It really depends how you're wired and what mood you're in.

Toop One thing that occurs to me is that you were talking about moving away from the records and into this area of being a kind of composer,

and then you're making work for exhibitions. Presumably that means you're performing much less? Do you miss that?

Marclay Yes, I do miss making live music, improvising something on the spot. Making a video or a sculpture is very time-consuming. There isn't that same kind of instant gratification. The reason for not performing so much any more with records and turntables has to do with the relevance of the instruments. In the early 1990s, with the advent of the digital, I started questioning what I was doing, and then there was a revival of the vinyl record through this DJ culture, it started booming just as I was ready to quit. So I got this second wind, but now, even though there's still a thriving DJ culture, it doesn't seem to be as relevant as it was, it has become a tired fad.

Toop The idea of turntable festivals seems slightly tired as an idea now.

Marclay Yes, that's why there are festivals for it. (*laughter*) I'm doing something next month at such a festival, Transmediale in Berlin. With Florian Kaufmann, aka DJ Flo, we've been performing this project called *Tabula Rasa*. It's still about DJing but with a twist. I come to the concert with three turntables but no records. I start making sounds with the turntables only, while Flo cuts an acetate with a lathe on stage, recording what I'm doing: rubbing my finger on the needle, hitting the tone arm, or making feedback with the turntables. Then he hands me that first acetate, which I start manipulating, changing the speed, scratching, spinning backwards, etc., while he's recording a second acetate. This goes on back and forth for about an hour. By the end I'm manipulating about six discs. We've done this a few times since 2000, but this project is still exciting because, while I'm dealing with this old analogue technology, I'm not quoting from recorded music, it's only about the live recording on acetate, with all its limitations, fragility and unpredictability. It's challenging to get it to work well and to get an interesting composition going, the sounds are very limited. I do use some effects and a looping device, but I'm just working with the recording process, the electrical amplification and the acetate, that's all. It feels extremely live because I can't rely on pre-recorded LPs. I'm creating my own palette of sounds as we go. I like this fragile process, it still feels interesting because it's new for me and I have to struggle. Limiting the sound source is also interesting. I have to keep on my toes because I can fail more easily.

Toop It could go horribly wrong in public, yes.

Marclay And because of that, when it works, it's really magical. It's that tension – between failing and succeeding – that makes for an interesting concert experience.

Toop I think the only way to keep alive as an artist is to continue to introduce difficulties, dangers or new problems for yourself or to reinvent yourself. If you have a tool which encourages complacency, then that's really not good for anybody. And a guitar can also be a tool for encouraging complacency. But, you know, it's certainly possible to stay in one spot for a long time and not be in any danger at all with a laptop, and that's true. So I think you always have to build in elements that make life difficult.

Marclay And not have any safety nets. *Tabula Rasa* is very much like that, there's no net. The whole laptop phenomenon has reduced that risk-taking and made performance less challenging, therefore less interesting for the audience.

Toop What about moving to London? I know you've been travelling a lot but I wonder if that's had an effect on what you're thinking about in terms of new work?

Marclay Not yet really, I'm still trying to get used to London. I was happy to present *Screen Play* recently with local musicians, which is a very open score comprised of photographs that are meant to be used as a graphic score. It's a set of 75 photographs I took during my travels of readymade musical notation, mostly decorative-type notation, like what you would see on the awning of a music store, or a design on a t-shirt or advertisement: a few wavy staff lines and notes kind of flying around. You know the type, designed by decorators or graphic designers with no knowledge of music. It's just these symbols representing an abstracted idea of music, like using a treble clef to signify music. These images were published as a box of large playing cards, and you can organize them in any order you want. With this project I hope to reach a wider audience and completely lose control over who is playing it; anybody who has a set of cards can play it. I've organized a few concerts around *Shuffle.* Steve Beresford put together this great ensemble for the London premiere, and it was great fun. In this case,

the audience doesn't really see what generates the music, as opposed to *Screen Play*.

Because I don't read or write music, and have a certain fascination with music notation, I can look at it from a distance and not think, oh, this is silly, or absurd notation. I just see it as visually interesting and intriguing. But somehow, when you give these naïve charts to musicians who can read classical music, suddenly there are possibilities for interpretation, these anonymous decorative and kitschy graphics become music.

Toop I've got some calligraphy around the house. I like it as a visual sign but then somebody comes and they look at it and they say, oh, yeah, that's a poem. (*laughs*)

Marclay These problems of translation are fascinating, I'm really interested in how we all have these different vantage points and levels of understandings. We just spoke about mistakes or lack of knowledge, problems that we encounter in the process of making music and how there's something positive about these deficiencies. *Mixed Reviews* (1999–2001) is another video that I consider a music composition, even though it's silent. It first started as a text, sentences that critics used to describe the music at a gig or on a record. And because it's an impossible thing to do – to describe a sound in words – they use all kinds of metaphors. So I collaged all these descriptions found in newspapers and magazines, strung them together to create a long sound description that made sense musically, and then I had a deaf person sign it. What you see is a silent video of someone describing sounds in sign language. There's a tremendous loss between the original music and these silent gestures, but you still get a sense that it's music. Of course, someone who understands sign language will have a totally different experience, but will still feel this loss. I am very intrigued by this impossibility to describe music in words.

Christian Marclay and David Toop, 'Conversation between Christian Marclay and David Toop Recorded at Toop's Home in London on 3 December 2007', in John Zorn, ed., *Arcana III: Musicians on Music* (New York: Hips Road/Tzadik, 2008) 138–52.

In Conversation with Students
at the University of Rennes
2009

Audience How does photography fit into your current practice?

Christian Marclay My use of photography varies a great deal. I use my camera mainly to take notes. Instead of a sketchbook, I have a camera. I use it to capture visual references, interesting coincidences, things I find curious or funny, or that I might be able to use later on in my work. It could be an object, a poster, a flower, or anything that catches my attention or triggers an idea.

The camera is like a magnifying glass; it forces me to look around more attentively. At the same time it allows me to go on being absent-minded, knowing that I can always come back to it. Speed is important – that's why I use an automatic camera. For me, snapshots are a quick way of remembering things. It's like jotting ideas on a notepad. I then have the elements I can work with when I'm not in a hurry. Photography is a means of recording that possesses a mnemonic function, like a journal. These last fifteen years or so, I've always had a little camera in my pocket. Today it's a digital one, no bigger than a packet of cigarettes. Nowadays I cannot leave home without my phone, my glasses and my camera. If I forget just one of those items I feel lost. They are like prostheses that help me to see and communicate better.

I tend to take more pictures when I'm on the road, travelling to other cities, because I'm more alert, more open to new surroundings. In unfamiliar places my visual perception is sharper. When I discover streets and situations different from the ones I'm used to in my daily life, I drop this habit of walking without thinking, which I tend to do in my own neighbourhood. More than ever, artists need to travel. In the eighteenth century they went on an initiatory journey, the Grand Tour. Now, every day seems to be a new stop on an endless journey. I feel the need to take photographs, positioning myself not as a tourist but more as a scientist seeking out rare specimens, or a detective hunting for clues.

Audience Over the course of your career the status of these photographs has evolved. Can you say something about this change?

Marclay My relation to photography hasn't changed. What has changed is my desire to share these images rather than keep them for myself like a private diary. Of course, the fact of making public what was initially a private activity affects the way I think about photography. Knowing that they are going to be seen by other people, I am more concerned about the quality of the images and their composition. I want them to tell their story the best way they can. I still make a distinction between different kinds of images. Some are destined to be shown, a few are made solely for research purposes, and others, finally, are private photographs. Sometimes these categories overlap.

I don't often take pictures of people, and especially not of people in the street – maybe that's because I myself don't like to be photographed. A camera can be very intrusive and I don't like to be faced with one. I mainly take pictures of people who are close to me. Why would I want to own photographs of people I don't know? I have never understood those collectors who buy images of strangers and hang them in their home. For me, a photographic portrait is a very personal thing.

But I must confess that sometimes I will collect images of strangers as part of a different process. For example, since 1992 I have been accumulating photographs of people playing music – old snapshots I find at flea markets. Oddly enough, the older the photos, the more generic they seem to me, because I don't have a personal connection with their subject and time. These images show ordinary people playing music, not professional musicians. Most of them are in a domestic setting and were taken by amateurs. A selection of these was used for *Amplification*, my installation at the Venice Biennale in 1995.

I also collect pictures of dancers at parties. That's another interesting subject, because when you see a picture of people dancing you know that there was music, even if the musicians or record player are outside the frame of the image. With dancers, the stillness of the image heightens its silence; the absence of sound is underscored by the absence of movement. The image seems even more frozen than ever.

I've always collected postcards, records, books, curios. The fact of collecting has influenced my artistic practice. By keeping found photographs or magazine cuttings, I'm accumulating material to work with. Appropriation has always played an important role in my work. I was very interested in the 'Pictures Generation' artists even if I wasn't part of that movement. Their practice

of appropriation is one I'm very familiar with, and what they did with photographs, I did with vinyl records.

However, I'm a false collector, because I'm far from systematic. In my work it would be more appropriate to speak of accumulating than of collecting. Taking photographs is a similar process except that, instead of amassing objects, you capture ephemeral impressions and situations. It takes up less space and is easily stored away in the camera's digital memory. Photography is a way of grasping the unusual, but also of observing everyday life and finding similarities between things and situations. Like archiving, it is a reaction against the transience of life. Photographing is akin to recording, but instead of sounds I'm recording images.

Audience Your interest in these temporal issues is a striking aspect of your work, as attested by the objects you use and the way some of them are now obsolete, like the old phones, audio cassettes, etc. Is your experimentation with old photographic techniques, with the photogram and cyanotype in particular, the sign of a nostalgic relation to images?

Marclay Is nostalgia missing the past or simply referring to it? Any photograph is nostalgic, because it always bears witness to a past. You cannot get away from the past. Photography is the witness of change, in a self-evident way. The longer the time elapsed between the click of the camera and the viewing of the captured image, the greater the feeling of loss. I don't yearn for the past; rather, I try to understand the present through it. Photography has the astonishing power to allow time travel. That's why taking photographs is so fascinating, even if it always looks towards the past. A photograph helps me understand the passing of time, like a landmark on a timeline.

I'm attracted by the feeling of loss you get from images that try to represent sound. The main thing missing in the image of a sound is the sound itself. We know photography is a medium that cannot capture sound. All it can capture are visual traces – the residues of something invisible, just as words on a page are the traces of an invisible thought.

Audience You like to be involved with the hanging of your snapshots in an exhibition; can you tell us about your procedure here?

Marclay Not many people have seen my snapshots, even though I have thousands of them. Today, with digital photography, large numbers of images aren't printed because I can look at them on my computer. It is a private activity. Once in a while I select a number of them to print, and they become more public. Seeing many of my photographs hanging together is also interesting for me. As in any other exhibition, I have to deal with constraints: the configuration of the space and the number of works presented. I play with that tension and create a dialogue between all of the images. Each time I install them, I discover new ways to read them. I try to avoid associating images in a way that is too obvious. I let the viewers create their own links as they walk around.

Audience The titles of all your snapshots indicate the place and the year they were taken. What is the function of these titles for you?

Marclay I note the date and the place in order to remember, because the banality of situations is often repetitious. I take pictures in the street, and it could be any street. Often there is not a lot of local specificity in these images. Above all, I don't want to impose an interpretation with a title that would explain the image or that would underline a detail. However, the dates and places do have an autobiographical character because they document my movements.

Audience The use of small format cameras and prints seems to be important to this activity.

Marclay I like small format cameras and small prints for their intimate relation to the image. Photographs in small dimensions are a condensed reality. They suggest an everyday experience of photography – that of the small prints on paper that I used to have developed at the neighbourhood drugstore or, today, the ones I find on the screen of my digital camera or laptop. For me, there isn't often much justification for large format prints. However, with photograms and cyanotypes, it's the object that defines the format of the image. Thus my latest cyanotypes are very big – some up to four by eight feet. The process imposes a scale that coincides with the objects used. The hand has more of a role there than it does with the snapshots. If these snapshots are outdoor sketches then cameraless

photographs are akin to working in the studio. The time spent making
a photogram or cyanotype is much longer. These are two very different
activities, subject to their respective constraints. Small format prints allow
me to show a lot of images together, none of which are necessarily any more
interesting than the others in my view. I try to bring out the familiarity of these
subjects and their diversity.

Christian Marclay and Masters Programme students, University of Rennes II; published in
Christian Marclay: Snap! (Dijon: Les Presses du Réel, 2009); trans. Charles Penwarden, 'A
Conversation with Christian Marclay', in *Christian Marclay: Things I've Heard,* (San Francisco:
Fraenkel Gallery/New York: Paula Cooper Gallery, 2013) 81–3.

Herb Alpert's Tijuana Brass:
Whipped Cream & Other Delights
2009

When I started digging through record crates in the late 1970s – a regular activity that I kept up until the end of the 1990s in search of raw material for my work – I stumbled across this amazing looking record, *Whipped Cream & Other Delights* by Herb Alpert's Tijuana Brass. The cover features a voluptuous model covered only in whipped cream from head to toe. Released in April 1965, the album shot to number one and stayed on the charts for more than three years, selling over six million copies in the United States. The record made Alpert rich and famous and the cover became iconic.

In the 1980s there seemed to be a copy in every crate I thumbed through. I got my first copy for 25 cents, then another, and soon I was buying every copy I could find, never spending more than a dollar for it. Soon it became evident that this record had a special meaning for many people because every time I went to the cash register to pay, the sales clerk (always male) would itemize the albums and pause on that particular cover and tell me a story about his first encounter with it. 'My father had this record', or, 'I had my first erection looking at her', or 'My mother used to hide it.' A friend told me how she realized she was a lesbian while looking at that cover. I wish I had recorded all these baby boomers reminiscing; it would tell the story of a generation that had discovered its sexuality through this image. The whipped cream was like Proust's madeleine: it made people remember. The stories sustained my curiosity and I kept buying the record whenever I spotted it. It was a way to celebrate its ubiquity, and in the back of my head I kept thinking the collection would become an artwork.

When, in 2001, Carlo McCormick asked me to contribute a selection of records from my archive for his exhibition 'The LP Show' at Exit Art in New York, I provided him with my entire collection of *Whipped Cream & Other Delights* – about 200 copies. Exhibited en masse as a wall grid from floor to ceiling, small differences between the mechanical reproductions became perceptible. Sometimes the hit title is highlighted in yellow; the printing quality varies depending on pressings, with matt paper in the States and glossy paper in Europe; the wear and tear; the taped repairs; the old price tags, and so on. It is like looking at Warhol's screenprints, infinite variations of a same

face. Among them I inserted five parody covers made in homage to the Tijuana Brass. Later, 'The LP Show' travelled to the Experience Music Project museum in Seattle. Coincidentally, the cover model, Dolores Erickson, who lives nearby, showed up for the opening. Sadly, I could not attend the event and missed my chance to meet Dolores. As a consolation, I received a picture of her standing in front of my wall of covers. Unfortunately I couldn't find this *mise-en-abîme* to reproduce here.

A year later, however, I did meet Herb Alpert when I was awarded the Herb Alpert Award for Visual Arts. There was a ceremony in New York and I thought of bringing a record for him to sign, but then at the last minute I felt silly and didn't bring it. But that year's Music Award winner, Laetitia Sonami, brought her copy to get autographed. She is a composer who uses sexy prostheses embedded with sensors to control her electronic music. The connection between body and music made sense.

The Alpert Award in the Arts provides cash prizes to artists working the fields of dance, film/video, music, theatre and the visual arts. Herb Alpert sold a lot of records, made a lot of money, and now he gives it away to many good causes. It's nice to know that all that cream was not wasted.

Christian Marclay, 'Herb Alpert's Tijuana Brass: *Whipped Cream & Other Delights'*, artwork selected for 'The Inner Sleeve' column, *The Wire*, no. 309 (November 2009) 77.

With my scores, I can't control the result. The music is not entirely mine. And even what generated the score is often not even mine; it is found, readymade music. The loss of control in music is actually what interests me the most

Never the Same Twice: In Conversation with Russell Ferguson, 2010

Never the Same Twice: In Conversation
with Russell Ferguson
2010

Russell Ferguson For most of your career, your activities as an artist and as a musician have seemed to follow almost parallel tracks. This exhibition at the Whitney ['Christian Marclay: Festival'] seems focused primarily on bringing your work as a composer into the space of the visual arts. I wonder whether you could say something about how these two tracks relate. Have you thought of them as separate, or have they always been aspects of one practice?

Christian Marclay I have straddled these two fields since very early on, when I was still an art student in Boston in the late 1970s. I started doing performance art and as a result got kicked out of the sculpture department. But when I started mixing records in performance, my work took a different turn. Music became central to my thinking. I don't really have two careers, because I make music the way a visual artist would. Sound and image are very closely intertwined in my work. Yet I feel more comfortable with the artist label than the composer label. I am not a composer. The only time I compose is when I perform or make a recording, or when I make an audiovisual composition with video. For a period in the early 1980s I stopped making art and focused on music. This was a very formative period for me. I was performing and touring a lot, collaborating with many musicians and learning so much from them. Many of these same musicians will be performing at the Whitney during the exhibition.

Ferguson Who are some of those musicians? How were they important to you?

Marclay John Zorn introduced me to a lot of musicians when he invited me to perform in his 'game pieces' in the early 1980s. These were group improvisations with rules such as in sports or strategy games. We were free to improvise within the precise guidelines determining our interaction, but not the specific sounds we made. Therefore the musical outcome was unpredictable. John was less concerned with the music than the structure of the pieces and the dynamic relation between the players. Because they were games, they were a lot of fun. The first Zorn piece I performed in was

Track and Field in 1982, and later *Darts*, *Locus Solus*, *Rugby* and *Cobra*, among others. There was a collage aspect to these fast-paced pieces, lots of jump-cut contrasts, and John liked the fact that I could conjure up the history of music at the drop of a needle, changing styles in an instant, from Braxton to Balinese. My first New York influence was punk and No Wave music, and it was interesting to see Zorn hire people like Arto Lindsay and Ikue Mori from the band DNA for his performances. Classical musicians, punks and all kinds of eccentrics, we played together regardless of genre and background. That mixing spirit was very much in the air at the time.

Through these performances I met many musicians who had very idiosyncratic ways of playing. I had to keep up with all that exceptional talent. It was a crash course in music improvisation. David Moss asked me to perform with him. We ended up performing a lot together and toured Japan in 1987, playing almost daily for a month. All this playing sharpened my skills as an improviser. I had met Elliott Sharp in 1981 when he asked me for a one-minute piece for his compilation LP *State of the Union*, which was my first recording on vinyl, made at home on a cassette player. Elliott and I have collaborated on many projects since. Butch Morris is also someone I befriended in those days. There were so many fascinating players: Anthony Coleman, Zeena Parkins, Tom Cora, Wayne Horwitz, Shelley Hirsch, Jim Staley, Fred Frith, among many others.

Ferguson I want to go back to your statement that you are 'not a composer', and that the only time you compose is when you 'perform or make a recording'. Do you not regard your scores (that other people can perform) as compositions?

Marclay My scores are not finished works. Every time they are performed they generate something new. They will never sound the same twice. Composing implies a determination or at least a structure, an absolute model that won't change much with each performance. Most of my scores don't even specify the instrumentation. They are open to a multitude of interpretations. The musicians are asked to be very creative. They are playing their music, not mine. 'Composer' also implies authorship; I prefer 'collaborator'. I am more like an instigator, who can disappear behind the score. I can hide in the audience and be surprised by what I hear. It's a very different experience from performing myself, or to be listening to someone

else's music being performed. The music is unfamiliar, yet I know what prompted it, because I was involved in the process.

Ferguson That's very modest. There are a lot of other composers whose scores incorporate aleatory elements, or at least elements that are very much up to the performers, and they still consider themselves the author of the work.

Marclay Maybe it's because of my visual-art background and my not having studied music in an academic way. If a fabricator makes an artwork for me, I direct him or her, and though there is an exchange of ideas, in the end I am the one who approves it or not. With my scores, I can't control the result. The music is not entirely mine. And even what generated the score is often not even mine; it is found, readymade music. The loss of control in music is actually what interests me the most. The struggle between control and loss of control is so much at the core of improvised music. Many artists have been interested in that threshold between determinacy and indeterminacy, and not just John Cage, but also Duchamp, Pollock, Burroughs, and others.

Ferguson Why is it that in your visual art you need, or want, complete control over every detail, but in the scores you are willing to surrender control almost entirely?

Marclay I never have complete control over anything, even when I think I do, and that is why I enjoy making art. Live music allows me more freedom because it is time based. It is very much of the moment. I can't go back to make corrections. I have to accept the mistakes and be attentive to the accidents, as they are often the springboards for discoveries. All scores imply a translation, and in all translation there is a loss of information, but there is also a potential gain. Selecting the interpreters is often as important as the score itself. Musicians with whom I have an affinity and shared history may be more suited to perform my pieces, and I may want to highlight their unique abilities. I have a piece called *Zoom Zoom* (2007–9) that was designed with Shelley Hirsch in mind. Others can perform it, but her skills are ideal for this work. She is a unique improviser, and her wild imagination always surprises me.

Ferguson Have you ever been taken aback or surprised by a performance of one of your scores? And would you say that there could be an illegitimate interpretation of them?

Marclay I have to accept that possibility. There have been performances that I didn't like as much as others, mainly because the interpreter was trying to outsmart the score, coming up with some gimmick instead of making some interesting music. That's the danger of giving someone so much freedom. Maybe because my scores are so visual, musicians sometimes feel this is their chance to be visual, to make performance art or something more theatrical, and as a result the music suffers. The best performances are usually the ones that focus on the music. When I played in John Zorn's pieces there was always someone who would use some strategy to negate the music, because there were ways, while playing by the rules, to become a soloist, and decide to do nothing. The silence was a way to show off one's prowess, but it never served the music well.

Ferguson For you as a musician, what are the main differences between free improvisation and performing someone else's score?

Marclay As a DJ I don't have the possibility of playing specific notes, so I'm limited with respect to traditional notation. But I can enjoy the constraints of a score or the directions of a composer. It usually forces me to explore possibilities that I may not access on my own. In Butch Morris's 'conductions' I was reacting to his directives, but it always remained an exchange, a collaboration in real time. We were all communicating at the same time, and his baton doesn't denote authority, but rather reflects and structures the group effort. In such structured improvisations the players bring a lot of their own skills and talent to the table. No one wants robots interpreting their music.

Collective free improvisation is never completely free because the musicians are reacting to one another, but one is not necessarily freer when improvising alone. I find playing with a group more interesting. Music is the most social of all the arts, and not just for the musicians. The audience plays its role – their presence adds a dynamic element to the event. That is what I like about live music, it is always social and unpredictable.

Ferguson Is there on any level a political dimension to the implied
collaboration between you and the performers of your scores?

Marclay You cannot create in a vacuum. I tend to base my work on realities
we all share. I do not create from an imagination disconnected from everyday
life. I'm less interested in dream or fantasy worlds, so of course the work
will reflect the sociopolitical structures I live in, and sometimes be critical
of them. My work with records is critical of the music industry, and it may
sound rebellious to some, but luckily it is not only that, it is also a way for
me to perform and enjoy the pleasure of collaboration with other musicians.
Performing with records and turntables is less interesting to me today because
vinyl records don't have the same cultural relevance they had in the 1980s.
I have to remain conscious of the social implications of any of my works.
Writing a traditional score implies a social hierarchy, which is not what I'm
trying to do here. I am not creating a composition out of sounds I imagined,
organizing them in a structure for musicians faithfully to recreate. Instead
I'm providing a framework, a context in which sounds can develop freely
through social interaction.

Ferguson You suggested earlier that your scores are in some ways unfinished
works. I'm interested in the point at which you might consider them completed.
Are they complete in some sense when you yourself finish making them,
or only after they have been performed? And to what extent do they exist
as purely visual works? .

Marclay The score is just a spark that triggers a reaction. It is a skeleton
that needs the flesh and blood of the performer to come to life. A spark
flickers for only an instant, so the idea of finished or unfinished is not
really appropriate here. Some of my scores don't necessarily need to
be performed to be appreciated. *Ephemera* (2009) or *Shuffle* (2007),
for instance, bring attention to the ubiquitous presence of graphic music
in our daily life. Maybe that's enough.
　　I'm interested in how something that is meaningless to one person
can generate particular sounds for someone else. To a musician the visual
stimuli result in action. Those sounds then create a bridge with an audience.
This translation of the senses is fascinating. Not because there is a mystery
there. On the contrary, the mystery is what I'm trying to eliminate. I'm not

interested in the mystery of the score, or its invisibility. I don't care so much for the mystique that occurs when the performer is the only one privy to the information of the score. In my video-scores such as *Screen Play* (2005) or *The Bell and the Glass* (2003), I alter the traditional dynamic between composer, performer and listener, because the projection shows the listener what the musicians are responding to. And I also create a situation in which sound and image influence each other. Music doesn't need to be blind. This idea that music should remain pure and be listened to with eyes closed is outdated.

Ferguson Do you think that pursuing both art and music has made it harder for people to get a complete sense of your work? To what extent do you have two separate audiences?

Marclay Music is performed in music spaces and art is presented in art spaces. This reinforces the divide. This exhibition will be a chance for a lot of people to see and, especially, to *hear* an aspect of my work that is less known. There has been so much talk about crossover between art and music, but in reality music is not taken seriously in the art world because it is less marketable. Also music in an exhibition gallery is less than ideal because of the bad acoustics. Maybe it is only an architectural problem? Yet an art audience comes with an openness often greater than in some academic music circles. When I make an audiovisual composition such as *Video Quartet* (2002), or *Crossfire* (2007), it is usually presented in an art context. The public reads it more in visual terms than musical ones, even though the work is really, for me, as much music as it is art. Each context comes with its limitations, and these video installations are technically too complex to present in a traditional music venue. But there is nothing wrong with having two audiences. As long as someone is affected by the work, I don't care who they are.

Christian Marclay and Russell Ferguson, 'Never the Same Twice: Christian Marclay Interviewed by Russell Ferguson', in *Christian Marclay: Festival*, vol. 1 (New York: Whitney Museum of American Art/New Haven and London: Yale University Press, 2010) 67–9.

Music I've Seen: In Conversation
with Frances Richard
2013

[...] *Last April, Marclay spoke with poet Frances Richard at San Francisco's Fraenkel Gallery. Marclay, who divides his residence between New York and London, was in the Bay Area for an exhibition of his photographs, titled 'Things I've Heard', at the gallery and to open his celebrated video work* The Clock *(2011), a monumental twenty-four-hour piece comprised of collaged film clips featuring each minute of the day, at the San Francisco Museum of Modern Art.*

Frances Richard You laminate so many layers of meaning into a simple gesture. In the *Zoom Zoom* (2007–9) and *Shuffle* photographs (2007), for instance, we get a direct depiction of packaging and signage. That brings along references to various visual regimes – street photography, Pop art, Flickr. Then, if we read the images as transcriptions of sounds instead of as representations of objects, we can choose to imagine that sound as abstract. Or as sound that communicates a specific message. We can conjure up audible sound – 'Pop pop puff' – or just think about sound-ness: 'Ah, onomatopoeia.' So many interpretive options are in play.

Christian Marclay That's when things are interesting and successful, when there are many possibilities for entering the work and interpreting it. In *Shuffle*, the pictures are far from being interesting in themselves. It's about documenting quickly, and not about composing a perfect image that would stand alone. I was interested in how musical notation is used every day by non-musicians – by graphic designers, by decorators – to signify 'music', but without any intention of generating real music. Yet, because of the symbols, if I put these pictures in the hands of musicians, they're potentially playable. They made me think of graphic scores in experimental music. I have to mention that I can't read or write music.

Richard I was going to ask you about that.

Marclay So these, to me, are very abstract. But if you give them to musicians,

something can happen, and that's what interests me: how they get translated. There's also an element of randomness, because the cards get shuffled and the responses are improvised. So there's definitely a notion of play. *Zoom Zoom* is also very playful. In the performance of *Zoom Zoom*, I select on the fly from a pool of images on my computer while Shelley Hirsch improvises in response. I trigger her, and I react to what she does. I have all these thumbnail images in a grid onscreen, and I click on what I want. So no two performances are alike. Shelley has this incredible ability to tell stories and pick up on details in the image that extend beyond the onomatopoeia. She might comment on a person's haircut or whatever.

Richard You're DJing images, and Shelley Hirsch is the 'dancer' – her voice is responding to the visual 'music' you play, in the way that bodies on a dance floor might respond to aural music. You make these complex transpositions from image to music to text, and onomatopoeia seems like a perfect vehicle for that. Was it intentional, to build up a library of images that could be performed this way?

Marclay These pictures were taken over more than a decade. I wouldn't have been able to accumulate so many in a short amount of time, and this project started without my having in mind the idea of a score. It became a score later on, as I realized that I was accumulating these images and that Shelley would be the perfect interpreter. I always have a camera. It's like a sketchbook, a way to quickly remember. These days the pictures are digital, so I put them on my laptop; I look at them once in a while … But I don't take a picture with a strong intention. What I like about taking pictures is that it's instantaneous …

Richard … and in that way playful. Do you record sound in the same wanting-to-remember way?

Marclay I don't do it with sound. I'm thinking of doing it with video, because my phone makes good videos. I don't even print most of my images. They exist only as digital files. Photography-as-photography is kind of dying. As soon as photography became portable, you could take it on the street. Now cameras are so small it's even easier. But making a print as a way to share an image is not what is popular now. We're constantly e-mailing pictures to people, and they have a different nature: more ephemeral, less tangible.

Richard Although here we are in a gallery full of framed prints. And *Shuffle* presents a box of prints – mass-produced, yes, but still made to be handled, dealt out, toyed with.

Marclay There are so many ways to think about photography. It can be tiny, on your phone, or it can be a billboard, or a film-sized projection, or printed in a magazine. I don't think we've been in a time before when so much photography is available in so many formats, when everyone is a photographer.

Richard Isn't that something people have said about photography since the very beginning, from Charles Baudelaire to Walter Benjamin to Susan Sontag?

Marclay Yes, but if you were Baudelaire being a flâneur on the street, it was complicated to take a picture. I used to take pictures with a 35-millimetre camera. It was a small point-and-shoot, always in my pocket. But I had thirty-six shots, and it cost money to process, so I made different decisions. Now, I shoot-shoot-shoot. I don't think about it.

Richard Both *Zoom Zoom* and *Shuffle* centre on performance, collaboration, the real-time interaction of live bodies. Even so, do you think that in some deep way these are digital projects, in that the images depend on that dematerialized, shoot-shoot-shoot attitude?

Marclay Yes, in a way, because these images become 'live' again. They offer cues for action. As with the way I use records, they don't document as much as offer material for new sounds. If you put a unique print behind glass, it becomes a precious thing, while the *Shuffle* images are cheaply available and made to be handled. A digital picture can be sent to a friend with your phone, and you lose control over it – it can be sent around, even go viral. These are new ways to communicate that didn't exist before.

Richard I read a comment somewhere about your video *Telephones* (1995) – a compilation of film clips of people using telephones – remarking that many of the movie vignettes stitched together in this piece would never happen now, simply because the phone no longer has a cord. Drama is attached to the fact that we used to have to sit by the phone and wait. And if we wanted to know who was calling, we had to answer.

Marclay Right. It is interesting how objects affect our state of mind.

Richard Vinyl albums, even CDs, are moribund formats. Turntablism has revived vinyl for the cognoscenti, but it's not a universal form the way it was for decades. Even decks of cards are a sunsetting technology. We play solitaire on our phones; we play video poker.

Marclay Social game-playing still exists. But it also has an old-fashioned quality because it forces people to sit physically together in one room instead of virtually.

Richard Here's something you said more than a decade ago: 'I've always had this theory that recorded sound is dead sound, in the sense that it's not live anymore. Old records have this quality of time past, this sense of loss. The music is embalmed. I'm trying to bring it back to life through my art.' That's what we're talking about, no? Something embalmed by reproduction and obsolescence, that gets re-enlivened by being noticed in new ways.

Marclay Technology has a short lifespan. It's almost as if you need that sunset to be aware of a technology as itself. As in a sunset, there's this extraordinary view that you don't get during the day; suddenly it gets very colourful; there's a sense of, 'Oh, it's almost over; let's have a better look at it.' You can be more critical, and more appreciative, because it's on the way out.

Richard So criticality and nostalgia sort of sit in the same spot? Maybe nostalgia isn't exactly the right word. Retro?

Marclay Nostalgia and criticality do seem to be opposites. But there's always a sense of nostalgia in something that records the passing of time. You can't escape that, but you can have a critical look at things that seem nostalgic. We assume, because we're able to capture sounds or images, that they will exist forever, when in fact obsolescence makes you feel the limit of those assumptions. There's a nice tension there. Life is short, and all we have that's certain is the past.

Richard I slip from thinking about these traces of time past to thinking about realizations that come from seeing repetitions to thinking about, as it were,

a score imprinted on the world by accident. This is something I return
to as a poet. The mediaeval trope of the Book of Nature – which is there
to be decoded by the initiated – speaks to this idea. The scores in *Shuffle*
and *Zoom Zoom* are like this; they're inscribed on the world by the world's
own self-perpetuating logic, hiding in plain sight, waiting to be noticed
and interpreted by those who have the eyes to see and ears to hear. Except
– and this is a giant difference! – these signs are made not by nature, but
by culture. Specifically late-capitalist, consumerist, more-or-less-trashy
advertising culture.

Marclay I relate this 'writing' to the idea of an open score, where there are
no rules, really, but a potential for events. You have to interpret it. You have
to decipher it in whatever way you can, and everybody has different abilities,
makes different connections. I think my work is about showing the multiplicity
of interpretations rather than creating a strict, closed structure which is only
understandable in a unique way.

Richard I see these images as poised on a threshold, lighthearted but not
overly affirmative. Not negative. Not positive. Formal, but not intensely so.
Curious, maybe ...

Marclay Hesitant, maybe. There's a hesitance. [...] The picture-taking
happens quickly, and I don't know what I'm looking for. I tend to frame things
in a fairly classical way. We all have this baggage of compositional devices
that are so ingrained in our ways of seeing; we can't help using them. I still
frame things straight-on, try to square the horizon line with the camera.
These conventions are reflexes. I'm making the images recognizable for
the viewer. But, then, I might pair things within the frame to trigger a possible
narrative or critical point of view.

 (*together looking through the catalogue* Things I've Heard) For example,
here's an image of a night bell (New York, 2003). The fact that the sign is
posted on a black wall, and there's nothing else – if it was on a white wall,
the picture would be very different. Or, another example: Here are two
things side by side. One is a cash register, the other is an accordion (London,
2006). They are different objects, yet formally similar, and money and music
go hand in hand.

Richard Do you think about pseudomorphism a lot?

Marclay What do you mean?

Richard Well, you make this proposition, in effect, that *Zoom Zoom*, or *Shuffle*, or the group of images in *Things I've Heard* make up a set, that these things – which are so disparate – rhyme somehow, or belong in a series. Take the accordion and the cash register. They both have a vaguely Deco curved silhouette. They're red and gold and black and white. They have keys. They have numbers. They have a grille or slot where something comes out or goes in.

Marclay They also both make a sound. Ka-ching!

Richard But one could argue that's all pseudomorphism, superficial accident. They don't really have anything to do with one another.

Marclay Yes. But the reason they are together is to offer a third reading, totally disconnected from their initial usage. They tell a beautiful story together. Like if you're writing poetry, you put together two words that rhyme or off-rhyme, and even though they may be unrelated, that rhyme is going to give the phrase a different weight. It kind of forces them together.

Richard That's true. This is like a game structure, where the game is about accumulation yielding a meaning that couldn't emerge in any other way. Like in *Telephones*, where it becomes about the pathos and repetitiveness of trying to communicate, the relentless similarity in unlike situations. 'Hello', 'Hello?', 'Hello', 'Hello?', 'Goodbye', 'Goodbye', 'Goodbye'.

Marclay That's why I said 'hesitant'. When I snap a photograph, I'm just seeing something, and I capture it. It's very different than, let's say, if I were to create a set and stage a situation to be photographed, or if I went out of my way to document specific things.

Richard You would never arrange a photograph.

Marclay No. I might adjust something, the way I scraped the snow off the

Yamaha box on the street (New York, 2003). I'm not a purist in that sense. I wanted the viewer to know there was a picture of a guitar on the box. At first I thought you could see it through the snow, which was a nice kind of veil. But it didn't come through. So I brushed some snow off. There's something between the silencing of the snow and this guitar that is not in the box anymore. It's winter; the box is on the curb with the trash; maybe a kid received that guitar for Christmas. There's a potential for narrative. For me, there's always this moment of hesitation when I take the photograph. Is it worth stopping for? At the same time, it's never a big statement. Most of my pictures are really small statements. There's a banality to them.

Richard How would you compare that moment, that split-second intuitive decision, with an improvisatory decision in performance?

Marclay It's a nice way to think about it, in terms of improvisation and playing music. It's not the 'decisive moment' of classic street photography. Because my images rarely involve people, the notion of speed is less an issue. But still, there's that decision to pull the camera out of the pocket and use it. In playing improvised music, you are constantly making decisions; you are reacting to others, and you never know where the hell it's going to lead. Photography is solitary and there are lags between seeing with your eyes and seeing through the lens, and then seeing the image on your computer, or as a print, and seeing things that you hadn't noticed. I often see things after the fact. So there's a revelatory quality. And this definitely includes a sense of playfulness, because you're not sure what the consequences are going to be.

Richard I'm thinking of John Zorn's game structures and the open work, the open score.

Marclay There are strict rules, but you are never going to play the same thing twice.

Richard Maybe this is my bias as a poet. But, for me, both these projects have that sense of a script that isn't a script – a graphic meaning that's printed on the world just off the scale of language. Does that feel right?

Marclay Yes, it does. I think of snapshots, often, in terms of poetry, just because they play with language. *Shuffle* also has to do with the different type of writing that is musical notation, a language I don't write or read. The project says something about my lack of musical knowledge and these shortcuts that allow me to generate music without knowing what the signs literally mean.

Richard Like the photograph of the night bell – the wit or resonance of the image depends on our being able to read English, to understand those two words. That's a different role for language than when we see some enigmatic sign that we know has meaning, but in a system in which we are illiterate. Take this image (from *Shuffle*, of musical notation on a window, with lace curtain and other signage). [...] We have musical notation and Greek – two languages I don't read. That makes me ask myself about the filigree on the balcony railing or the laciness of the curtain. I'm ready to read those as a secret script too.

Marclay Yes, definitely. This is what interests me, how everything in *Shuffle* is potentially music. You've got staff lines; you've got the reference to pitch, maybe, and to structure. You have rhythmic division.

Richard You could start playing the decorative metal musical notes attached to the metal gate, and then go on to play the holes in the bricks, the lines of the telephone wires, the lines of the siding on the house, the shapes of the trees ...

Marclay It invites you to look not just at music, but at the world around the music as its extension.

Christian Marclay and Frances Richard, 'Music I've Seen: Christian Marclay in Conversation with Frances Richard', *Aperture*, no. 212 (Fall 2013) 26–33.

A drawing is a recording of some sort and a record is a kind of drawing; the groove is like an etching, but the difference is the extra dimension of sound; the sound transcends the object

In Conversation with David Toop, 2003

ON&BY CHRISTIAN MARCLAY

Dennis Cooper
Christian Marclay
1989

The recent histories of visual art and popular music are weirdly paralleled.
Starting in at least the mid 1970s, when punk and situationists garrotted
the bloated corpse of what was then known as art-(or progressive)-rock,
visual artists have been revising their medium, however coincidentally,
in a like manner. Neo-expressionism, and to a certain extent, East Village
art, were pretty much the painterly equivalents of Punk and early New Wave.
Like Johnny Rotten, David Byrne, et al., David Salle, Julian Schnabel, et al.
intended to return an exhausted form to kind of square one, in the belief
that the act of painting, given an honest and quirky enough treatment,
could update the genius of emotion originally represented in the works of
Pollock, de Kooning and other lofty gesturalists. But even more than those
quasi-emoters, current conceptual artists like Haim Steinbach, Ashley
Bickerton and Jeff Koons are fascinated and informed by the issues bandied
about in popular music circles. Their art tends to be parasitic, reconstituting
the images of recording stars and mimicking pop advertising formats in a
kind of fannish, self-consciously impotent homage.

Christian Marclay is the only artist I can think of who has physically
conjoined the two mediums to create a third form, complete with its own
resonances and associations. His work is enormously current, and specially
within the currency of conceptual art because, while it brings up issues
tangential to the larger infra-art dialogue about commodification –
specifically, in his case, the psychologically distressed product – it is
far more refreshing and buoyant than most. Marclay's modification
of recording industry tools such as records, microphones, speakers,
etc., references these tools' physical magic. Like the originals, Marclay's
sculptures tend to take forms whose content is accessible only through
the decoding device of a mediative instrument – a stylus, a plug, wiring –
but they brilliantly celebrate these secondary instruments' absence,
appealing directly to the imagination.

Because of the advent of CDs and cassettes, forms whose physical
intangibility make them far less lovable than vinyl discs, there's almost a
memorializing element to Marclay's pieces, many of which play intricately

with the concrete availability of the LP or 45, while suggesting the almost
religious unavailability of their individual identities, i.e. their particular
sound. Marclay's work is full of dichotomies, but the largest of them
is the mysterious way in which its cold, elegant minimalism contains
and exudes the gorgeously sloppy aesthetic fragrance of pop music,
in particular, and recorded sound in general. While the speaker cabinet
was a dominant reference point of his early pieces, recent works have
referred to more generalized transmitters such as the telephone and
the bicycle bell. All are objects with modest design charm but enormous
potential power. The trick of Marclay's best constructions involves
spotlighting the simple yet easily overlooked discrepancy therein.
This fetishistic concern with detail at the possible expense of the larger
picture is hardly uncommon these days, but for Marclay this concentration
is not only the usual formal end in itself familiar from neo-conceptual
art at large, but a suggestion of possible transcendence within the most
accessible and least aesthetically explored bric à brac. It's no coincidence
that he titled one of his early pieces *Ghost* (1985), for Marclay's almost
academic approach to the history of audio equipment is simultaneously
an idiosyncratic survey by someone who can't help meddling a bit, and,
more importantly, a playground for some of the most haunting qualities
inherent in these veteran objects.

Ghost, along with the more recent *Dead Stories* and *Music Wall to
Wall* (1986), are part of what might be called Marclay's ultra-sculptural
work, namely sound pieces created out of pre-existing recordings in a live
performance situation. Manipulating up to eight turntables simultaneously,
he sculpts exquisitely complex aural webs from the details of a variety
of found records containing anything from pop songs to symphonies to
sound effects. Formally, this mode of composition relates to the scratching
techniques and editing interferences central to late-breaking pop music
forms like hip hop and acid house, as well as to the stylizations of avant-
garde record 'producers' Adrian Sherwood, Marshall Jefferson and others.
On the other hand, Marclay's compositions have the almost holy intensity
more commonly sought after by so-called serious composers. Again, as
in his static works, there's a pragmatic magic at play as Marclay's delicate
operations seem to uncover and devise escape routes, messages, warnings
and new areas of beauty in seeming aural garbage. While the tone is both
hypnotic and contemplative, the result is a kind of perceptual corruption.

In fact, if such a thing is possible these days, Marclay might even be termed a spiritual artist. For while his manner of composition is rigorous and iconographic, the effect is generously, wildly cognitive.

Dennis Cooper, 'Christian Marclay', in *Christian Marclay* (Zürich: Shedhalle, 1989) n.p.

Wayne Koestenbaum
Corpse on a Pink Record Cover
Dancing Upside Down
1992

On used LP record jackets I bestow my own questionable desire for lost
trashy eras: I succumb to the period pungence of *Herb Alpert & the Tijuana
Brass*, or *Switched-On Bacharach*, or *Drum Drops*, or *Music for Sensuous
Lovers by 'Z'*. I make no bones about my vulnerability to *Drum Drops*.

There are two kinds of boy: the boy who messes up his room and
the boy who doesn't mess up his room. Now, too late, I want to learn how
to make a mess; from Christian Marclay's masks (old LP covers, arranged
into faces) I want to learn how to be a contained delinquent.

When a teenager scatters album covers over his floor, he is on the road
to hard-guy status. When frolicsome ingénue Dorothy Moore, in Douglas
Sirk's *Written on the Wind* (1956) listens to pop records alone in her room,
she proves herself a demon-in-training, a masturbator, a misfit. I admire
the whirling singles on her toy-sized phonograph, boxy and pert as a make-
up kit or a set of curlers.

A record jacket masks the LP, the grooves, the source. I have always
empathized with covers, masks, alibis. Not because I'm a compulsive liar,
but because truth-telling is impossible, and, as Oscar Wilde noted, the
'truth of masks' will set us free.

Marclay resuscitates record covers by reusing them. But he also
underscores their obsolescence. LPs have stopped revolving. Vinyl's
era is past. So Marclay's studio is a wax museum, a church, a reliquary,
but without the smell of incense.

I am not describing Marclay's intentions. I am describing the aura of
mourning, silence and soiled sacredness that adhere to record-cover masks
as I look at them on a pink-skied Saturday, 3 May 1992, in the middle of a
particular history.

We never see the backs of Marclay's found records. The garrulous text
on the verso is mute. We receive just the cover's come-on: image of mouth,
flower, eye, banana, hand. Just the masturbation of the 12 x 12. Just the
sheen and sufficiency of the square.

Across the hall from Marclay's Times Square studio: United Prosthesis
Laboratories. Downstairs, on 42nd Street: porn parlours and a surgical

supply store with a window display of body parts. A miniature man in
a truss. A false arm. Cream-coloured, cloying objects, quaint as Atget's
photograph of a long-gone Parisian window.

This is the neighbourhood of seduction. This is the neighbourhood of
dismemberment, displacement, decay. This is the neighbourhood of the LP.

A tear appears on the cover of Tchaikovsky's 'Pathétique' symphony of
the 'pathic', the fruit, the invert. One can't *invert* these covers; can't turn
them over; can't release their anteriors.

Tears, semen, sweat: fluids that emit sentiment. On an album cover,
a lady sheds a Tchaikovsky pervert tear, which rhymes with the corny
snowdrop on the jacket of *Twilight Memories*. These are the tears of
schlocky easy-listening.

Of course I would give my arm to own *Twilight Memories*.

What is the mask's gender? Record covers sometimes feature a woman's
painted mouth. One mouth (*Panchito Riset*) is excessively lipsticked, and
Marclay has turned it upside-down, so it stops looking like a mouth and
begins to resemble a painted, pouting anus. So many parallel orifices on
record covers! Orifice of the eye. Orifice of the clock. Orifice of the tear.
Orifice of the egg. Orifice of the spindle hole.

Perhaps my urge is to fuck the record, or to imagine that I am the
record, being fucked. Or perhaps, inspired by records, I want to check into
the language of sex, a discourse neon-lit and transient as a motel. Record
covers are flash cards for Sex Ed. I memorize my cues. *Big Beat, Nice and
Easy, Tease, Juicy*.

The masks radiate dismemberment: body parts separated into zones,
a body's fictive 'wholeness' cut up. Marclay comments on this violence,
but he also mimics it. He accelerates the body's inevitable dispersion into
alienated, laden regions.

In an earlier piece, Marclay wittily juxtaposed Herbert von Karajan's
torso with a woman's bare legs. This was a simple, binary irony: the joy
of seeing von Karajan forcibly cross dressed. But the masks go beyond
dichotomies of black/white, man/woman. Instead, the mask presents a
triangle, a trinity (two eyes and a mouth) which jams the binary opposition.
The interactions on the masks are too multiple for easy reading, the eye's
equivalent to easy listening. A body has as many definitional possibilities
as the mask's grid has squares. And the body's baffling checkerboard does
not tolerate easy listening.

Because Marclay has glued shut the cover's lips and removed the record, there is silence inside Dorothy Lamour's *The Road to Romance*, and yet her elegant white-gloved hands still promise sound. There is no longer any music inside Mireille Mathieu's *Pardonne-moi ce caprice d'enfant*, and not one of the masks will forgive, with its hieratic gaze, the caprice of the child who wants music, ease, passivity. Nor can we forgive the culture that created these images and teased us into desiring them. Who can forgive the machine that produced our hunger to consume? Who can forgive the turntable its oiled revolutions? But who would ever ask the turntable to stop?

No one will ever listen to *Broadway Goes to College*. No one will ever listen to *Persuasive Percussion* or its dreary sequel *Provocative Percussion*. I won't wax melancholy about the death of *Broadway Goes to College* as a musical experience. After all, Marclay has recycled it into a carnival costume.

I read these masks as a drag act in mosaïc-tesserae of discourses that used to charm and have now grown tawdry.

I see the promise of new sexual organs, or new ways of imagining the old sexual organs. Or I see a metaphor for how we are gridlocked into the old ways.

No genuine sexuality resides beneath the album's cheesy, hollow sexuality. I don't distinguish real from fake. All I know of sexuality is its surpassing fakeness: the stud model's face, the sugary tongue.

The mask is all I know of sexuality. If I found the record that Marclay has discarded, or if I opened the sealed cover and magically discovered music inside it, would I obtain the actual body beneath the sleazy provocation, the passé solicitation?

A body with dated sex appeal sleeps within the LP. When the record died, a sexy ghost-body got trapped inside the album cover. And I respect this phonographic phantasm, this LP genie: even at the risk of fetishism, I will not kill off the record or refuse its claim on my passions.

One cover, *Star Dancing*, arrests me. (Marclay has turned it upside-down.) Pink, it pictures dancing couples, men and women. One couple, up front, is the central couple. The others are mirror reflections or look-alike friends of the central couple. The woman wears a strapless gown; the man, a tux. He leads: no choice in the matter. Her hand exerts a subtle, guiding pressure. The substanceless floor is supposed to resemble cloud. Stars dot the floor, but they are not genuine constellations, they are effects produced by the record company's graphic artist – a hack, a genius. The couples slow-dance.

No. I remember the cover's colour wrong. *Star Dancing* is not pink. It is sky blue.

Blue for boy. Pink for girl. Do not make a mistake, on penalty of death, or excommunication, or exile from the kingdom of the dancing couple, their prom-sleek hegemony, waxed as a vintage Mercury's hood ...

If I blur my eyes, the couple ceases to be two lovers, a man and a woman, and becomes one black-and-white immobile unit, a corpse, a body that has stopped dancing, a body that refuses the dominant culture's invitation to a dance.

The cover is blue or pink, depending on how you look at it. The couple is a corpse or a couple, depending on how you look at it. Or depending on how the mask looks at you. For the mask is looking at you. The mask doesn't care who you are, it has no reverence for your secrets, but its business is to stare you down.

Wayne Koestenbaum, 'Corpse on a Pink Record Cover Dancing Upside Down', in *Christian Marclay: Masks* (Rome: Valentina Moncada, 1992) n.p.

Thomas Y. Levin
Indexicality Concrète: *The Aesthetic Politics of Christian Marclay's Gramophonia*
1999

Consider for a moment the theoretical ramifications of that trenchant reworking of the technologies and products of the late capitalist music industry popularized by black pop culture as 'mix and scratch'. Transforming corporate commodities into occasions for a new, real-time artisanal performance practice, 'scratching' literally and figuratively reads these artefacts against the grain, making them 'say' things they never did before. Appropriating the - appropriately named - gramophone stylus as a creative and expressive writing instrument, the scratch DJ simultaneously foregrounds the inscriptional status of the recordings s/he employs/plays through strategic sampling and violations of their teleological structure, refusing the linearity of the record's acoustic spiral in favour of a percussive, rhythmic writing/rewriting that obeys the dictates of a higher 'groove' in a performative act that could be read as staging (in a rather splendid allegorical move) the refusal of that - literally - straight and narrow spiral path. Something very remarkable is going on here: an aesthetic redemption of that very sound - the familiar abrasiveness of the gramophonic scratch - that for so long was synonymous with technological failure, an acoustic event that only recently was still disturbing enough to require one to interrupt a recording before it had run its course.

This shift is historically overdetermined, taking place as it does, beginning in the early eighties, at the very moment that the technological era of the scratch - the era of the analogic recording - had effectively become an anachronism. In the current CD era, the gramophone record has been displaced by a digital recording medium that, while hardly without its own conditions of failure (now called tracking or sampling errors), certainly eliminates the scratch as a signifier of breakdown. One can do all sorts of strange and violent things to CDs,[1] but thanks to oversampling, a scratch simply is not what it used to be: In the age of digital recording and playback, the sound of error has changed significantly. This has had various consequences: the moment the scratch is no longer the signal of malfunction but is instead the almost nostalgic trace of a bygone era of mechanical reproducibility, one can say that it has become auratic, and as such it

suddenly becomes available for aesthetic practices of all sorts. Indeed, the practice of scratch, in its celebration of the physicality of the interface, points to the defining characteristic of this now largely historical episteme of acoustic inscription – tactility, the analogic or indexical trace that has been effectively eliminated by the material conditions of digital recording.

If scratch culture – with its insistence on the physicality of the interface – can be understood as both a playful mourning for the era of indexical inscription and a celebration of the wide range of possibilities that this anachronism has opened up, the same is true of the proliferation of work on gramophoniana well beyond the borders of the pop world and into the domain of so-called high culture. During the eighties, in the wake of the extensive centennial celebrations of the 'invention' of the phonograph in 1977,[2] there was a striking increase of work by visual artists on issues of acoustic (and specifically gramophonic) inscription, much of which was chronicled in a groundbreaking exhibition entitled 'Broken Music' at the DAAD Galerie in Berlin in 1989. What this show compellingly demonstrated – not least by means of the extensive artist biblio-discography in its superb and largely unprecedented catalogue[3] – was that, far from being a mere centennial fad, the exploration of the gramophonic medium as a site for alternative acoustic and visual practices has had a long, distinguished and generally overlooked history. The deliciously heterodox character of this creative exploration of the techno-logics of mechanically reproduced sound by means of artistic practices of all sorts – often involving (and at times combining) visual and sonic performance, sculpture and graphic elements – may well have contributed to its invisibility, due, at least in part, to its incompatibility with the segregationist tendencies of the reigning classificatory imperatives of both the art world and a certain history of art. Yet despite its comparative critical neglect, the practice of creative gramophonia (for lack of a better term) remains a remarkably vital – and increasingly acknowledged – domain of contemporary artistic activity. And while one could discuss a wide range of contemporary work in this context – such as the installations and 'imaginary records' of the Canadian artist Raymond Gervais[4] or Paul DeMarinis' striking and highly suggestive retro-futurist sound installation entitled *The Edison Effect* (1989–93), featuring gramophonic cylinders and other early media 'read' by lasers[5] – there is probably no body of work more consistently, indeed obsessively, engaged in working through the theoretical and expressive dimensions of sonic

mechanical reproducibility than the prolific, rigorous, playful and endlessly inventive oeuvre – ranging from performances, installations and sculptures to CDs, videos and curatorial activities – of the New York based artist and turntablist Christian Marclay.[6] In the last few years, Marclay has put together shows based on acoustic themes at the Whitney Museum at Phillip Morris, New York ('Pictures at an Exhibition', 1997) and the Kunsthaus Zürich ('Arranged and Conducted', Summer 1997).[7] He has also shown his work at the Venice Biennale (*Amplification*, a set of six diaphanous scrims of found snapshots of people playing music that was hung in the Chiesa di San Stae in 1995); performed with various other DJs (including DJ Olive, the Audio Janitor and Otomo Yoshihide); and has released a CD entitled *Records 1981–1989* (Atavistic Records, Chicago: ALP62CD) that collects some of his more obscure recordings and rare performances. On the assumption that most readers here are more likely to be familiar with Marclay's work as a visual artist, and given my conviction that the issues Marclay's work explores remain quite consistent across the wide ranging modalities of his interventions, I will focus more on the literally and figuratively gramophonic dimensions of his wide-ranging creative output.

Nowhere is the engagement with mechanically reproduced sound more efficiently catalogued than in Marclay's 1984 video entitled (appropriately) *Record Players*,[8] which was included in a recent evening of performance and video that he curated at Manhattan's Knitting Factory (and which also featured his improvisations with the singer Shelley Hirsch and the Chinese pipa player Min Xiao-Fen, as well as videos and performances by Lee Ranaldo of Sonic Youth). The first thing one sees – and hears – in *Record Players* – whose very title names in its polysemy the re- or displacement of audio technology (the record player or gramophone) by ludic performance practices – are a field of long-playing records, those charming acoustic anachronisms, being gently scratched by the fingers of numerous hands, the materiality of the barely visible spiral grooves of the gramophonic surfaces rendered audible by a literally digital rubbing against the grain. But the harmlessness of this opening is deceptive. Soon the mild topical performance of vinylity – the signature gesture of turntablism (be it the avant-gardist recasting of the moves of the club DJ or Marclay's more radicalized variants which include beating the record against the tone-arm or against the record player itself) – gives way to another, more dramatically percussive movement: After having been scratched and then rubbed

against each other, the records are now subjected to a set of increasingly aggressive operations. The gentle, high-pitched rustle extracted from the physicality of the LP's topographic structure is quickly replaced by the characteristic warbling that results from waving the semi-flexible discs in the air like fans, teasing out sound from that very distorted condition – the warp – which was the guarantee of disfunctionality in a bygone gramophonic era.

But this is only a prolegomenon to the even more brash acoustics of these same sound carriers being bashed against each other until finally – pushing the LP's warp capacity beyond its limit – there erupts the violent staccato which is the sonic signature of the discs being shattered into pieces. Here – in a gesture that is the exact inversion of Marclay's *Untitled* (1987) that foregrounded the fetishism of the vinyl disc as such by means of a limited and signed edition of grooveless, 12 inch records with blank gold labels individually presented in elegant, ultrasuede drawstring pouches[9] – the materiality of the gramophone record as thing – in this case the brittleness of the disk itself – is again harvested for its sonic yield. For those who have ever wondered what it sounds like when you break a record in half would be fascinated by the vast aural array of rhythmically – almost fugally – edited instances of this transgressive gesture that marks the dramatic highpoint of the performance. What is not immediately evident is that this very gesture – albeit under more controlled conditions – is also the mode of production for Marclay's corpus of *Recycled Records* from the early 1980s, gramophonic montages constructed out of pieces of other (broken) LPs that are then carefully cut to size and glued together to form a composite whole. In a manner reminiscent of Milan Knizak's Fluxus practice of abusing records by burning, scratching, painting, cutting and then reassembling them, Marclay creates gramophonic hybrids which – thanks to the liberal use of coloured vinyl – work not only as compelling visual artefacts which materialize the DJ's practice of gramophonic mixing, but also as functional sound carriers which, when played, render their own material heterogeneity readable in the form of regular and clearly audible pops and skips.

In the final section of Marclay's video, the dropping of the acoustic shards onto the floor signals the transition to the comparatively calmer, but semiotically dense performative coda which involves systematically stepping and walking on the vinyl detritus, literally impressing upon the grooves another chance inscription whose aleatory singularity (no two

records are marked by the same footsteps) stands in marked contrast
with the LP's status as a mechanically reproduced multiple (every record
is an example of a set of identical iterations). Here again the video invokes
a strategy that informs a number of Marclay's other works, best exemplified,
perhaps, in *Record Without a Cover* (1985) – a record of Marclay's works which
was sold without sleeve or dustjacket and with an explicit admonition not
to provide it with either – and in *Footsteps* (1989) in which Marclay 'tiled' a
gallery floor with 3,500 identical LPs of recorded sounds of footsteps which
visitors walked over during the six weeks of the installation; the one-sided
records were then boxed and sold as a limited edition of 'unique' artefacts.[10]
Each LP combines recorded footsteps (present as indexical gramophonic
traces) and the acoustic consequences of the random surface abrasions
caused by – equally indexical – traces of the actual gallery visitor's footsteps.
The resulting – sonically compelling – *mise-en-abîme* of indexicality not only
translates into material terms the theoretical stakes of Marclay's turntablist
activities – the encounter of pre-recorded and 'real-time' indexicalities –
but also simultaneously reveals both his 'live' and his artefactual practices
as performative presentations of the central semiotic signature of
gramophonic inscription – that is the index.

On the surface, as it were, it might look as if Marclay is simply replacing
the delicate decryption technology which is the gramophonic stylus with
a more crude interface, one that attempts to 'read' the gramophone record
in different – and seemingly more violent – ways. And yet as any audio
technician will confirm, the violence of the latter – scratching, etc. –
differs only in degree and not in kind from the former, seemingly 'proper'
scansion of the acoustic grooves. For each time a gramophone needle traces
its path through the hills and valleys of the LP's pre-recorded acoustic
spiral, what 'is actually – albeit largely imperceptibly – happening is that
the grooves are not only being degraded (they wear out, as everybody
knows from the sad fate of their favourite all-too-often-played LP) but
they are also inscribing the present moment of the playback, the acoustics
of the playback environment, into the vinyl palimpsest. In other words,
every playing of any gramophone record is also already a scratching,
a defacement, a particularization of the multiple. The foregrounding of
that gesture of particularization – wresting singularity out of, or imposing it
onto the order of iterability, making a unique object out of the mechanically
reproduced multiple, be it by means of performance, installation or any

other sort of strategic violence – is, I would argue, at the core of all
of Marclay's work. And it is here that one discovers nothing less than
a staging of the central (indexical) logic of the gramophonic order, the
condition of the LP as trace of both whatever is recorded on it and of
the vagaries of its subsequent performance history. Marclay's oeuvre
thus also turns out to be a systematic exploration of the very economy
of technologized memory – the involuntary mnemonic specificity
of the acoustic patina – which is forever lost in the age of digital
acoustic inscription.

1 The new possibilities of CD sampling errors – which have been explored recently by avant-
 electronic groups such as Oval – have long been the focus of the Japanese Fluxus artist
 Yasunao Tone, as systematically demonstrated in his 1997 CD *Solo/or Wounded CD*
 (Tzadik/New Japan). For some interesting reflections on the techno-pragmatics of
 gramophonic vs. CD error production, see the discussion between Marclay and Tone
 in *Music* (New York), no. 1 (1997) 39–46.
2 See, for example, *Le Magasin du phonographe* (Brussels, 1977); *Le Phonographe à cent ans
 1877-1977* (Paris, 1977); as well as special issues of audio magazines such as *Studio Sound*,
 vol. 9, no. 6 (June 1977); *Son* (July/August 1977), and others.
3 Ursula Block and Michael Glasmeier, eds, *Broken Music: Artists' Record-works* (Berlin: DAAD
 and Gelbe Musik, 1989). The illustrated 'Artists' Recordworks: A Compendium' takes
 up almost 200 pages of this now out-of-print volume. A year earlier Block also co-curated
 an exhibit with Marclay at the Emily Harvey Gallery in New York entitled 'Extended Play'
 in which the catalogue came in the form of a 45 rpm disk-sized box containing loose pages,
 each devoted to one artist. For a more text-based compendium from almost the same time,
 see Dan Lander and Micah Lexier, eds, *Sound by Artists* (Toronto: Art Metropole/Walter
 Phillips Gallery, 1990), a collection of writings on and by sound artists including a 'Sound
 Page' by Marclay which consists of a bound (and consequently unplayable) flexidisk without
 a hole. The neo-gramophonic fascination evident here is also manifest in a renewed focus
 on phonographic issues in the work of a wide range of contemporary cultural theorists
 including, to name just a few, Friedrich Kittler, *Gramophone, Film, Typewriter* (Stanford
 University Press, 1999); Avital Ronell, *The Telephone Book: Technology, Schizophrenia, Electric
 Speech* (Lincoln: University of Nebraska Press, 1989); Michael Taussig, *Mimesis and Alterity:
 A Particular History of the Senses* (London and New York: Routledge, 1993); Douglas Kahn
 and Gregory Whitehead, eds, *Wireless Imagination: Sound, Radio and the Avant-Garde*
 (Cambridge, Masssachusetts: The MIT Press, 1992); and *Essays in Sound*, vols. 1 and 2
 (Darlinghurst, New South Wales: Contemporary Sound Arts, 1992/95).
4 Raymond Gervais' series of impossible records entitled *Disques de l'imaginaire* are
 conceptual sound pieces in which he imagines the acoustic encounter of deceased musical
 figures from radically different historical epochs.

5 Shown at the San Francisco Art Institute and numerous other venues, DeMarinis'
 exhibition, 'The Edison Effect' was accompanied by a CD *Listener's Companion* (Het
 Apollohuis, Eindhoven: ACD 039514).

6 For an extensive chronology of Marclay's solo and group exhibitions, a bibliography of
 reviews and catalogues, as well as a discography and listing of his collaborations and group
 projects, see the catalogue entitled *Christian Marclay* published by the DAAD Galerie
 in Berlin in collaboration with the Fri-Art Centre d'Art Contemporain in Fribourg
 (Switzerland), 1994.

7 See especially the playful and generously illustrated burlesque edition of *Züritipp* which
 accompanied the Zürich exhibit.

8 Based on a performance that took place at The Kitchen in 1982.

9 *Untitled (Record Without a Groove)* (Geneva and New York: Ecart Editions, 1987).

10 The acoustic content of the LPs – which had been recorded for the event in the deserted halls
 of The Clocktower in New York City but were then glued to the floor of the Shedhalle Zürich
 – could not be heard in the installation and was simply suggested by the title.

Thomas Y. Levin, '*Indexicality Concrète*: The Aesthetic Politics of Christian Marclay's
Gramophonia', *Parkett*, no. 56 (Fall 1999) 162–7.

Rahma Khazam
Jumpcut Jockey
2000

'It may seem like a contradiction, but I'm interested in sound, not just for how it sounds, but also for how it looks', says Christian Marclay in a dressing room deep among the postmodern pipes of Paris's Centre Pompidou. The crux of Marclay's twenty-year career has been an obsession with the relationship of sound and object. Not only is the New York based artist/ musician a pioneering turntablist, whose conceptual sonic collages and confrontational stance towards the record industry have had a defining impact on the avant-garde music scene; he has also led a parallel creative life making installations which express sonic information in visual terms. Take, for instance, the pieces he presented earlier this year at the Pompidou. In the rarefied environment of 'Le Temps, Vite!' (Time, Quickly!), an exhibition celebrating the start of the new millennium, a cylindrical pile of LPs made up his *Endless Column* (1988): silent witnesses to a bygone musical past. Close by in a glass cabinet squatted *The Beatles* (1989), a pillow crocheted from audiotape containing The Fab Four's complete recordings. Its prosaic and reassuring form evoked the nostalgic aura that has come to replace the hysterical fan worship of their heyday. Between the two lay his *Moebius Loop* (1994), a snake-like assemblage of found cassettes. A mixture that included housewives' choice trash *(Barry Manilow's Greatest Hits)* or self-help tapes *(How to Get Results with People),* these mute artefacts likewise conjured up long-forgotten soundworlds made all the more poignant by their dormant, silent state. In common with Marclay's other installation pieces, which have been exhibited more frequently in art spaces around the world in the past few years, *Moebius Loop* hovers on the cusp of art and music. As he puts it, 'A record is an object, a thing, it's visual, and it contains music. Is that not related?'

For a genre-defying artist such as Marclay, jumping from art to music and back again is all in a day's work. He recently performed in the basement of the Centre Pompidou, several floors down from the exhibition, in front of a very different audience made up of diehard music fans. It was an opportunity to witness his formidable performance skills: a tall, spare figure bent over his turntables, he delivered staccato salvoes of quickfire

manipulations, while orchestrating a symphony of abrasive scratches, unearthly drones and gunshot scatter. Playing alongside him were two young DJs, Brooklyn scenester DJ Olive of We, and French whizzkid Erik M. They belong to a new generation of turntable artists who have been influenced by Marclay's distinctive brand of sonic activism. 'For a long time I didn't have other DJs to play with. The only other DJs were hip hop DJs, and I tried, but they weren't interested', laments Marclay. Instead, he appears in more familiar company as one of the avant-garde luminaries contributing to Sonic Youth's recent *Goodbye 20th Century* album, and has been performing extensively in a trio with Lee Ranaldo and free drummer William Hooker. The rest of his time has been taken up with growing commitments on the art circuit. Last year's engagements included the Venice Biennale, as well as installations in Prague and Lyon. He is currently working on photos, sculptures and videos for a number of shows, and recently completed a video installation for London's 'Sonic Boom' exhibition. A typically laconic piece, *Guitar Drag* shows an amplified electric guitar being dragged behind a truck. Its loud, rasping soundtrack and violent imagery allude to the recent racist murder in Texas, but also to rock 'n' roll, guitar bashings, Fluxus performances, art history, trucks and cars, rodeos and violence. Like his other video pieces, it exploits the sonic and visual possibilities of the medium in new and imaginative ways: *Telephones* (1995), for instance, is a collage of clips from classic Hollywood movies and contemporary films featuring ringing telephones, and characters engaged in phone conversations. Kneading together these sequences to form a suspenseful narrative, it pokes fun at cinema's reverential treatment of the telephone. *Up and Out* (1998) is a similarly disconcerting comment on the inviolability of cult movies: here, Marclay has replaced the 1960s soundtrack of Antonioni's film *Blow-Up* with that of Brian De Palma's 1980s remake *Blow Out,* so that the viewer watches the original while listening to the remodel.

Marclay has always had to juggle his musical commitments and his desire to make art. Yet despite his enduring musical achievements, he has not allowed his career as a turntablist to overshadow his visual work. 'Because I'm more trained as a visual artist than I am as a musician – I never studied music, so I just did what came through my mind – I feel like I have a better grasp of what I'm doing as a visual artist. When I started, I never thought I would end up making music. I'd always spent my time

in sculptors' studios and I viewed my work with sound as I would sculpture.'

Born in California in 1955 and brought up in Switzerland, Marclay spent the mid 1970s studying art in Geneva, where he came into contact with Ecart, an active Fluxus group. The Fluxus movement had a critical attitude towards music – in particular, the rituals surrounding classical music – and his experiences there exerted a lasting influence. 'Fluxus music was very minimal', he recalls, 'in the sense that the actions it involved were quite simple and did not require any formal musical training. It was the same freedom I found in punk music, where musicians would form a group and learn to play their instruments as they went along.' But an even more important aspect of punk, as far as Marclay was concerned, was its theatricality. Indeed punk, and certain performance artists of the seventies, including body-art extremist Vito Acconci, played equal parts in shaping Marclay's musical outlook. 'Punk's physical presence and attitude weren't so far removed from the work of certain exponents of performance art, such as Dan Graham, Vito Acconci or Laurie Anderson', he remarks. 'Another influence was Joseph Beuys. Performance art interested me and it was through my desire to do performances that I began to make music.'

By the late 1970s, he had enrolled at the Massachusetts College of Art in Boston, where he formed a music/performance duo with fellow student Kurt Henry called The Bachelors, Even. Marclay sang while Henry played guitar, and they created aural and visual rhythms using film loops from cartoons. The group's performances were extremely physical: they would chop wood with an axe, smash mirrors and neon lights, and explode television sets on stage. Like Fluxus and punk before him, Marclay was seeking to demystify the physical act of music making, focusing the audience's attention on 'the way in which the sounds were made and the gesture that produced the sound'. It was also a way of connecting sounds with images, of making music with a visual dimension. In 1979, during his stint with The Bachelors, Even, Marclay stumbled upon the idea that was to be the basis of his future career as a turntablist: 'I used to play cassettes during the performances on which I had taped loops taken from old records. Then it occurred to me to play the records on stage in order to show how the sound was produced.'

Marclay may have taken the name of his group The Bachelors, Even from Marcel Duchamp's famous *Large Glass,* but the surrealist's groundbreaking development of the readymade has proved more relevant to Marclay's visual

work, even though his music makes liberal use of found sound fragments lifted from LPs. 'Thinking of the record as a readymade – as 'readymade music' – introduced something for me, but it's always reinvested by my performance and manipulations. I don't just take a record, but I appropriate and manipulate it and make something new out of something old.'

Marclay's record manipulations would horrify vinyl fetishists: his *Recycled Records* are collages made by cutting up discs and sticking them back together in different combinations, while an average live improvisation finds him playing records backwards or at different speeds, and preparing them with stickers or paint. Of course, there are precedents: early experimentalists such as composer Darius Milhaud or Bauhaus artist László Moholy-Nagy, who were investigating the potential of turntables back in the 1920s and 1930s; John Cage and the *musique concrète* composers; and Polish artist Milan Knizak who, unknown to Marclay at first, had been producing 'broken music' from records back in the mid 1960s.

But although Knizak used similar methods, his art pranks bore little relation to Marclay's complex musical cut-ups. As for the more refined *musique concrète* productions and, for that matter, Cage's conceptual experiments, they had little impact on his work at this early stage. 'Cage and the *musique concrète* people also used records, and they did eventually become references. But when I started using my records, it wasn't so much a conscious decision to make music or *musique concrète*, but experimenting with the idea of performance. I was definitely more aware of their work than I was of hip hop DJs when I started. I mean, I didn't know what hip hop was'. Not that the likes of Kool Herc and Grandmaster Flash had much to teach him at that point: in 1982, Marclay claimed in an interview with a local New York newspaper that he could scratch as well, if not better, than the majority of the city's spinners. Whether or not it was true, his sole collaboration with a hip hop DJ – he performed with Jazzy Joyce in Tokyo in 1991 – proved unsatisfactory for reasons that had more to do with hip hop's reliance on rhythm, and its limited source material, than questions of technique. As Marclay puts it, 'Our outlooks are so different. Hip hop DJs make dance music, and that's something I've never tried to do.'

In 1978, New York was in the throes of a period of intense cross-fertilization, and the No Wave movement was in full swing. Marclay came to the city that year on a college exchange programme, and found himself right in the heart of this frenzied activity. 'Art music people would come

to clubs, and you would find Dan Graham performing at the Mudd Club, and Nam June Paik at CBGBs', he recalls. Groups like DNA and Glenn Branca's Theoretical Girls were fashioning strange musical hybrids by applying minimalist discipline to rock power. Attracted by the directness of their performances, Marclay organized a festival based around them called Eventworks in Boston. 'I brought a lot of people over: DNA, Non, Rhys Chatham and Karole Armitage, Dan Graham – people who were doing interesting things in relation to rock music. I was looking at performance art through my interest in punk and rock music and seeing how they influenced the performance movement. And then I went back to New York and got involved in music.' One of the first musicians with whom Marclay played in New York was John Zorn, who also included him early on in many of his *Game Pieces*; Marclay met a number of his future collaborators during these sessions. 'There was a very active scene in New York in the early 1980s, and there were a lot of very small, very alternative clubs. John even had a little club in the storefront of his building called The Saint. The audiences were very small, but then we would all go to Europe to play for large audiences and make some money.' In those days, Marclay was the only turntable artist on the New York music scene operating outside the hip hop milieu, but he persevered nonetheless. 'I was lucky enough to be in an environment that appreciated it. [The musicians I was working with] encouraged me to do what I was doing, and they could hear something interesting, more in a way than I could.' Throughout the 1980s, he collaborated with such sparring partners as Elliott Sharp, David Moss, John Zorn, Tenko, Zeena Parkins, Butch Morris and Fred Frith, honing the formidable improvisational skills that have become an integral part of his sets. 'I like improvisation, because it allows you to interact with others', he explains. 'Music lends itself to working with others, and that has always been a difference with regard to my work as a visual artist, where I tend to work alone.'

Towards the end of the 1980s, Marclay's career as an artist took off in earnest. Some of his best pieces date back to this period, among them *Endless Column* (1988) and *Bone Yard* (1990), the latter a mound of 1,000 hydrostone casts shaped like telephone receivers, resembling a pile of bones. Like the majority of Marclay's visual works, they exuded a deep, pregnant silence. 'My pieces are silent so that you can fill in the blank. I want people to use their memory, their own memory. Memory is our own recording device, so instead of imposing a standardized memory

like a record, we have our own personal memories, which are more
selective', he explains. 'Music often has the power to trigger memories,
but images can also do so. You might see something that visually reminds
you of a certain kind of music, or you might project your own sounds onto
an image. A lot of my work is about how image is expressive of sound,
how sound is expressed visually.' Some of Marclay's works have a mystical,
esoteric quality about them: the synaesthetic ideal of the *Gesamtkunstwerk*,
or the sound sculptures of Harry Partch, who regarded music as a magical,
ritualistic experience, are cases in point. However, Marclay's assemblages
of found objects are rooted in everyday life: it is the social and cultural
significance of these objects that interests him. The empty, half-open
instrument cases of *Accompagnement musical* (1995) evoke long vanished
symphonies; *Interiors* (1996), a series of rooms decorated with wallpaper,
cushions and curtains bearing musical motifs, sheds new light on Satie's
notion of furniture music; while *Birdhouses* (1994) conjures up various poetic
images and associations. Here, Marclay scattered birdseed on hollowed-
out loudspeakers, and placed them on a balcony for the birds to perch on.

A few of his pieces incorporate both sound and visuals, as in one of
his most striking installations, *Footsteps* (1989). For this piece, he covered
the floor of the Shedhalle in Zürich with 3,500 vinyl discs on which he had
recorded the sound of his own footsteps. Visitors to the exhibition walked
all over the records, after which they were removed, packaged and sold. As
Marclay explains, '*Footsteps* was a comment on the notion of the recording
as a finished product which cannot undergo any alteration. I was interested
in how each album became a one of a kind record that was damaged
differently; and in creating a certain confusion between what was recorded
and what was "damage". The kind of rhythm you get from the scratch
on a record is pretty similar to footsteps: the clicking of heels on a surface
resembles the clicking of a needle, the scratch. So you get this incidental
mix between the two.' A recent project titled *The Sounds of Christmas*,
which he presented at the Artpace Foundation for Contemporary Art in
San Antonio, Texas, likewise functioned on different levels. On this occasion,
he collected 1,000 Christmas records and invited local DJs to remix them.
The collection of records also existed as a database, held on a computer
in the gallery, and videos of the record covers were projected on the walls.
Marclay reasons, 'I'm as much interested in how that Christmas music
is packaged and how important that visual presence is, as to offer this

collection, this archive as a tool for other DJs to use – a music that DJs in general would never use. So I'm interacting with different fields here, with the young DJ community in the city of San Antonio, and their stereotypes, and this schmaltzy Christmas music which is so seasonal and so rehashed: a dozen tunes that are reinterpreted every year.'

By the mid 1990s, Marclay was performing less frequently as a result of his increasing involvement in art. However, a new generation of turntablists, who were big fans of his work, were emerging from the underground parties of New York's ambient movement. 'There were people like DJ Olive and Spooky, who were quite active on the new DJ scene, and their interest in my work encouraged me to perform again', he says. 'I had a new audience, but also a new group of musicians to perform with, this time playing the same instrument.'

In 1996, Marclay staged the first performance of his *djTRIO* project – a piece for three turntablists which he performs regularly with different musicians. Although he usually likes to improvise without a structure, for the trio he gives the performers a general outline, cueing them with hand signals to trigger synchronized changes. Participants have included DJ Spooky, Otomo Yoshihide and Toshio Kajiwara; but one of the most memorable performances of the piece featured DJ Olive and Erik M in a classical concert hall in Cologne, with an added ensemble of 15 classical flautists. He expands, *djTRIO* is about putting DJs in a group context. If we accept the DJ as a musician, then the DJ must be treated like a musician, and allowed to perform in a group, to create collectively. This is not about the old idea of the DJ as a soloist, dictating beats to a dancing crowd.' Indeed, for Marclay, the test of a good DJ is his ability to play in a group. 'In order to create collectively, you have to let go of the ego', he continues, 'but DJs don't always have the skills to listen and play with others. That's why I like playing with Olive and Erik, because they're sensitive players.'

Marclay's turntable collages deliberately foreground residual sounds such as scratches, clicks and pops, drawing attention to the medium rather than the music. Indeed, these sounds of wear and tear are an inherent part of his performances. 'What I try to do is acknowledge the presence of records and turntables sonically, not just visually, so you hear the record, you hear the turntable, those are sounds. In traditional DJing, the scratching is the only sound that reveals the record more clearly. A lot of the time it is about the skills of the DJ, the taste of the DJ and the selection of the DJ, more than

it is about the turntables and the process. The process for me is very important, and I don't want you to forget that I'm mixing records, you're always going to hear that.' His work is also a critique of consumerism. He recycles records purchased in thrift stores, finding a use for each of them. 'You find an interesting sound on each record, even if it's just a very small fragment. So it's always a discovery and a mystery to buy a record. A record is always full of expectation.' He also takes pride in his old Califone turntables, which used to be standard equipment in the audio-visual departments of American schools. 'They're very resistant and they have four speeds, so they have a lot of possibilities', says Marclay, whose predilection for ancient equipment has not prevented him from engaging in virtuoso displays – he employs between three and eight turntables on regular gigs. 'I've used 100', he asserts, referring to his notorious concert at Tokyo's Panasonic Hall in 1991, at which he was assisted by Jazzy Joyce, Nicolas Collins and Otomo Yoshihide.

Marclay's focus has always been on live performance, on bringing the 'dead' sounds preserved on records back to life. His numerous collaborative albums may well lack the excitement and physicality of his live shows, but that doesn't detract from their appeal. On *Live,* a duet with Günter Müller on drums and electronics released on Müller's For 4 Ears label, schmaltzy tunes and tense filmic fragments merge with a variety of creaks, groans and taps to form a serried, ever changing tapestry of sounds, whose origins are sometimes hard to identify. 'I like that confusion', he comments, 'it has to do with Günter's live processing of his drum sound.' Marclay has also collaborated extensively with such percussionists as David Moss and William Hooker. 'There's something about drums being very abstract and giving me room to improvise', he explains.

More than mere documents of his music, Marclay's recordings serve as a critique of the vinyl object itself. *Record Without a Cover*, for instance, prefigured *Footsteps*: as the name indicates, it was sold without a cover, and the dirt and scratches it accumulated over time made each copy unique. The process also called into question the status of the composer, for as Marclay points out, 'I no longer had the final say over the result.' *More Encores* is an entirely different proposition. Released in 1988, this early plunderphonic masterpiece features Marclay spinning extracts from albums by John Cage, Louis Armstrong, Johann Strauss, Martin Denny and Maria Callas, among others.

Another significant release is *Records*, a compilation of pieces from
1981–89. Fluctuating between the bleak pessimism of 'Neutral' and the
disorienting mayhem of 'Night Music', its dislocated textures, brooding
undertones and wheezy, half-buried groans foreshadow the dark,
deconstructed experiments of Illbient. Forthcoming releases include
an album with Elliott Sharp, due for release in June. A CD with fellow
turntablist Otomo Yoshihide is also in the works. 'Otomo is an interesting
DJ and his way of working is similar to mine', says Marclay, 'All the music
comes from records, but we reworked the sounds extensively in the recording
studio.' Asked how he feels about the issue of copyright, he replies, 'I respect
the notion of intellectual property, but I don't consider that I am stealing
from anyone. I use recorded music in such a way that it really becomes my
own music. Sometimes there may be quotes that people might recognize, but
I find that perfectly acceptable, because we hear recorded music everywhere,
it is imposed on us, and so in a sense it's part of the public domain.'

Marclay hasn't only turned the record and the turntable into
instruments in their own right. He has also developed playing techniques
for these new instruments and refined them over the years. 'Nowadays
I trust improvisation a lot more', he says. 'I used to compose pieces and
rehearse them, I would number the records and go through a routine and
I don't do that any more. These days, I just select records, I think about
what I can do with them, and then in the context of the performance I just
dive into it. The music really drives you to create, and one thing leads to
another. That's why I like to improvise with other people, because they'll
force you to go in directions that you wouldn't by yourself. I also try to stay
away from loops. So many people use loops. I like to use as many techniques
as possible, and the loop is just one of them. It's a skipping record, it's basic
record vocabulary.'

Today however, the approaching obsolescence of his chosen medium,
vinyl, has reduced the confrontational element of his art. 'My work had
a different impact in the 1980s', he confesses, 'when people still listened
to records. Then they could really relate to it, but now some people might
come to my concerts who've never had a chance to listen to records, and for
them it's a totally different experience. Records are not the standard means
of distribution today, so outside the DJ culture they are nostalgic and old
fashioned.' But then, Marclay's work has always been far more than just
a critique of the record industry. 'I think there is space for it in what I do,

but there is also the desire to make pieces that move me and that have a poetic and humorous dimension.'

The reason Marclay remains loyal to vinyl is because CDs are pretty much impervious to his manipulations. Then again, the emergence of the Internet and the new digital communications technologies could soon render CDs obsolete. Yet he welcomes these developments for, as he points out, music lost its immaterial dimension once the means to record it became available. 'What I find interesting about this development is that it gives music back its freedom', he concludes. 'All of a sudden it is detached from its fetishist medium, whether the record or the cassette, and so it has an immaterial quality. And that is the very essence of music.'

Rahma Khazam, 'Jumpcut Jockey', *The Wire*, no. 195 (May 2000) 28–33.

Douglas Kahn
Surround Sound
2003

Christian Marclay is an artist who works with the embedded ubiquity of sound. He has located sounds in so many settings that their accumulation has begun to signal a new sense of how wide-ranging the state of sound might be. An important part of this effort has been aided by his willingness to pursue sound where it is ostensibly silent, harboured in the private audition of thought or registered in normally mute materials and representations. Sound is often thought to be dependent upon an action or force to lend it a fleeting, ephemeral existence. However, when the embeddedness of sound is sought, all the effects and intimations of sound are included, even those that exist long before or after a sound in the conventional sense.

To take a concrete example of the various ways in which a sound may be *embedded:* when the Indonesian volcano Krakatoa blew in 1883, the eruption was heard for hundreds of miles. 'Blew' evokes explosion and blowing, a violent venting that includes a variety of materials both real and imagined, fused in an incendiary event. It is where action, sound and listening are joined, but even then there are different reports. The force of Krakatoa's echo arrayed infinite scenes of destruction, both the remains and the absence of the island. At the time the eruption was heard very far away, and was carried much further by a journalistic echo that continues in histories, casual citations such as this, and vulgar references to pustules. Today, the name alone conjures up ideas of an explosive sound on a massive scale, aided no doubt by the onomatopoetic KRAK lodged in its name, as if it were the attack of the sound itself.

The closest example of the *ubiquity* of sound is in Western ideas of a totality of sound. Such ideas go back to antiquity, to a cosmological sound that saturated terrestrial existence so completely that no one could hear it except for an adept like Pythagoras, who happened to have championed the idea. This of course underscores the notion of the 'music of the spheres', which people have contemplated off and on for centuries and survives in different versions to this day. In the modern period, such ideas were left to the big plans and big designs of Western art-music composers and commentators, from the utterances of the Romantics through the

grandiloquently humble listening of John Cage, assigned to the metaphysical beat. The notion of a totality of sound relied on subsuming the expanse of sound under the inherited precepts of Western art music. Twentieth-century composers who sought hitherto extramusical sounds as sonic material clipped sounds from their roots, from their embeddedness in the world, leaving only phonic, socially deracinated remains, in order to make the claim that they were dealing with all sound. These composers shied away from the musical and sonic actualities of popular culture and mass culture, while nevertheless showing a willingness to appropriate more distant cultures and musics. They avoided material cultures and the corporeal, removing themselves from whole realms of daily experience.

This modernist totality of sound should not be confused with the ubiquity of sound that Marclay is beginning to demonstrate. A totality can be grasped all at once; conceptually it is contained, a top-down approach where the importance of the particulars is diminished in service of the whole. Ubiquity, on the other hand, can only be experienced through its particulars, through a bottom-up approach. As such it will always be incomplete, in a state of formation, never achieving the closure that a totality claims at its inception.

Other artists have explored many states and types of sound without appealing to totality. This is particularly true of the generation of artists coming of age in the late 1950s and 60s: Joe Jones, George Maciunas, Yoko Ono, Nam June Paik, Ben Patterson, Mieko Shiomi, and many other inter-media artists, including Michael Snow, Bruce Conner, Max Neuhaus and Annea Lockwood. Unwitting influences and various precursors to specific Marclay methods, including his cut-up and modified LPs, can also be culled from the work of Arthur Köpcke and Milan Knizak. At the same time Spike Jones and Ernie Kovacs ushered in and extended the vaudevillian tradition, with its slapstick and melancholic sound and sound effects, into mass media, which even found fans among some of the artists just mentioned. Indeed, the acceptance of popular culture was pivotal for artists such as Paik, Ono and Conner. It should be mentioned that none of these artists, despite their varied insights on the embeddedness of sound, ever produced the diversity of work to signal a ubiquity of sound.

In 1977 Marclay was exposed first hand to the latest in the club scene's punk, new wave and performance art while participating in an exchange programme at the Cooper Union in New York, where he studied with Hans

Haacke. Back in Boston, his burgeoning interest in music and performance
rendered him useless to the sculpture department at the Massachusetts
College of Art (MassArt) where he was a student, so he retreated to the
hospitality of its Studio for Interrelated Media. Soon thereafter he took
the stage in a Duchampian punk duo, The Bachelors, Even, playing recordings
on old turntables commandeered from the audio-visual department, unaware
until several years later of the contemporaneous scratching by Grandmaster
Flash, Afrika Bambaataa, and others. In 1980 Marclay organized Eventworks
'80 in order to explore the relationships between punk rock music and
performance art, and brought to Boston such acts as DNA, Karole Armitage
and Rhys Chatham, Dan Graham, Johanna Went, Beth B and Scott B, Julia
Heyward and Eric Bogosian. RoseLee Goldberg lectured on the historical
background. Here, in the fusion of performance with music, is how many
people first encountered Marclay, playing turntables for mercurial groups
of the Lower East Side improv scene in New York City.

The vibrant trade between music and the other arts conducted under
the umbrella of performance opened new artistic possibilities, just as more
recently they have opened up under the auspices of sound. Marclay has long
been in a position to develop the relatively unexplored territory of sound.
He is moving past the particularizations characteristic of postmodernism,
whether in the scattershot of pastiche or the mélange of identities,
and developing, almost by default, a comprehensiveness characteristic
of modernism, yet without the presumptions underlying notions of
modernist totality.

Marclay's sense of the expanse of sound hearkens back to discourses
of the nineteenth century, before sound began to be filtered through
the reductive tropes of Western art music in the early twentieth century.
The development of scientific instruments for visualizing sound, and
of audio-phonic media and communication technologies exemplified
by the telephone and phonograph, encouraged ideas of bringing sounds
into visual and textual registers, into inscriptions (the jagged lines of
phonography) and objects (cylinders, discs, amplifying horns, telephones),
bringing sounds from far off distances and different times and equalizing
them as phenomena in the very idea of 'sound'. More and more sounds
were brought into daily existence, into visual, material and commodity
culture, in unprecedented ways, subsequently transforming the listening
to, making of, and understanding of sounds.

Writers were the first to put the potential of these new developments to work. Lucidly, they were only required to work with the ideas of the mechanics, avoiding the limitations of the mechanism itself. Thus, early instances of sound in the arts were within the realm of the conceptual. Alfred Jarry, the eccentric Frenchman whose famous 'Merdre!' launched the avant-garde, could very well be the earliest precursor of Marclay, as well as the first turntablist. Mixing modern technology, the mythological and the rampant misogyny of the time, Jarry spun a short tale about a cylinder in 'Phonographe' (1884), in which the contraption becomes a 'mineral siren'. Here one of the castrating songstresses is sunk into the perch of her coastal rock in the same manner that Echo – an uppity nymph always getting in the last word, punished by repeating nothing but last words – had been banished to the monotonous task of reproducibility as a rock face. About a century later, Marclay melded technology and mythology when he tiled a floor with thousands of compact discs in *Echo and Narcissus* (1992): a hard space of pending audio-phonic replay played the female lead of Echo, released from repeating everyone else's sounds by the grit and grain in her voice, and the pooling of mirrored surfaces played the male role of Narcissus, looking his very best until the wear and tear of gallery visitors walking on water took its toll.

Several projects by Marclay suggest that the expanse of sound has roots in art that go back much further than the discourses of the nineteenth century. In a facsimile issue of *Züritipp* (5–26 September 1997), a supplement of the Zürich newspaper *Tages Anzeiger* that he edited in conjunction with an exhibition, Marclay included a reprint of Richard Woodbridge's 1969 paper from the Institute of Electrical and Electronic Engineers calling for an 'Acoustic Archaeology', which would provide means for detecting sounds caught in pottery and paint strokes. This led Woodbridge to consider other sites for 'adventitious acoustic recording', such as 'Scratches, markings, engravings, grooves, chasings, smears, etc., on or in "plastic" materials encompassing metal, wax, wood, bone, mud, paint, crystal, and many others. Artefacts could include objects of personal adornment, sword blades, arrow shafts, pots, engraving plates, paintings, and various items of calligraphic interest.'[1] Acoustic archaeology, in this regard, suggests that the existence of sound in that historical phenomenon known as 'art' was preceded by thousands of years at the inception of material culture.

With his 1997 installation at the Whitney Museum of American Art

at Philip Morris in New York, *Pictures at an Exhibition*, Marclay became
a musical iconographer in order to suggest how sound has always played
its part in art (earlier versions of this idea were presented as *Accompagnement
musical*, Musée d'Art et d'Histoire, Geneva, 1995; *Musical Chairs,* Villa
Merkel, Esslingen, 1996; and *Arranged and Conducted,* Kunsthaus Zürich,
1997). Following Modest Mussorgsky's composition of the same name,
itself inspired by Victor Hartmann's drawings, Marclay's Whitney installation
used a wide repertoire of drawings, paintings, photographs and other
artworks to create a composition that turned each viewer into a composer/
performer of mental music. Over forty works from the museum's collection
were hung salon-style, with Richard Artschwager's *Organ of Cause and
Effect III* (1986) off to the side. Facing the wall, arrayed pew-like (the
Artschwager organ contributed to the church reference), were several
benches, each with a cushion covered in kitschy music-related fabric.
The images on the wall were all realist depictions of sound and music,
even as realism extends to a Roy Lichtenstein cartoon explosion. Many
images elicited an implied sound. Other images generated sounds through
acts of interpolation; that is, where images did not telegraph implied sounds,
the observer/listener became free to imagine an array of auditive possibilities.
Indeed, the entire wall of images became transformed into a grand score,
as the room itself dissolved into a veritable stage for mind-music and
conceptual sound improvisation. One might follow different threads
here and there, as in Nam June Paik's *Random Access* (1963, presented at
his 'Exposition of Music-Electronic Television'), in which a tape recorder
playback head can be run over a pick-up-sticks-like array of pre-recorded
audio tape lengths fixed to the wall; or venture off into improvisatory mixing,
having already rehearsed mental music from the elements of Marclay's
Body Mix album covers.

Marclay's insistence on conceptual sounds poses a challenge for ideas
of listening, especially musical listening. It is usually thought that people
cannot grasp the multiple foci of musical and auditory phenomena in
which many different sounds can occupy the same space and time. The
intricacy of a Bach fugue, for instance, could not be fully experienced in
real time. Attention is presumed to be directed like a ray, scanning various
parts in order to reconstitute the whole. In this way, actual listening is
understood to be inadequate. In turn, this may create a source of humility
that lends to the adoration of certain music. But what if private audition

was in fact capable of not only complex listening, but also handling even more complex forms of internal performance? A complexly layered, infinitesimally shifting mental performance could invoke innumerable genres and classes of sound in continuous or disjunctive manners unavailable to composition, recorded forms or performance. It could become a rehearsal for even more complex forms of listening and musical or sound production. Music itself would become less an occasion for adoration and more one for provocation. In a similar manner, the historiographic listening and performance involved in Marclay's *Pictures* does not merely unlock vibrations from the putative silence of the past, it does so for all images, objects and texts. Indeed, it is possible to think of mute images and objects only if one can imagine a soundless imagination.

The intracranial stage is more active than many have imagined. The neurologist Wilder Penfield performed experiments to observe what happened when different areas of the cerebral cortex were stimulated by a mild electric current. He was, in effect, the first bio-turntablist, lowering a wire instead of a stylus onto the grooves of the brain. When Penfield brought the wire down on one patient's exposed brain, the patient, still conscious and alert, was convinced that there was a gramophone playing in the operating room.[2] Marclay has generated a commensurate understanding through less invasive means: 'Everybody grew up listening to all this stuff, and all this music is, in a way, already sampled in our heads.'[3] Playing with the records of memory turns everyone into a record player and fuses audiophonic technologies with neuro-technics. People in media-saturated societies have so many songs, noises, sound bites and snippets recorded in their heads that they can register the type of quoting and referencing in Marclay's DJ work. Particular passages in a performance will be loaded only if they are already loaded, no matter how obliquely, in people's minds. One plays particular passages and plays with minds at the same time.

In other work, Marclay removes himself by asking the question why, if everyone already has all these recordings stacked in their brains, must a person wait for someone else to perform them to hear their contents? To this end he provides occasions for such performances. These are the performative parameters of Marclay's art – performing recordings and creating occasions for other people to perform – with which he plays both ends off the middle like an accordion. As the godfather of postmodern DJs, Marclay developed a formidable set of performance and improvisatory

skills to manipulate materials and meanings. He improvises cuts and mixes between turntables and has cut up and mixed fragments of LPs themselves for these purposes. When he collages an LP he provides an occasion for others to perform the composition using latent sounds. In this way records ape that other form of recording on the front end of music: notation in a score. His *Recycled Records* (1980–86) are not neutral shards of a collage but the visual notation of stutter-step rhythms and curt segues among different musics, musicians and their attendant social scenes. A *Recycled Record*, for instance, can become an icon, trumping all the framed gold and platinum records that stand for one-in-a-million by existing as one-of-a-kind.

In one respect, Marclay is bringing submerged cuts to the surface, working with a medium not designed to be cut or, more accurately, not designed to be cut anymore. After all, in the production process a disc lathe carves a jagged and bumpy groove onto the surface of the master recording, and this happens long after the producer confirms that a band is about to 'cut a record'. Just as Marclay plays off the term 'record player', so too he may simply be taking this term literally. Cutting the surface relates to a second class of cuts: the scratches usually heard as distractions from the music. In this sense one of Marclay's cuts is a scratch from hell, an accidental skip that has been taken to extremes. Whereas the submerged character of the first class of cuts resembles genetic or computer code, the cuts apparent on the surface lead us back to that older artistic engineering form of montage.

Some of Marclay's *Body Mixes* undercut publicity by taking it literally, a tactic reminiscent of Jaroslav Hasek's Good Soldier Svejk, whose obedience, taken to a logical conclusion, resulted in sabotage. Thus *Footstompin'* (1991) contributes to the longtime transformation of another crotch grabber, Michael Jackson – seen here as an odalisque inherited from Édouard Manet via magazine centrefolds – morphs into Diana Ross, with whiteness beginning to creep up one leg. The corporate construction of Jackson as a celebrity along with his own internalization of surgical montage pushes Marclay's image perilously close to an act of documentary.

Bodies also extend to musical instruments, which as a class have a long history of anthropomorphism within the visual arts, such as in Salvador Dalí's *Three Young Surrealist Women Holding in Their Arms the Skins of an Orchestra* (1936); Claes Oldenburg's similarly detumescent *Giant Soft Drum Set* (1967), deflating male aggression years before soft rock; or Charlotte Moorman and Nam June Paik's variations on a cello. Indeed, the tradition is so strong

that when Marclay puts *f*-holes on *Door* (1988), we are prone to recall Man Ray's *Ingres' Violin* (1924), in which the nude Kiki sits with *f*-holes on her back, rather like a cello or double bass. Likewise, *Door* invokes Duchamp's *Porte, 11 rue Larrey* (1927), which he had built in a corner of his apartment so that it simultaneously closed on one room while opening to another. When closed, Marclay's *Door* would formalize the status of any room as a resonant chamber and, just like a lounge act, would 'play the room'.

Just as a record silently contains a characteristic set of sounds residing under the skin of an album cover, so too are all musical instruments examples of intrinsic sound (as is any object lacking the proper action to produce an audible sound). One room of *Accompagnement musical*, which was populated by the open, empty cases of instruments in the museum's collection, amplified the phantom character of the instruments, while the instrumental modification piece *Virtuoso* (2000) virtually broadcasts the long sustained tones it contains. Here Marclay plays on the instruments' own anthropomorphism – the lungs of its bellows and larynx of its reeds – and by doing so generates both a new music and a new scale of musician.

Anthropomorphism also underscores *Guitar Drag* (2000), certainly Marclay's grisliest work. *Guitar Drag* is a video of an electric guitar being dragged on a dirt road behind a pick-up truck. Each bump in the road jars loose an additional reference. The most immediate is the tradition of guitar destruction in rock performance. Instrument destruction provided comic relief in many a vaudeville routine; it was up to rock to elevate it to dramatic spectacle. Inspired in part by Gustav Metzger's auto-destruction, guitar abuse and the noises it produced became signature moments for The Who and Jimi Hendrix. Marclay's pick-up truck is not going down just any dirt road; it is a road in Texas. The piece refers to the modern-day lynching of James Byrd, an African-American man killed by three white men who chained and dragged him by his ankles outside Jasper, Texas. In this work you have Hendrix, but also Billie Holiday's 'Strange Fruit', the aggression of young males, noise as transgression and as an ecstatic sound of hate.

Marclay has engaged film sound and music from the beginning of his career. While at MassArt he wanted to film a musical of sorts, because he liked the surreal manner in which people in musicals break out into song for little or no apparent reason. On John Zorn's concept album of the film music of Ennio Morricone, *The Big Gundown* (1985), Marclay can be heard at times spinning turntable sounds that reinstate the cinematic roots of the music.

He contributed to the soundtrack for Abigail Child's short experimental film *Perils* (1985–87). More recently he has gone into conceptual overdrive with his video *Up and Out* (1998), a radical expression of the asynchronous sound-image principles first formulated by Russian revolutionary filmmakers in the 1920s and used to good effect by Jean-Luc Godard in *Je vous salue, Marie* (*Hail Mary*, 1985). More specifically, Marclay's interest in asynchronous sound-image relationships derives from watching Merce Cunningham's dance company perform with John Cage's music: the choreography and the music are produced independently, and relate to one another only in that they are performed at the same time. Marclay was fascinated by how connections could be so easily made between the music and dance despite their functional independence. To make *Up and Out* Marclay stripped the soundtrack from Michelangelo Antonioni's *Blow-Up* (1966) and replaced it with the soundtrack from Brian De Palma's *Blow Out* (1981), itself an homage to *Blow-Up*. The visual images and soundtrack make a beautiful pair because the photographer (David Hemmings in *Blow-Up*) and the sound-effects specialist (John Travolta in *Blow Out*) are both forced into forensic roles, as are the viewers of *Up and Out,* who must use their wits to piece the images and sounds together. *Up and Out* also provokes insights into the workings of Euro-American media culture by cutting between two continents and two decades: here the counterculture's cry in *Blow-Up* clashes with the loud implosion of the early Reagan years in *Blow Out*.

His most recent video work is the masterful cinematic installation *Video Quartet* (2002), a four-screen projection made up of clips from hundreds of movie scenes depicting musical performance, along with other scenes of vocalization, general noise making, and even the calligraphic lilt of a ball rolling to a standstill. Although Bruce Conner is the Picasso of these parts (Conner accompanied The Bachelors, Even on film during a performance at a club in San Francisco in the early 1980s), the earliest major practitioner of 'compilation films', or films made with other films, was the Russian revolutionary filmmaker Esfir Shub, who used private home movies of Tsar Nicholas II in her *The Fall of the Romanov Dynasty* (1927).[4] *Video Quartet*'s meticulous composition of sound and image, from which the sound alone could easily stand, represents a departure for Marclay. Although he may not have been the first person to cut up and perform with records, he was perhaps the first freely to improvise with turntables. He has kept

the primacy of performance attached to his music, while composition has largely been reserved for his visual work. In *Video Quartet* he is composing with both the visual and audio components of recorded performances, since the post-production techniques of cinema in general render it a compositional medium. The question arises whether Marclay will reinstate the recorded performances of cinema into live performative mode.

Through the diversity of his work, of which we have only scratched the surface, Marclay reveals the breadth of phenomena at the centre of a general artistic and cultural shift toward sound. It is not an ecstatic revelation, but rather a slow burn that has developed as his oeuvre has grown and his approach matured. Marclay has gone beyond the limits of the modernist battery of sounds to include everything we can and cannot hear, and will never hear: all the symbolic and imagined sounds with their poetic, corporeal and political resonances on display. He includes the sounds he has tracked to their existence in bodies, objects, images, scenes, texts, inscriptions, and in the mix of their complex relationships, where they can be heard as at least a whimper of an echo, as background radiation, as misfired memory. He releases sounds from their obligations as vibrating air, puts them in new lodgings, and relocates them through performance. The diligence with which he has investigated so many sites has had a cumulative effect. The work progressively generates an unfolding parallel of the embedded and ubiquitous nature of sound in the world. The way Marclay operates as a general discoverer of sounds wherever they might occur and however they might operate makes us all better listeners as a result. What makes Marclay's work thrive is how the context within which it can be understood has itself grown. Marclay is working the groove, cultivating the surround sound.

1 Richard G. Woodbridge, III, 'Acoustic Recordings from Antiquity', *Proceedings of the IEEE*
 57, no. 8 (August 1969) 1465–6.

2 Jefferson Lewis, *Something Hidden: A Biography of Wilder Penfield* (New York; Doubleday,
 1981).

3 Christian Marclay, in Vincent Katz, 'Interview with Christian Marclay', *The Print Collector's*
 Newsletter, vol. 22, no.1 (March/April 1991) 7.

4 See Jay Leyda, *Films Beget Films: A Study of the Compilation Film* (New York: Hill & Wang,
 1964).

Douglas Kahn, 'Surround Sound', in *Christian Marclay* (Los Angeles: The Hammer Museum
at UCLA, 2003) 59–81.

David Toop
Performative Image, Inscribed, Even:
The Fluid Sound Worlds of Christian Marclay
2003

Phonography is doomed to invoke history at every level, yet simultaneously elevated by history from its material substance to a dizzying mythology shared by even the most casual user of the technology. In a Christian Marclay performance, records are slapped down onto turntables without ceremony, liquorice pancakes flipped onto the mould at production line speed. A rack of records stands by Marclay's two industrial-strength decks and I recall my elder sister's late 1950s record rack, close enough to a wire toast rack in its design to conflate and confuse the rectangular perfumed seduction of burnt bread and the circular mystery of the platter.

Burning wax leads to melting, as any owner of vinyl left out in the hot sun can testify. Records have been platters, wax and numbers, 45 and 33.3 rpm waxings plunging us into an arcane science, a delirium of metaphors. In Marclay's hands, the wax melts, leaving a residue that can be visual, metaphorical, symbolic or sonic. Analogue history is a diverse and haphazard store of associations. In the wire toast rack on the stage sits a record with the Vocalion label. I think of jazz and blues records in my own collection, the distinctive Vocalion logo, a strand of American musical heritage through which the label names themselves carried traces of the mythology of recording (Vocalion descended from Aeolian). Coloured vinyl stands to attention, dishes in the drying rack, each waiting its turn to turn as Marclay works through his set. The colour of vinyl adds a sidebar to collecting, the candy-coloured (as Roy Orbison might have said) disc sought for its sense of bizarre juxtaposition; my translucent green Korean discs of Confucian music, Chinese language instruction 45s pressed on blue flexible vinyl; or Marclay's own *Record Without a Cover*, re-pressed on white vinyl. To re-press may repress previous faults, but coloured vinyl pressings can be more noisy than their black counterparts, so *Record Without a Cover*, a record whose intent is to deteriorate under the stress of being treated without proper care, hits the ground running.

Marclay lifts records from the turntable, stylus still embedded in the groove, dragging slurred timestretch bombs from the spiral scratch. This gouging, scoring action of the needle adds a spectre of pain to the process

of playing a record, linking phonography to dentistry, carving inscriptions
onto gravestones, vaccination, the art of tattooing, acupuncture, piercings,
heroin, murder, the disgruntled bird whose beak is forced to function
as stylus in *The Flintstones*, dipped against its will onto stone platters
of caveman rock and roll that rotate on the shell of a turtle.

Etching is a close relative; inscription with a needle, acid-bathed, then
pressed, or vice versa. Inscription and juxtaposition are two of the keys to
Marclay's work. In his wonderfully prescient book, *The Recording Angel,* Evan
Eisenberg wrote in 1987 of the cool mode he identifies in recorded music:

> It can be seen as emerging from several of the paradoxes of phonography. To
> the abstraction of the audience it responds by speaking as if to a single, utterly
> known individual, in the manner of a disembodied voice. To the reification
> of music it responds by creating a curious object. To the hardening of musical
> language it responds by juxtaposing phrases rather than using them; in place
> of rhetoric there is irony. (The same irony protects the phonographer from
> the irony of his unseen listeners, against which he would be defenceless –
> like the blind musician of folklore, whose descendent he is.)

Marclay freely admits that his collages began as things to do when he was
bored. 'I never thought about them as finished works of art', he says. This
sense of free play permeates his work, in which the open informality of musical
improvisation closely links with the way in which modes can be flipped,
meanings can be transformed and materials transmuted. Similarly, his
photographs document a series of moments on the very edge of significance,
incidents that only the most alert mind will register and frame. Here is
an improviser's appreciation of the fragile instant; a quickness of eye that
approximates the quickness of ear that can detect undercurrents, implications
and concrete reference in musical flow.

Phonography and photography are almost identical words; in the grain
of one is the inscribed memory of the other. A photograph is a record, ghosting
a physical presence onto plastic, replaying memories like a score. The needle
is also a form of pen, guided into hidden inscriptions beneath the surface
of its black parchment. Record player design encapsulates the idea of self-
destruction in perpetuity. The needle ploughs through the spiralled groove,
wearing away both itself and the music it transmits. Each performance
writes its own slow suicide note. Decay follows death as an inscription

on the body. 'A drawing is a recording of some sort', Marclay has said, 'and a record is a kind of drawing; the groove is like an etching, but the difference is the extra dimension of sound; the sound transcends the object. The elusive vibrations of that spiral drawing need to be decoded by a turntable. This type of drawing needs a machine to make it vibrate into life. Or if it's a score, it needs a performer to interpret it. But when you watch somebody drawing or playing music, you can still identify with their physical presence.'

Marclay's photographs and collages can be read, or played, like scores. Within the exhibition, there is the possibility of 'hearing' the room, moving around the sequence of images as if each sounded its individual noise, notes or complex of sounds: a bagpiper plays outside a shop selling underwear, an abandoned church bell booms, the music of Charles Ives is thrown into a food blender, there are snatches of Elvis or the Rolling Stones. In one photograph, a faux red brick wall is stencilled with the image of an ear; the grain of plywood echoes the elaborate, elegant curves of the ear. The walls on which Marclay's images are hung become ears in themselves, hearing the implicit sounds which they display, yet simultaneously sounding (silently) as a single conceptual audio work.

There is an element of chance, in the way such a sequence will be 'heard' by each viewer. This connects with the surprises of his video works, in which bizarre and unexpected juxtapositions develop the narrative dislocations of pioneering John Cage works for electronic tape such as *Williams Mix* (1951–53). One of John Cage's stories, collected for his 'Indeterminacy lecture' of 1958–59, then recorded in collaboration with David Tudor, describes a suspended mechanical pen seen in a stationer's shop window on Hollywood Boulevard, writing third grade penmanship exercises onto a mechanically operated roll of paper. An advertisement in the shop window praised the perfection of this device. Cage was fascinated, for the pen had run out of control, tearing the paper to shreds, splattering both window and advertisement with ink, though leaving the claim to perfection still visible.

Christian Marclay compares his photographs to the kind of sketches made by travellers, hasty recordings of memorable scenes as fragile as dreams in their tendency to slip from memory into a void of forgetting. 'Now we have cameras – it's easier', he says. As in performance with many different records, they mark unrelated sequences of juxtaposition. Cage's

anecdotes have influenced this way of seeing incident in accident; Cage believed, as he wrote in *Silence*, that '... all things – stories, incidental sounds from the environment, and by extension, beings – are related, and that this complexity is more evident when it is not oversimplified by an idea of relationship in one person's mind'.

Sounds jump into almost-actuality, just from the image: tin cans tied to the back of a marital get-away vehicle plunge us into indeterminacy and the surviving role of noise in contemporary ritual. A blue telephone sits on the floor in an empty apartment. The door is open. I think of an interview with Isaac Hayes, after his bankruptcy, sitting in an empty apartment with only a telephone. At some point, that telephone will ring. Within the silence of the photographic image, we can hear the echoes in that empty room. In a New York City fleamarket, a painting of a Spanish woman playing guitar left-handed sits amongst pots and pans. The wall is covered in graffiti, a music coalesces in our heads, Hispanic hip hop flamenco with improvised metal percussion. A dog wearing a plastic cone collar, like one of Marclay's impossible hybrid instruments (his collage of a French horn fused with human organs) or an inversion of His Master's Voice, a canine loudspeaker: the woofer listening to tweeters. A car fitted with an inverted wire coathanger as a radio aerial. The radio only picks up stations that play clothing records, such as The Coasters' 'Shopping for Clothes', Glenn Miller's 'Silk Stockings', Run–D.M.C's 'My Adidas', or James Brown's 'Hot Pants'.

Either in subversion or make-do, objects in a consumer society glide easily from one function to another. Marcel Duchamp is the grandfather here. Marclay creates silent objects which make us listen, notations for participatory audition. 'Among our articles of lazy hardware', wrote Duchamp, 'we recommend a faucet which stops dripping when nobody is listening to it.' Marclay collages together Duchamp, *The Bride Stripped Bare By Her Bachelors, Even,* and the record cover of *My Fair Lady* (Pygmalion and Galatea being a recurrent narrative in his work), Eliza Doolittle hanging from the strings of her puppeteer (the bride being stripped bare by her bachelor), or he lays cassette tape onto photo paper and exposes it, in the style of Man Ray.

Just as Duchamp detached visual art from the retinal, so Marclay detaches sonic art from the aural. 'I always rejected the idea of Duchamp as a master', says Marclay, who named his first band The Bachelors, Even, 'but over the years I keep going back to him. He's inescapable.' Inescapable in the sense

that even Duchamp's experiments with oculism and illusion, the *Rotary Glass Plates* (1920) and the *Rotary Hemisphere* (1924), can return us to the spinning discs on a record deck. Within the readymade of 1916, *With Hidden Noise*, is an object that makes a sound, the nature of the object known to only one man, Walter Arensberg, now dead. In 1920, May Ray photographed dust breeding on the surface of the *Large Glass* as it lay across sawhorses in Duchamp's apartment. Duchamp then fixed the dust with varnish.

Another Marclay photograph: the reflection of a tree in the glass façade of the École de Musique in Paris. The tree appears to be growing through the soundhole of a guitar. I think of Max Ernst. Marclay accepts the connection. 'He found the fantastic in the ordinary', he says. The photographs are triggers, shooting the gaze off into other worlds. As Cage says, these other worlds are our world. 'It's like these little moments of recognition that we encounter every day', Marclay says. 'They're small and insignificant. They need to have enough excitement to pull out the camera and press the shutter, but most people pass them by.'

For Marclay, sound always exists in a social context in which objects and iconography are fluid in use and meaning, shifting between levels of significance and textuality. Phones become bones. Paintings of music become silent records. Mirrors become feedback. His photograph of a canoe projecting from the back of a pick-up truck draws my eye down to the number plate: Michigan WHISPER Great Lakes. Instantly, I can hear the silence of that canoe on the water. Watching his video piece shot in Texas, *Guitar Drag* (2000) – a Fender Stratocaster guitar plugged into a live amplifier then dragged at high speed from the back of a pick-up truck – thoughts come in a rush: racial killing, cowboys, Billie Holiday's 'Strange Fruit', the Fluxus events of Nam June Paik and Robin Page, Sam Peckinpah's *The Wild Bunch*, Jayne Mansfield beheaded in a car crash outside New Orleans and the times I saw Jimi Hendrix destroy his Stratocaster on stage, *Guitar Drag* is another form of inscription, a drawing in the dust, a mysterious track connected by rope and guitar cable to a soundtrack; I thought of inscriptions in nature generating sound, such as the sound of a river or wind running through cavities and channels in rocks or buildings.

The history of recorded sound is a public archive, distributed unevenly through official archives and libraries, though largely among record collectors, music lovers, attics, garages, shops, fleamarkets and landfill

sites. There is a sense of constant, infinite mix that has become both part of our cultural experience and a standard technique in the practice of much sound art and all turntablism. Among its many charms, Marclay's *Video Quartet* (2002) a mix of film clips ranging from Harpo Marx and Rex Harrison (*My Fair Lady* again) to Sean Penn playing guitar and Dustin Hoffman doodling on the vibes, illustrates human capacity to link unrelated events into a musical structure. In performance, Marclay overlays blues and exotica, many unfathomable sources, tapping the records, slowing them, waving them in the air. They are objects and sound, the history of record sound, plastic circles, open mouths, secret language.

Inscrutable in its mass-produced anonymity, a record makes a sound, even before the needle joins the groove, its black circle a Mary Quant hairstyle from the 1960s, the interior of a telephone receiver or loudspeaker, a Simon and Garfunkel song, 'The Sounds of Silence'. Materiality transmutes into aether; sound waves become substance. Mute is sound. In Marclay's work, the relationship between audible sound, an image signifying sound, a photograph documenting the enactment of sound, the notation of sound and the material aspect of a sound source are so closely threaded that our basic perception of distinctive, separate categories is challenged. Like the notorious *National Enquirer* headline – 'Boy Can See with His Ears' – Marclay asks us to abandon restrictive physical and conceptual distinctions. Hearing with the eyes, we see the world so much more clearly.

David Toop, 'Performative Image, Inscribed, Even: The Fluid Sound Worlds of Christian Marclay', in *Antipodes Notations* (London: White Cube, July 2003) 22–6.

Tom Morton
Sound Effects
2007

In the February 2002 issue of DC Comics' *Green Arrow*, the writer Kevin Smith introduced Onomatopoeia, a super villain with a curious super power. Like other comic-book characters, Onomatopoeia's existence is carved up into discrete temporal slices, still images that when read in sequence imply narrative progression, imply change. Like other comic-book characters, too, he inhabits a world in which sound is instantly transubstantiated into text. Say something here, and it will appear in a speech bubble above your head; walk across a marble floor in high-heels, and the words *'CLIK CLAK'* will hover about your calves. And yet, while the rest of *Green Arrow's* cast appears to be unaware of this fact, Onomatopoeia is not. Unlike standard super villains – with their command of magnetism, their octopus limbs – Smith's creation's super power derives from the formal conventions of the comic book itself. When Onomatopoeia utters an onomatopoeic phrase, it not only appears on the page in a speech bubble, but also as a sound effect. This may sound harmless, but we should remember that in comics every effect has its cause. *'DRIP'* presupposes a dripping tap, *'SLAM!'* presupposes a slamming door, and *'BLAM!'* presupposes the blast of a gun. It follows that Onomatopoeia is the only super villain that – like a comic book writer – can kill with mere words.

Christian Marclay's recent series of prints employ onomatopoeia, torn (quite literally) from the comic-book page. The artist began these works by flipping through numerous super-hero books, ripping out the sound effects that clustered in the right-angled corner panels. Sets of four or five of these ragged swatches were then arranged into rectangles, in a Dr Frankenstein-like approximation of their original form, while other onomatopoeic scraps were strung together like beads on an abacus, so that, for example, the vowels of the word *'AAAAAAAAAAAAAAAAAAAAAHHH!'* wound through three unrelated scenes, creating a notional sequence alive with non sequiturs. Despite their formal aping of the comic-book page, Marclay's works are very different from their source material. Composed of near-impossible-to-identify panels torn from multiple titles published by multiple companies between the 1980s and 90s, these new pages are unconcerned with the

purity of particular imagined worlds, or even with the notion of narrative progression. While the heroes of classic comic books always beat the baddies and get the girl, Marclay's cut-ups offer no such teleological guarantees. Indeed, we see little evidence of the hero at all here, save for the odd flap or flourish of cape. He has been edited out, left on the artists' studio floor.

For all that the works in this series disavow the narratives of their source material, they are nevertheless touched by how comics depict time. The onomatopoeic sound effects that Marclay collages, with their exclamation marks, their jagged capital letters, are, strictly speaking, not an event or even the corollary of an event, but something of a third order – *'CONK'* is not a punch landed on a costumed ne'er-do-well, nor is it the sound of that punch being landed, but rather its representation, or even reification. The artist does not show us the cause of the noisy phrases in these works (his careful tearing has removed the prime mover), and we obviously do not hear its acoustic fall-out. What we're left with is a sound effect that, by being isolated, has been transformed into an event in itself. Thought about for a moment, this makes perfect sense. In a comic book, actions and their consequences exist simultaneously – a single panel will show, say, Superman thinking about extinguishing a burning building, Superman expelling a blast of super-breath (with, of course, the appropriate sound effects), and the final guttering of the flames. Who is to say, in this lateral temporal schema, that the *'WHOOSH!'* arcing about the Man of Steel's puffed and mighty cheeks is something contingent?

This notion of onomatopoeic sound effects as events-in-themselves is drawn into sharper focus when we consider them as examples of (failed) translation – a theme Marclay also riffs on in his work *Mixed Reviews,* in which phrases from writing about musical performances and recordings is sampled and collaged, and even translated into the silent gestures of American Sign Language. In the artist's comic-book works, he presents us with words that represent sounds through both textual and visual approximation, so that what is perhaps the splintering of a door is rendered as *'KRAK',* written (or should that be drawn?) in a strained, serrated font. And yet, while such onomatopoeia might be said to aim at the naturalistic imitation of sound, they nevertheless pass through a cultural and linguistic filter, and something is lost in translation. Were Batman to have policed the streets of ancient Rome, the onomatopoeic Latin word *TUXTAX!* rather

than *BAM!* would have soundtracked the beatings he metes out to super villains. Similarly, translate the howl of Ace the Bat-Hound into German, French, Russian, Hebrew, Japanese, Spanish, Danish and Finnish, and he greets Gotham's moon with, variously, *WAU-WAU, OUAH-OUAH, GAF-GAF, HAV-HAV, WAN-WAN, GUAU- GUAU, VOV-VOV* and *HAU-HAU*. The musician Frank Zappa once remarked that 'Writing about music is like dancing about architecture.' Something similar might be said about the comic-book writer's attempts to relay sound.

In one analysis, all that might be said about the words *KA-BOOM!, FWAASH!, THRAK!* and *BWHAMM!* is that they point only to themselves. However, I suspect that for Marclay the 'failure' of onomatopoeia precisely to translate the sonic into the textual is a cause not for mourning but something like celebration. His comic book works revel in these sound effects' every lush vowel, their every monumental exclamation mark. This is art that – like Superman playfully squeezing a lump of coal into a diamond with his bare hands – compacts the raw material of pop culture into something dense, glittering and multi-faceted.

Marclay's video installation *Crossfire* (2007) is also the product of sifting, cutting and pasting. For this piece, the artist edited together short clips from several hundred movies, from *Bonnie and Clyde* (1967) to *Boyz in the Hood* (1991), each of them depicting a character or characters holding, or discharging, guns. A four-screen projection that surrounds the viewer, the video begins with footage of what might be best described as the foreplay of arms – fingers fluttering down steely barrels, jacket fronts being drawn back to reveal gun-filled armpit holsters, firearms from rifles to revolvers being cleaned, inspected and aimed. These fetishistic shots – half mating dance, half masturbatory dream – give way to a series of to-camera gunshots, ranging from precision sniping to the manic incontinence of machine-gun fire. As the number of assailants increases, the hail of bullets becomes heavier and heavier, and the four screens – each of which stream different clips – fill with the flashing entropy of battle. Suddenly, one of the characters from the clips yells *'STOP!',* the piece silences, and gunfire gives way to post-coital images of smoking weapons, and various marksmen peering out from the screen at the damage they've inflicted, their faces ranging from the regretful to the unambiguously elated. This lull, however, is short lived, and the gunmen soon resume their shooting, discharging bullets that whistle towards the camera as if to shatter the lens, or some frangible human

skull. Played on a continuous loop, *Crossfire* is an endless cycle of violence in which the viewer is not the quarry, but collateral damage.

To be caught up in *Crossfire* – spinning from one screen to the next like a body in its death spasms – is to be caught up in a movie world that plays by movie rules. The cop on one screen seems to fire on the cowboy on another, who does not die but simply disappears, to be replaced by a detective, or a gangster, or a grizzled Vietnam vet. One archetype gives way to another; change does not occur, only the illusion of change. The logic of the piece is that of Anton Chekhov's maxim that 'If a gun appears in the first act, it must be fired before the curtain falls', reconfigured for a culture in which the clip is more powerful than the protracted narrative, and in which violence and entertainment overlap in a pernicious Venn diagram. *Crossfire* is, in a sense, a critique of this, but Marclay complicates things by not only retaining the slickness of his source material, but also by enhancing it through its balletic rearrangement. Watching the piece, imagining ourselves viewed through the assailants' crosshairs, we experience a complex matrix of emotions. One, of course, is pleasure at the piece's bravura formal composition. Another is terror, or its simulation, which is also a pleasure of sorts. Oddest of all is the feeling of lack prompted by the fact that Marclay has edited out the effects of all that blazing gunfire: there is no blood here, no gaping exit wounds. In *Crossfire,* as in all fictions, everybody's hands are clean – the gunmen's, their creators', the artist's, our own – but, like Lady Macbeth in her guilty madness, it's hard for us not to imagine them as being marked by some red, irrevocable stain. While the artist's 1995 work *Telephones* – in which he edited footage from classic movies of people placing and answering phone calls into a melancholy narrative of failed communication – addressed the solipsism of mainstream film, his montage of fictional gunmen firing on one another in blithe disregard for anybody in their bullets' path is considerably more explicit in its presentation of Hollywood as a self-regarding world apart. In *Crossfire,* one event is not contingent on another – there are no consequences, no cause and effect. It is on this, I suspect, that Marclay's recent work turns. Every clip and comic book cutting here – every cocked Glock, every '*KERASH!*' – is a singularity, a blast of sound and fury signifying nothing, and a lot more besides. As the metafictional super villain Onomatopoeia illustrates, when one understands how a medium operates, one may make events-in-themselves have a cumulative effect, make fragments signify.

Marclay's collaged comics and films might not tell us stories in the traditional sense, but they tell us much about the cultural forms they riff on – about how a bullet can fail to draw blood, and how a word can kill.

Tom Morton, 'Sound Effects', in *Christian Marclay: Crossfire* (London: White Cube, 2007) 3–5.

Jean-Pierre Criqui
The World According to Christian Marclay
2007

Some things that happen for the first time
Seem to be happening again.
– Richard Rodgers and Lorenz Hart, *Where or When*, 1937

What does Christian Marclay do? One possible answer lies in the title
of this book [*Replay*, 2007], being published to mark this exhibition. In
this instance, the word 'replay' straight away asks to be considered as
a collage, a sort of portmanteau word resulting from the assembly of two
terms from clearly distinct semantic fields. 'Re' first of all indicates that
we are dealing here with notions of doubling and duplication – repetition,
reproduction, rerun. Then the English words 'record' and 'recording' come
to mind, the disc carrying the recorded sound, the object Marclay makes
fundamental to his artistic activity, and recording both as a process and
a product. It should be noted that in French the term *record*, in the sense
of a 'memory' and 'recollection', was in current use up until the sixteenth
century, while the verb *recorder* meant 'to remember' or 'to recall' until
the eighteenth. 'Memory is our own recording device', Marclay specifically
reminds us.[1] 'Play', the second half of the title, which echoes the second
syllable of the artist's own name, suggests a form of reopenness and leads
us both in the direction of childhood and of confrontation with chance,
toward improvisation and the 'incidental', seizing the opportune moment
(what the ancient Greeks called *kairos*). However, some idea of 'execution'
is added to that: a musical composition is played, and a record is played
(and can be played by a person or a machine). From the ludic to the
mechanical, and vice versa: 'play' covers a very wide variety of connotations,
parallel in a way to the range of different returns (accidental or completely
programmed, single or everlasting) implied by the prefix 're'. It is in the
space of the double to-and-fro postulated by 'replay' – a space traversed
by various rubbing and whirring sounds, punctuated by a number of
collisions – that Marclay acts, it is there that the operations from which
his work stems take place.

Even before the occurrence of any sound event that could be repeated, replayed or transformed, we like to think that there could have been silence. Silence as the original, generative condition of audible phenomena – a virgin backcloth against which they would stand out. But the problem, or paradox, with which such total silence faces us is well known: in so far as it can be created in a laboratory, it nonetheless remains a silence *for nobody,* and any individual who finds him or herself in such a situation, even if completely free of tinnitus, will then hear the sound of one's own body at work. It is what John Cage experienced in an anechoic chamber at Harvard, which led him to revise his conception of silence, a revision that prompted his famous silent composition *4′33″,* produced two years later in 1952 (in 1948, under the title *Silent Prayer* and based on a completely different logic, Cage had come up with the proposition for a 'portion of silence' to be *broadcast* in public places, modelled on Muzak, hoping to frustrate its effects in this way).[2] With *4′33″,* silence, a sound combination among others, lost its status as a virtual entity and attained unique existence. The equally varied and inventive manipulations Christian Marclay undertook on records (mainly 12 inch vinyl records) right from the start allowed him, at the same time as organizing the diversion of this recorded medium for new uses and new aesthetic purposes, to assess the consequences of Cage's 'gesture' (an abstention in the form of a pointed forefinger):

> The silent record, or more commonly a silent section on a record, reveals the medium more than recorded sound can. A silent record is no longer a simulacrum, but an empty bearer of sound; stripped of music. It reveals its imperfection and vulnerability. Only the surface noise and incidental blemishes are audible, clicking and crackling. Silence on a record demonstrates the uselessness of distinguishing noise and silence from music. Just as did John Cage's *4′33″.*[3]

Playing on silence as a material, but also on the idea and image of silence, constitutes one of the main focuses of Marclay's work. Thus 'The Electric Chair', his solo exhibition staged at the Paula Cooper Gallery in New York in autumn 2006, re-explored the views of the electric chair Warhol had shown in his 1963 'Death and Disasters' series by means of screenprints on canvas and paper, made with the technical assistance of Donald Sheridan, who used to be one of Warhol's collaborators. These new works concentrate on the sign 'Silence', which can be seen reproduced in the first

paintings Warhol devoted to this theme. Who was (perhaps still is) that laconic warning really intended for? The prison staff and the small number of spectators, called on to observe the sanctuary of harshness and conceal their emotion, or indeed their satisfaction? The condemned man himself – as we know that his execution does not always happen with the instant immediacy such a device would seem to impose? Or might it perhaps be a kind of prediction, or promise – announcing the end product guaranteed by the infernal machine? Here Marclay has undoubtedly produced some of his darkest and most overtly funereal works, on a par with *Guitar Drag* (2000), the very noisy video metaphorically re-enacting the lynching of an African American called James Byrd on a Texas road – these images, where death and electricity are again associated, seem to offer a silent echo of that work.

Silence has long haunted the work of Marclay in the most diverse ways. *Untitled* (1987), for example, consists of a 12-inch record without a groove, given into the care of its owner in a deluxe and – in a rather compensatory way – very tactile protective sleeve. Music that it is impossible to listen to could be said to form the ideal counterpoint to the uncut record; as another example of this we may cite *The Beatles* (1989), a pillow made from magnetic tape, recording all the work sung by the Fab Four which has been crocheted – a sly reference to the song 'Carry That Weight' towards the end of *Abbey Road* ('I never give you my pillow/I only send you my invitation'), a placid evocation of daydreaming relating to bygone childhood (Marclay was born in 1955) or the frustrations art does not fail sometimes to engender in both artists and spectators. A record also holds our attention by the attraction exerted by what complements and surrounds it – its *parerga*, its paratext. The sleeve obviously occupies pride of place here, and Marclay has shown unparalleled imagination in appropriating this partial object for fans or music-lovers. *Silence* (1990), which comes within his activities in this field, combines the eponymous word and a photograph of a tape recorder fitted with empty spools, the result of a montage of two record sleeves (one of them for a record by the group The Silencers).

Where installation is concerned, *Amplification* (1995), shown in Venice during the 1995 Biennale, was displayed in the interior of San Stae church; six large printed veils – fine-meshed scrims or pieces of muslin – freely suspended, reproduced six anonymous photos the artist had unearthed at the flea market, on a monumental scale. These amateur snapshots (three

in black and white, three in colour) had as their common subject the non-professional performance of music: a little girl playing the recorder by the light of a dining-room lamp; an old lady deciphering a score at an upright piano; a fair-haired fellow accompanying himself on the guitar right in the middle of a family reunion while the hilarious man next to him divides his attention between a pair of maracas and the woman hanging on his neck. The same photographs could be seen again in small neutral frames on the various altars in the church, serving both as maquettes for the enlargements floating above, and footnotes to them. With a remarkable economy of means, and in keeping with the spirit of the place, *Amplification* instilled in those who entered the church the feeling of a gently melancholy *moriendo,* as if these images preserved on the brink of oblivion and disappearance had been able to prolong for a time the vanished sounds, the memory of which they encapsulated.[4] In a more comic but equally silent vein, the 1999–2001 video *Mixed Reviews (American Sign Language)* shows Jonathan Hall Kovacs, a sign-language interpreter, himself deaf and mute, interpreting for the camera a collection of sentences taken from various music reviews, juxtaposed by Marclay to form a continuous text. His performance is amazing, in particular because of the way it succeeds in reconstituting the variations of dynamics described in the text in question. *Mixed Reviews* in the most literal sense gives body to a doubly imaginary music, with absolutely no acoustic reality, but also without any homogeneous referent in the world of sound, since in its totality the montage of quotations made by the artist refers only to a chimera, a pot-pourri, the improbable, burlesque nature of which must soon become obvious to anyone hard of hearing. Finally, to conclude this short list of some of the silences developed by Marclay (there are many others), mention should be made of *Tinsel* (2005), a music box whose lid is engraved with the word 'Silent', an anagram of the title of the work. Once it is opened the box plays an atonal melodic loop integrating the gradual slowing down of the mechanism. Then on the inside of the lid there is a second anagram: 'Listen'.

Just like recorded sound and its bearers, the moving image occupies a very diversified role in Marclay's work. First it may be noted that it can intervene during musical performances and intersect live with what is properly speaking an acoustic production. Thus in *Tabula Rasa* (2005), for example, for about an hour Marclay weaves an increasingly complex soundtrack from a few

noises generated initially without a record or instrument, purely by manipulating his turntable 'unloaded' (knocks on the tone arm, feedback, etc.), then from acetates cut on stage by the musician and sound engineer Florian Kaufmann, who reproduces the soundscape of his fellow performer as it develops. Video cameras record the operations of the two men, which are projected behind them in a large format. The use of video here adds to this kind of stratified recycling, fed by the performers without any respite, while allowing viewers to gain a better visual apprehension of what they are witnessing. For like everything Marclay does, *Tabula Rasa* uses no 'stunts' or 'secrets' and is in no way based on the cult of technique or any attempt to achieve virtuosity.[5] In accordance with the same almost didactic spirit, *Gestures* (1999) is composed of four synchronized screens or monitors with a turntable corresponding to each of them, filmed as a close shot: for nine minutes, the artist – only his hands are seen – is going to carry out in that restricted space a whole catalogue of gestures, with the records, 'prepared' or not, spinning before our eyes at a steady pace. To the ear the result is a joyous cacophony – with an evident drive, an evident rhythmic intensity underlying it – in which Marclay's interest in 'sounds that people don't want'[6] is overwhelmingly demonstrated.

 Video Quartet (2002) is likewise divided into four simultaneous projections, this time aligned horizontally to form a huge curtain about 12 metres long. Here there is no longer any question of real-time transfer, or the recording of this performance, or of that orchestrated by Marclay. As was already the case with *Telephones* (1995), in this instance cinema serves as a potentially infinite repertory of fragments to be retrieved and reassembled. The main thread of *Telephones* was very simple, and hilariously effective. That of *Video Quartet* is more complex and variegated: it deals primarily with the music played in films, though this does not mean that other kinds of noise are excluded, nor are a few silent clips. At the acoustic level, the piece gears the principle of *Up and Out* (1998) down to the point of vertigo; while that work had consisted of combining the pictures of one film and the sound track of another – *Blow-Up* (1966) by Michelangelo Antonioni and *Blow Out* (1981) by Brian De Palma – the difference, here, is that nothing in *Video Quartet* is substituted for anything, and everything coexists, since Marclay has kept the original sound for each extract. From the scene projected initially on the left (Dustin Hoffman strumming on a xylophone while money is exchanged in the foreground in *Macadam Cowboy*, 1969, by John

Schlesinger) to the final image on the right-hand side (a trumpeter in profile holding a note), it is the memory of the ordinary cinema lover (as in Jean Louis Schefer's book title, *L'homme ordinaire du cinéma*),[7] that Marclay opens up before our eyes – like an animated magic slate that gives rise to meetings between the silhouettes and voices of John Wayne and Arthur Rubinstein, Charlotte Moorman and Rita Hayworth, Dizzy Gillespie and Jane Fonda, Maria Callas and Jean Rochefort (and many others left to the powers of identification of each viewer).

 Crossfire (2007), still being edited when these lines were written, reconnects with the thematic simplicity of *Telephones* but in a clearly more tragic tonality, and modulating the quadruple projection of *Video Quartet:* the pictures are now shown in twos facing one another, and the viewer is completely caught in the crossfire, surrounded by a stunning ballet of appearances and disappearances. Let us linger for a moment over these last two words, which ask to resonate a little. Where disappearance is concerned, it goes without saying that Marclay's new video installation, bristling with shooters of all kinds, confronts us with the most macabre accepted meaning of the word. When we think about it, we will realize too that already in *Video Quartet* the great majority of those featured were among the *disappeared* in that sense (which is also valid for a good many of the real people featured in *Crossfire*), to such a point that any appearance is implicitly charged in these works, which in this respect are reminiscent of *Amplification* and its spectral overtones. Without too much exaggeration, it would basically be plausible to suggest that the general 'replay' movement from which all, or virtually all, Marclay's work arises has some similarities with a ghost story – a 'ghost story for grown-ups' as Aby Warburg put it, discussing the resurgence of antique motifs in Renaissance art.[8] Whether he is measuring himself on stage against Jimi Hendrix, invoked like a ghost in a 1985 performance with the more than eloquent title *Ghost (I Don't Live Today)*, or attempting, supported by a magician's white gloves, to reanimate a whole collection of Fluxus objects by extracting a sound from each of them – *Shake Rattle and Roll (fluxmix)*, an installation of 16 video monitors dated 2004 – Marclay mixes the shades of Schopenhauer (his 'Essay on Ghosts' written in 1850) and Thomas Edison (the gramophone as a spirit machine), and so calls to mind a tradition of modern literary myths; and his work often seems to beam up the reasons and inventions underlying them into the present, in order to replay them.[9]

Finally, to return to the question asked right at the beginning: it is suggested that Marclay is busy constructing a world of which 'replay' would be the founding rule, the federative story. He is making a world in his own way, the way of an artist; replaying worlds in a system sufficiently hazy to have the appearance of relative coherence and to continue to turn for some time – like the earth, or like a record.[10] A world is sometimes contained in very little, and depends on very little: a point shimmering to infinity, discovered deep in the darkness of a cellar in Buenos Aires, as in 'The Aleph', the short story by Borges; a hole made in the lavatory door of a commonplace Paris bistro, as in Jean Eustache's film *Une sale histoire*.[11] Likewise, Marclay's world is capable of being built on a mere nothing: a gesture, a sound, an everyday object transposed and seen in a new light, a few images taken from the double of the world recorded by cine-cameras. 'World-making as we know it always starts from worlds already on hand; the making is a remaking', Nelson Goodman wrote.[12] Thus Christian Marclay begins again, but this new start is of course also a first time.

1 Quoted in Rahma Khazam, 'Jumpcut Jockey' *The Wire*, no. 195 (May 2000) 31.
2 Cage's 'Lecture on Nothing' (1950) is contemporary with his visit to the anechoic chamber and would be reproduced in 1961 in his book *Silence*. On these questions, apart from the various texts and statements by Cage himself, see Douglas Kahn, 'John Cage: Silence and Silencing', *Noise, Water, Meat: A History of Sound in the Arts* (Cambridge, Massachusetts: The MIT Press, 1999). As we know, reversing the principle stated by Marx, the ideas of the avant-garde have often appeared first as farce. This is true of the notion of a silent composition which 'La musique d'après demain', a 'futurist tale' by Henri Falk, published in *Le Journal* on 15 June 1913, put forward as a joke. Falk features a composer, the appropriately named Leycodéçons (*L'écho des sons* – the echo of sounds), the founder of 'silencism' and the author of a 'silencist symphony', *Motus*. In conclusion we learn that silencism 'did very well, appealing even to music-haters, accessible to countless amateur composers, and allowing unemployed deaf people to become brilliant exponents of music criticism'. This text is quoted by Giovanni Lista in 'Russolo, peinture et bruitisme', the preface to his French edition, *L'Art des bruits*, of 'The Art of Noises' (1916) by Luigi Russolo, trans. N. Sparta (Lausanne: L'Âge d'Homme, 1975) 9–10.
3 Christian Marclay, 'Extended Play' (1988), reprinted in Jennifer González, Kim Gordon, Matthew Higgs, *Christian Marclay* (London and New York: Phaidon, 2005) 135. In a text originally published by the magazine *Der Kreis* in 1938, Panofsky, not someone you would really expect to find indulging in thoughts about the nature and issues of phonography, had stressed the specific dualities of reproduction on record: 'A good gramophone record is "good" not in so far as it makes me think that Caruso is singing in the next room, but in so

far as it communicates the musical intention of his singing to me, by conveying what might be described as the maximum of Caruso-like "sounds" conceivable in a sphere of radical otherness, that of the specific acoustics of the gramophone.' See Erwin Panofsky, 'Original et reproduction en fac-similé', trans. J-F. Poirier, *Les Cahiers du Musée national d'art moderne*, no. 53 (Autumn 1995) 45–55; and the study by Brigitte Buettner following it in the same issue, 'Panofsky à l'ère de la reproduction mécanisée. Une question de perspective', 57–77. Marclay's approach consists of amplifying the 'radical otherness' of the record and the instruments used to read it in every conceivable way, by means of an arsenal of disruptive procedures, the principle underlying which follows the law stated by Walter Benjamin in his day: 'For a fragment of the past to be able to be touched by the present, there must be no continuity between them.' – *Paris, capitale du vingtième siècle. Le livre des passages*, trans. J. Lacoste (Paris: Cerf, 1969) 487. The best analysis of these tactics has been put forward by Thomas Y. Levin: '*Indexicality Concrète*: The Aesthetic Politics of Christian Marclay's Gramophonia', *Parkett*, no. 56 (1999) 162–7. Moreover, we will see that this mix of shock aesthetics, chance encounter and cut-up also to a large extent characterizes the treatment Marclay metes out to images, animated or otherwise.

4 See the catalogue *Christian Marclay: Amplification* (Bern: Office fédéral de la culture/Baden: Lars Müller, 1995) with text by Russell Ferguson, 'The Sound of Silence'. [...] For another point of view on silence in Marclay's work, see Miwon Kwon, 'Silence is a Rhythm, Too', in *Christian Marclay*, exh. cat. (Los Angeles: UCLA Hammer Museum/Göttingen: Steidl, 2003) 111–27.

5 A feature observed by Francis Baudevin, in *Hello spirale* (Zürich: JRP/Ringier, 2115) 56: 'When you attend [a Christian Marclay] concert for the first time, you observe first and foremost how he does it. What are the gestures of his music? Over the years I've noticed that his body movements are becoming slower, as if to assert his wish not to succumb to a demonstration of virtuosity.' Baudevin's little book, in the form of a conversation in French with Valérie Mavridorakis, is a truly delightful document about musical curiosity and the visual arts in the contemporary era.

6 'I'm interested in the sounds that people don't want', Marclay states at the start of a mini-documentary about him produced by Tom Patterson for *EGG, the Arts Show* (PBS Channel 13) (www.pbs.org).

7 Jean Louis Schefer, *L'Homme ordinaire du cinéma* (Paris: Cahiers du cinéma/Gallimard, 1988).

8 These words by Warburg are in a note dated 2 July 1929, written with a view to his atlas *Mnemosyne*: 'On the influence of the antique. This story is like a fairy tale to tell. A ghost story for grown-ups.' Georges Didi-Huberman, from whom I am borrowing the phrase, used it as an epigraph in his authoritative book, *L'Image survivante. Histoire de l'art au temps des fantômes selon Aby Warburg* (Paris: Minuit, 2002). Moreover, it may be noted that a number of books are now being deliberately set in the register of some form or other of *haunting*. On this see the very suggestive insights of Michel Gauthier, 'Le temps des nécromants', in Mark Alizart and Christophe Kihm, eds, *Fresh Théorie II* (Paris: Léo Scheer, 2006) 175–86.

9 From an obviously endless list, here we will mention only *L'Ève future* (1886) by Villiers de l'Isle-Adam; *Le Château des Carpathes* (1892) by Jules Verne; *L'Invention de Morel* (1948) by Bioy Casarès; *Krapp's Last Tape* (1958) by Samuel Beckett, or again, closer to the spectres

of New York, William Burroughs' hallucinatory ruminations on the 'invisible generation' in *The Ticket that Exploded* (1962–67).

10 In *The Recording Angel: Music, Records and Culture from Ariststle to Zappa*, 2nd ed. (New Haven and London: Yale University Press, 2005), Evan Eisenberg emphasizes that it is only on a record that the various pieces of information relating to the human species have been encoded – among them music by Bach, the Javanese gamelan and Chuck Berry, the author of *Around and Around*, carried into space by the Voyager spacecraft – and he writes: 'A record is a world. It is the world scratched by man in a form that may survive him.' (210)

11 The Borges story dates from 1945 and was subsequently included in the collection published under the same title; the Eustache film, its structure focusing on the very notion of 'replay' as a story within a story, was made in 1977. On what these two works have in common see Jean-Pierre Criqui, 'Le secret le mieux gardé du monde', *Un trou dans la vie. Essais sur l'art depuis 1960* (Paris: Desclée de Brouwer, 2002) 113–20.

12 Nelson Goodman, *Ways of Worldmaking* (Indianapolis: Hackett Publishing Company, 1978) 6.

Jean-Pierre Criqui, 'The World According to Christian Marclay', in *Replay/Christian Marclay*, ed. Jean-Pierre Criqui (Paris: Cité de la Musique/Melbourne: Australian Centre for the Moving Image/Zürich: JRP/Ringier, 2007) 68–79.

Clément Chéroux
Christian Marclay's Photo-phonography
2009

French photography journals in the years around 1900 featured many
articles full of technical details describing new ways to link the recording of
visible and audible material, from 'Sounds and Photography' to 'Photography
and Music', 'The Reproduction of Sounds Using Photography', 'Images of
the Voice' or 'On the Photography of Heart Noises'.[1] This desire to record
sound waves on a medium more usually destined to capture light reflects
a more general contemporary enthusiasm for synaesthetic phenomena –
those states of consciousness in which it is possible to see music, hear
the vibrations of light or associate colours with sounds, flavours or aromas.
'Many people are aware that sound is always associated with colour – that
when, for example, a musical note is sounded, a flash of colour corresponding
to it may be seen by those whose finer senses are already to some extent
developed', wrote Annie Besant and Charles Webster Leadbeater in 1901,
in *Thought Forms*, a classic of theosophical literature.[2] Meanwhile, the splendid
plates illustrating the chapter entitled 'Forms built by music' show what a
clairvoyant can see in a church where music by Mendelssohn, Gounod or
Wagner is being played. This fascination with the simultaneous interaction
of the senses, which so marked scientific and parascientific research at the
turn of the century, also influenced the arts and literature, from Rimbaud's
vowels (*A* black, *E* white, *I* red, *O* blue ...) to Kandinsky's *Improvisations* and
Scriabin's *Prometheus*. Haunted by Wagner's notion of the total work of art,
many twentieth-century avant-garde movements, from Futurism to Fluxus,
continually sought to create the *Gesamtkunstwerk* through synaesthesia,
believing the arts could be unified through the union of the senses.[3]

The visual oeuvre patiently constructed by Christian Marclay over
the last thirty years has its roots in this rich history of the relationship
between sound and image. But it also marks a new departure. Through
his performances, installations, videos, collages and found and transformed
objects, this Swiss-American artist, living and working in London and New
York, has been working on the visibility of sound since the late 1970s. He
has said, 'A lot of my work is about how an image is expressive of sound,
how sound is expressed visually.'[4] In the early 1980s Marclay performed

on stage with a turntable strapped to his body like a traditional instrument. Over the following two decades he made several installations using vinyl records, magnetic tape, audiocassettes and musical instruments in unusual ways. In 1997, at the Kunsthaus Zürich, and again at the Whitney Museum, New York, he selected works from the museum's collections that had something to do with sound – including Edvard Munch's *Military Music on Karl Johan Gate*, Werner Bischof's *Flute Player* and Harold Edgerton's famous images showing a revolver firing and a hammer breaking glass – and hung them in a compact arrangement that inevitably produced an effect of visual cacophony. As Marclay himself explained in an interview of 2005, all these pieces were responses to the same question: 'How can we make a sound using an image?'[5]

In the late 1980s, in parallel to his performances, installations and novel uses for objects that make sound, Marclay added another string to his bow – or perhaps we should say his guitar – by taking up photography. With the benefit of hindsight, however, many of his earlier works had reflected an interest in this medium. *Door* of 1988, a simple door with two cello sound holes cut into it, was a kind of echo of Man Ray's photograph of Kiki de Montparnasse, the famous *Violon d'Ingres*. Marclay's work also recalls a strange theory developed in the late nineteenth century by the Swedish playwright August Strindberg. Listening to a piano in a neighbouring room, Strindberg observed that he heard the music better when the door was open. At the time he was experimenting with astronomic photography and working with the very weak light from the constellations he wanted to photograph. Thinking analogically, he had the idea that, like sound waves, waves of light would be more effective if there were no obstacles to their propagation. As he had opened the door the better to hear the music, so he removed the lens from his camera to allow the light to pass more freely. Then he removed the camera altogether, pointing the photographic plate at the night sky.[6] Whether by coincidence or by following the same analogical reasoning, shortly after making his door with sound holes Marclay also made photographs without a camera (photograms).

A year later, in 1989, Marclay made *Footsteps*. In this piece the floor was entirely covered with vinyl records, which visitors were then invited to walk over, so that, as the work's title suggests, every step was recorded by the trace it left on the grooved surface of the record. Seeking the most direct possible form of recording, and following a logic similar to that of Strindberg, Marclay

reduced the technical mechanism to the bare minimum, ultimately retaining only the recording surface. In 1992 he used the same principle for an installation at the Israel Museum, but replaced vinyl records with compact discs. Entitled *Echo and Narcissus*, this work was more than a simple reiteration (echo) of the earlier piece to reflect developments in recording formats; it also enabled visitors to play with their own image (Narcissus), multiplied and diffracted by the floor of CDs. Of this installation Marclay said, 'A mirror is a form of visual recording that is reminiscent, in its relation to vanity, to a record that enables us to listen to ourselves over and over. But, unlike photography and cinema, the mirror is a transitory method of recording, so its ephemeral reflection is very like sound.'[7]

He didn't know how right he was: when the first daguerreotypes – those images on metal covered with a thin, reflective layer of silver – appeared in 1839, many commentators observed that Daguerre had at last invented 'the mirror that will retain images'. In this light it is interesting to recall that the earliest photographic experiments by Nicéphore Niépce used photopolymers (bitumen of Judea), which are now the basis of most formats for storing computer data, including CDs.[8] This endless play on analogy – and the analogical – indicates the extent to which the photographic model is important in Marclay's work or, to put it another way, that he had a kind of aspiration to photography very early on.

Marclay began using photographic images directly in the late 1980s. He began by collecting a great many images that had some kind of link to sound – because they showed a musician, an instrument or a note on a score, or simply because they evoked music. This mass of anodyne images – photographs cut out of newspapers, small snapshots with ragged edges found in flea market shoe boxes, CD covers and so on – provided the material for some of Marclay's important pieces from the last decade of the twentieth century. In *Chorus* of 1988 he assembled a set of close-up photographs of mouths cut out of magazines. *White Noise* of 1993 is a room in which the walls have been entirely covered with small amateur snapshots. Bought by the boxful at the flea market in Berlin, the images were pinned to face the wall, showing only their backs, which are sometimes inscribed with a name, place, date or memory. *Amplification*, shown at the Venice Biennale of 1995, was also made from six private snapshots of amateur musicians, enlarged so that they could be printed on diaphanous screens several metres wide.[9] Over these years Marclay also collected CD covers, the content and function

of which often lead us to forget that they bear photographs. Although he says he is not a fetishist, Marclay undoubtedly has some kind of compulsion to accumulate. But beyond the simple pleasures of collection, these thousands of covers are above all a reservoir of images on which he regularly drew throughout the decade to create stunning montages which, in their telescoping of images, disjunctions of scale and mixing of genres, are reminiscent of the *cadavres exquis* of the surrealists. The reference to surrealism is apposite here, since Marclay's fascination with popular imagery recalls Paul Éluard's interest in the fantasy postcards of the early 1900s, which he collected furiously in the late 1920s and early 1930s. Several witnesses attest to the whole days he spent seeking them out and putting them into specially designed albums. For Éluard, these images were not art, just the 'small change of art', which sometimes produced 'the idea of gold'.[10] We see exactly the same with Marclay. He is not interested in collecting CDs for the graphic quality of their covers. In his eyes these covers are material to be used in his own visual creations.

In his works of the 1990s, found images seem gradually to give way to photographs taken by the artist himself. For example, *Graffiti Composition* (1996–2002) consists entirely of photographs taken by Marclay and his assistant, showing fragments of walls and fences in Berlin on which he had previously placed blank scores and which had gradually become covered with advertisements, tags and, sometimes, musical notation. The photographs were printed on loose sheets and, when placed end to end, could form a playable musical score. In this period Marclay never went out without a small amateur camera and systematically photographed everything that evoked sound, from a music shop sign in the form of a treble clef to a notice forbidding noise nuisance, street musicians and so on. The pictures were taken quickly, without careful framing or efforts to depict subjects from the front, sometimes even without pointing the camera at the subject and often with a flash. Marclay's photographs are thus authentic snapshots displaying all the characteristics of what can be termed amateur aesthetics.[11] Just as in most of the amateur photographs he spent many years collecting, including those he used for *Amplification*, what mattered was not to obtain high quality framing, composition or stylistic effects but to preserve the memory of something seen and appreciated. In this sense, for Marclay photography is a way of extending his collection. It offers him a kind of Lilliputian, two-dimensional reduction of the world.

While he may be unable, for one reason or another, to snatch something out of the public space, he can preserve its indexical trace. The photographs Marclay took every day were then organized into themed series – musical notes, onomatopoeias, notices and so on – just like a collection, and exhibited as such. Some were published. For example, in 2007 Marclay published *Shuffle*, a pack of cards made using photographs of musical notes, which can be shuffled, dealt and laid out on a table like a game of patience. This random score, made entirely from photographic notes, can then be played by musicians.

The photographs collected or produced by Marclay – or at any rate taken by him – share what he calls a 'sound quality'.[12] Obviously they do not produce sound, but they have the ability to invoke it. The image or, to be more precise, its content, acts as a starter that sends viewers on the trail of the sound. It is then up to them to produce it in their minds, giving rise to what we can term mental sounds, on the model of mental images. Here the artist is working with the silent nature of the images he uses. It is precisely because they are silent that these images of sound are able to increase the imaginative and projective abilities of the viewer. 'Absence is a void to be filled with one's own stories', explains Marclay. 'I find silence is much more powerful because we're always surrounded by sounds, and in silence we can think about sound. Silence is the negative space that defines sound.'[13] The piece called *White Noise* is particularly representative of the capacity of Marclay's works to generate sound out of silence. Viewers standing in the middle of the room – where, as we said, the walls are covered with small amateur photographs of which only the backs are visible – know that each white or beige rectangle is a potential image. The few inscriptions that appear on the backs of the prints not only remind us that these are photographs, they seem to shout what the images show. In this space upholstered in white, faintly reminiscent of a solitary confinement cell, the images seem to have been driven out, but their background noise – white noise – still resonates inside. No work has better produced an effect of deafening silence. Of course the projective principle used by Marclay, which consists in providing the image of a sound to encourage the viewer to imagine the sound itself, is highly susceptible to polysemy, as is perfectly illustrated by *Chorus*, the series of close-ups of wide-open mouths. For while some see or hear it as song, others perceive a scream. Like these mouths – and to echo the title of the famous book by Umberto Eco – this work is *open*,

it makes itself available to the plurality of subjectivities – and hence of interpretations.[14] This openness to polysemy does not displease Marclay. On the contrary, it contributes actively to the cacophonic effect he is trying to create.

As the few examples described above clearly show, Marclay's work reflects a constant preoccupation with synaesthesia and particularly with the ability of images to invoke hearing. But to reduce his work to this one aspect would be to diminish its scope. Alongside his interest in the visibility of sound, Marclay has also shown a fascination for recording, probably the nineteenth century's great contribution to the sensory field and almost certainly first discussed in theoretical terms by Walter Benjamin. The emergence of techniques of analogical reproduction, making it possible to record, preserve and repeat sounds and images, profoundly transformed our sensory relations with the world and in particular with works of art.[15] A sizable element of Marclay's work consists in interrogating this notion of recording. He understood that, to be effective, analogical recording in the form of a record or photograph requires the interface between the sound or visual element and the audience to become imperceptible. To put it another way, the more transparent the recording medium, the more effective the analogical effect. Once the artist becomes interested in the medium itself, he has to find ways of making it opaque, in other words making it perceptible again. In *The Formation of the Scientific Mind*, the philosopher Gaston Bachelard has shown that the problem of knowledge should be posed 'in terms of obstacles'.[16] An obstacle is usually a thing that gets in the way and blocks understanding. However, in Bachelard's view it can prove a valuable indicator of the processes at work in cognitive experience. For example, light in itself cannot be seen. To make it appear we must place an obstacle in its way to create a shadow. Bachelard's hypotheses have since been widely supported by advances in cognitive psychology and psychoanalytic research into slips and parapraxis. Today we know that knowledge can be acquired through obstacles. This is clearly the approach that Marclay has chosen to use in order to investigate analogical recording. He knows that the recording process must be hindered to make it visible, that the medium is most clearly perceived in its weaknesses, failures and areas of shadow.

A piece made in 1985 is particularly interesting in this regard. As its title suggests, *Record Without a Cover* is a blank disc distributed without a cover.

Every time it is handled, rubbed or scratched, a trace is left on the
extremely sensitive surface of the vinyl and, when the disc is played, this
trace becomes a sound. So this is not a record of pre-engraved music, but
of the capacity of the disc to record sounds, in other words the materiality
of the analogical recording format itself. 'A scratch on a record', says Marclay,
'is anathema to the audiophile. For me it's just another sound, it has even
more value than a sound cut into the groove, because this scratch or cut
makes its materiality audible. A record isn't just a sound conveyed in the
abstract, it's an object: the scratch reveals that.'[17] Elsewhere he says, 'With
Record Without a Cover you can't ignore the medium. You can't ignore that
you are listening to a recording.'[18] Although less ostensibly, Marclay's
photographic work also offers a theory of recording on the basis of its
failures, obstacles and areas of shadow. This is illustrated with particular
clarity by a work like *Fourth of July*. The images of a brass band that form
this series were taken, as the title reminds us, on the USA's Independence
Day. The edges of the prints are irregular because they have been torn.
For Marclay this tearing of the image is a kind of visual echo of the scratches
on a record, but there is more to it than that. The torn edges of the pictures
indicate that they were sampled from a print in a larger format. Here we
must recall that, ontologically speaking, photography is an act of sampling.
Unlike the painter, who starts with a blank canvas and whose task is to fill
it with forms and colours, the photographer's work consists in detaching
fragments of reality from a larger space-time continuum. While painting
is additive, photography is subtractive.[19] The torn edges of the images of
the *Fourth of July* series are thus not only a kind of visual equivalent of
scratching. They also remind us that all photography is torn from reality.
They make the medium visible.

But it is almost certainly in his photogram series that Marclay most
directly interrogates the notion of recording, both photographic and
phonographic. We should recall that the creation of a photogram involves
arranging more or less transparent objects on photographic paper and then
subjecting it to light. This causes the silver salts around the objects to darken.
When fixed and developed, the light-sensitive surface retains a negative
image of the objects placed on it. So photograms offer a perfect illustration
of Bachelard's theory: it is the obstacle that allows us to see the action of
light on photographic paper. By leaving out the camera – in other words the
problem of the formation of images in the optical chamber – and confining

his explorations to the transformation of silver salts through the action
of light, Marclay places himself in the tradition of the work of László
Moholy-Nagy. In the early 1920s Moholy-Nagy used photograms to gain
a greater understanding of the specificity of photography. In 1926 he wrote,
'There is a type of photographic work made without a camera and capable
of laying valuable, reliable foundations for a deeper understanding of the
wonders of photography.'[20] Two years later he noted, 'Photograms give us
greater, more substantial knowledge of the meaning of the photographic
process than images taken with a camera, mostly with little thought and
often mechanically.'[21] Moholy-Nagy also made great use of the photogram
principle in his teaching at the Bauhaus in Weimar, then crucially at the
New Bauhaus in Chicago, as it offered him a remarkable teaching tool
for the better understanding of photographic recording.[22]

Beyond photography, the photogram is also a means by which Marclay
questions phonographic recording. For example, in a series of 1990 entitled
Broken Record, he shattered a vinyl disk in the darkroom and laid out the
pieces on photographic paper. Another, untitled series of the same period
consists of translucent discs placed at random on larger pieces of photographic
paper. In *Record Without a Cover* Marclay was seeking to uncover the record,
to undress it. Here he seems to want to get inside the medium itself to
see what it contains. In this respect *Broken Record* has the appearance
of a 'primitive act'. Like the legendary sorcerers who broke their enemies'
skulls to snatch their souls, Marclay wants to break his records in order to
free the music from its vinyl sheath for a moment, immediately recapturing
it in photographic gelatine. The end is the same in the photograms, but
the means are different. Transparency enables the record to be seen and
looked into, without intrusion. Here Marclay is deliberately playing on the
formal resemblance between a photogram and an X-ray image. In 1923
Moholy-Nagy had noted, 'An X-ray is also a photogram, the image of an
object obtained without a camera. It enables us to look inside an object, to
see at once its external form and its internal structure.'[23] Two double pages
of his *Malerei Photographie Film*, published in 1925, are devoted to comparing
the two techniques.[24] But, beyond simple visual similarities, it is clearly
the capacity of Röntgen rays to see through bodies without the need to
open them up that interests Marclay here. In giving his photograms the
appearance of radiographic prints, he wants to indicate that he has X-rayed
his records in order to reveal their contents. In this sense the black-and-

white photograms of records can be seen as updated versions of *Broken Record*. It is no longer necessary to break records to see what is inside them; they can simply be subjected to the inquisitorial gaze of radiography. In this series, perhaps more than in his other photograms, Marclay is interested in the notion of transparency. This is of course the transparency of objects placed on light-sensitive paper, but also, and perhaps primarily, the transparency of the medium of phonographic recording. With the series of pseudo-X-rays Marclay shows that a record is undoubtedly transparent, but not entirely so. It still leaves a trace on the light-sensitive paper. This trace is not sound, but the signal of the recording process itself, the sign of its materiality – in other words, and again, background noise, visual interference.

In Marclay's photographic work, and throughout his oeuvre, there is a kind of dialectical tension between a desire to construct on the one hand and, on the other, a real fascination with deconstruction. By collecting images and objects linked to music, combining them in one way rather than another, establishing resonances and polarities between them, the artist produces what Georges Didi-Huberman has described as 'knowledge through montage'. Of this form of knowledge Didi-Huberman notes, 'Its heuristic value is incomparable: we have seen this from Baudelaire and his definition of the imagination as a 'scientific faculty' perceiving the 'intimate, secret relationships of things, correspondences and analogies' to the structuralism of Lévi-Strauss. Among others, Warburg and his atlas *Mnemosyne*, Walter Benjamin and his *Book of Passages* and Georges Bataille and his journal *Documents* have revealed the fertility of this kind of knowledge through montage.'[25] Conversely, in Marclay's work there is also what could be described here as a form of knowledge by dismantling (*démontage*). The way that Marclay investigates the process of phonographic recording – deliberately scratching records, breaking them to see what is inside them, going deeper than the grooves – is not without similarities to the childish tendency described by Baudelaire in his 'Morale du joujou':

Above all, most little brats want to see the soul – some after a period of use, others at once. The length of the toy's life depends on the speed with which the child is overcome by this desire. I can't find it in me to condemn this infantile mania: it is the metaphysical urge stirring. Once it has settled in the child's cerebral marrow, this desire fills his fingers and fingernails with singular force and agility. He turns his toy over and over, scratches

it, shakes it, bangs it against the walls and hurls it on the ground. Every now
and then he sets off its mechanical movements, sometimes in the opposite
direction. The marvellous life comes to an end. Like the populace besieging
the Tuileries, the child, makes a supreme effort; at last he prises it open,
he is the stronger. But where is the soul?[26]

Constructing and deconstructing, assembling and dismantling,
composing and decomposing. The dialectical tension that is always at work
in Marclay's work has something deeply playful about it. Didi-Huberman,
in an article on what he refers to here as 'knowledge through the kaleidoscope'
and which includes a discussion of Baudelaire's piece on toys, has shown
the extent to which play is based on precisely this two-sided process
of assembling and dismantling: 'How can we not see, in this exemplary
situation, that two heterogeneous timeframes are working together? That
the whirlwind impulse of destruction (shaking the toy, bashing it against
the walls, throwing it on the ground, etc.) is combined with the structural
impulse – an authentic desire for knowledge (testing the mechanism,
starting the movement in the opposite direction, etc.)? How can we not
accept that, in order to know what time is, we must see how mum's watch
works? And that, to this end, we must take the risk – or abandon ourselves
to the pleasure – of taking it apart, whether systematically or violently and
with some degree of anxiety, in other words breaking it?'[27] In Marclay's
work the playful aspect is greatly reinforced by the form he gives his works.
We can see it in the dimension of performance of course, but also in the
place given to chance in works like *Record Without a Cover* or *Graffiti
Composition*. It is reflected in the use of the photogram, which was a
technique described in books on photographic and scientific pastimes in
the late nineteenth century and widely practised for fun by amateurs long
before it became a canonical element of avant-garde photography.[28] We
can see it also in the pack of cards that can be cut, shuffled and dealt in
Shuffle and the assemblages of covers, whose similarity to the game of the
cadavre exquis has already been noted. For the surrealists, the importance
of these everyday games played in groups went beyond pure recreation.
They were fascinated by play because it stimulated the imagination and
offered, to borrow the words of André Breton, opportunities for 'the
most extraordinary encounters'.[29] The surrealists were clearly not alone
in realizing the heuristic and creative value of play. Much of the art
of the modern period is built on this collusion between creation and

recreation. 'The toy is the child's first introduction to art',[30] wrote Baudelaire. 'Play is the first step of creation',[31] noted Theo van Doesburg a few decades later, and the psychoanalyst D.W. Winnicott adds, 'It is by playing, and perhaps only when he plays, that the child or adult is free to be creative'.[32] This is something Christian Marclay has understood. The dialectical force that runs through all his work is not only playful, it is eminently creative.

1 'Les sons et la photographie', *Bulletin de la Société française de photographie* (1899) 318–19; G. Vieuille, 'La photographie et la musique', *L'Arc-en-ciel* (July 1898) 49–51; Louis Ancel, 'La photographie de la parole et la reproduction des sons à l'aide de la photographie', *Photo-revue* (20 April 1914) 130–31; 'Les images de la voix', *Moniteur de la photographie* (1896) 298–9; A. de Holowinski, 'Sur la photographie des bruits du Coeur', *Bulletin de la Société française de photographie* (1896) 358–61.

2 Annie Besant and Charles Webster Leadbeater, 'Forms Built by Music', in *Thought-Forms* (1901) (London and Benares: The Theosophical Publishing Society, 1905) 75.

3 See Sophie Duplaix and Marcella Lista, eds, *Sons & Lumières. Une histoire du son dans l'art du XXe siècle* (Paris: Éditions du Centre Georges Pompidou, 2004); Marcella Lista, *L'Oeuvre d'art totale à la naissance des avant-gardes* (Paris: CTHS, INHA, 2006).

4 Christian Marclay cited by Jennifer González, in Jennifer González, Kim Gordon and Matthew Higgs, *Christian Marclay* (London and New York: Phaidon Press, 2005) 52–3.

5 Jean-Philippe Renoult, 'Ce que vous voyez, ce que vous entendez. Entretien avec Christian Marclay', *Art Press*, no. 503 (February 2005) 4.

6 See Clément Chéroux, *L'Expérience photographique d'August Strindberg* (Arles: Actes Sud, 1994) 45–8.

7 Marclay cited in Peter Szendy, 'Christian Marclay, *Echo and Narcissus*', in Sophie Dupleix and Marcella Lista, eds, op. cit., 361.

8 On this, see Jean-Claude Dubois, 'De la photographie aux polymères et à la microlitho-graphie: un demi-siècle de progress dans l'électronique et la multimedia', in Joyce Delimata, ed., *Nicéphore Niépce, une nouvelle image* (Chalon-sur-Saône: Société des amis du musée Nicéphore Niépce, 1998) 140–48.

9 See *Christian Marclay. Amplification* (Bern: Federal Office of Culture, 1995).

10 Paul Éluard, 'Les plus belles cartes postales', *Minotaure*, no. 3-4 (1933) 86.

11 See Clément Chéroux, 'Les icônes domestiques', in Sylvain Morand, ed., *Instants anonymes* (Strasbourg: Musées de la ville de Strasbourg, 2008) 125–32.

12 Christian Marclay cited in Jennifer González, Kim Gordon and Matthew Higgs, op. cit., 128.

13 Ibid.

14 See Umberto Eco, *The Open Work*, trans. Anna Cancogni (Cambridge, Massachusetts: Harvard University Press, 1988).

15 See Walter Benjamin, 'The Work of Art in the Age of Mechanical Reproduction' (1935–36); trans. J.A. Underwood (London: Penguin, 2008).

16 Gaston Bachelard, *The Formation of the Scientific Mind*; trans. Mary McAllester Jones (Manchester: Clinamen Press, 2002).

17 Jean-Philippe Renoult, op. cit., 2.

18 Christian Marclay, cited in Jennifer González, Kim Gordon and Matthew Higgs, op. cit., 121.

19 See Philippe Dubois, *L'Acte photographique et autres essais* (Paris: Nathan, 1990) 169.

20 László Moholy-Nagy, 'Fotoplsastische Reklame' in *Bauhaus-Heft der Zeitschrift 'Offset Buch- und Werbekunst'* (Munich: Kraus Reprint, 1926; reprint, 1980).

21 Moholy-Nagy, 'Fotografie is Lichtgestaltung', *bauhaus*, vol. 2, no. 1 (1928).

22 See Alain Findeli, *Le Bauhaus de Chicago. L'Oeuvre pédagogique de László Moholy-Nagy* (Sillery, Paris: Les Éditions du Septentrion, Klincksieck, 1995).

23 László Moholy-Nagy, 'Fotoplastische Reklame', *loc. cit.* p. 129. On Moholy-Nagy and x-rays, see Hans Rooseboom, 'Nothing New under the Sun: The X-ray Photograph in the Vocabulary of New Photography', *Bulletin van Het Rijks Museum*, no. 2-3 (2001) 303-304.

24 László Moholy-Nagy, *Malerei Photographie Film* (Munich: A. Langen, 1925; reprinted 1986, after the edition of 1927, published with a title with modernized spelling: *Malerei Fotografie Film*) 68-71.

25 Georges Didi-Huberman, *Images malgré tout* (Paris: Éditions de Minuit, 2003) 151-2.

26 Charles Baudelaire, 'Morale du joujou' (1853), in *Écrits sur l'art* (Paris: LGF, 1992) 250.

27 Georges Didi-Huberman, 'Connaissance par le kaléidoscope. Morale du joujou et dialectique de l'image selon Walter Benjamin', *Études photographiques*, no. 7 (May 2000) 7.

28 See Albert Bergeret and Félix Drouin, *Les Récréations photographiques* (Paris: Charles Mendel, 1893) 38-41; C. Chaplot, *La Photographie récréative et fantaisiste. Recueil de divertissements, trucs, passé-temps photographiques* (Paris: Charles Mendel, undated [1904]) 45-52.

29 André Breton, 'Second manifesto du surrealism', in *Oeuvres complètes*, vol. 1 (Paris: Gallimard/'Bibliothèque de la Pléiade' series, 1988) 822.

30 Charles Baudelaire, op. cit., 246.

31 Theo van Doesburg, 'Film als reine Gestaltung', *Die Form*, no. 10 (15 May 1929) 241-8, English translation in *Form*, no. 1 (Summer 1966) 5.

32 D.W. Winnicott, *Playing and Reality* (New York, Basic Books, 1971) 53.

Clément Chéroux, 'Photo-phonographie de Christian Marclay', in *Christian Marclay: Snap* (Dijon: Les Presses du Réel, 2009) 17-34. Translated by Trista Selous, 2014.

Rob Young
The Sounds of Christmas
2010

London, December 2004. Three waist-high crates are delivered to the
pavilion on a freezing weekday. Levered open, they reveal their contents:
more than a thousand vinyl records. This is Christian Marclay's collection
of Christmas records, accumulated over several years, and which have
travelled all over the world, flipped through by countless fingers. They
have arrived at a temporary pavilion erected outside London's Tate Modern
to be exhibited as *The Sounds of Christmas*, which Marclay installs every
December at a designated location somewhere in the world. I was one
of the curators involved in bringing this seasonal artwork to the UK, and
was fortunate enough to be standing among the crates as their contents
were unpacked and placed between dividers on wooden racks constructed
specifically for this event.

What does Christmas sound like? The festivities did not begin, my
grandmother used to say, until she had heard the lone King's College
choirboy trill the opening lines of 'Once in Royal David's City', in the
ceremony of Nine Lessons and Carols that is broadcast from Cambridge
on British radio every Christmas Eve. Hipper households might throw
on Phil Spector's *Christmas Gift for You* or Dean Martin singing 'Frosty
the Snowman': Yuletide through a cocktail glass. For others, it might be
the Bach *Christmas Oratorio*, the sleigh bells that provide the icy leitmotif
throughout Paul McCartney's 'Wonderful Christmastime', or the angelic
warble of Aled Jones singing 'Walking in the Air'. This kind of music is
indelibly linked with the holiday festivities, conjuring the mood and setting
the tone. But until you've leafed through *The Sounds of Christmas*, you simply
have no idea how much choice is out there.

Christian Marclay began collecting Christmas LPs with artistic intent
at the end of the 1990s. 'I've always picked up cheap Christmas LPs', he
tells me, 'for when I was doing performances around the Christmas holidays.
I wanted to be seasonal. I only started buying them seriously when I was
on a residency in San Antonio, Texas, at Artpace in 1999. I developed this
project in Texas and went hunting for records all over San Antonio and as
far away as Austin.' By the time *The Sounds of Christmas* was first realized

in 1999 at Artpace, the collection consisted of nine hundred LPs. Now it
stands at more than twelve hundred, and in the last decade has travelled
to New York, San Francisco, Miami, Glasgow, London, Milwaukee,
Geneva, Montreal and Detroit. As an artwork. *The Sounds of Christmas*
fulfils overlapping functions: it is a visual feast that encourages viewer
interaction. Records are displayed in wooden browsers, as in a shop, and
each flick of the racks reveals another variation on the seasonal theme. In
the same space, all the record covers are projected in a random sequence
on six video monitors, documenting the endless variety of cover designs.

Juxtaposed in this way, the LP packages tell their own story. Stick a
plastic tree on a beach with the Sugar Loaf Mountain in the background:
Christmas in Rio. Snow, pine cones, reindeer-drawn sleighs: *A Norwegian
Christmas.* Christmas music rendered by Mormon, Pentecostal, Oxbridge,
African tribal, Greek Orthodox, Welsh male and Red Army choirs; Elvis,
punk rockers, thrash metallers, opera stars, trad folkies, Vegas schmoozers,
Japanese kotoists, cool-bop vibraphonists, Disney characters, Hawaiian
guitarists, period instrumentalists, avant-garde improvisers, Swiss yodelers,
gangsta rappers, soccer squads, military units, kindergarteners, Miami
Bass DJs. Literary depictions of Christmas – Dylan Thomas, Dickens –
read by Richard Burton and Paul Scofield. The Nativity rung on Cotswold
church bells or harmonized by families pressing up recitals in private
editions of ten. Everything and everybody, from the topmost to the
crapmost of the music industry, seems to have wanted a slice of the
Christmas pudding.

But this archive is not intended to be passively browsed. The installation
directive calls for a small stage and sound system to be provided, plus a
pair of DJ turntables and mixer. At each city, local DJs and musicians are
commissioned to create unique, improvised mixes at live events, using only
the Christmas albums as source material. They are permitted to sample the
records and transform the sounds with any kind of effects pedal or processing
software they want to bring, but the origin must be the music engraved in
the grooves of the collection's LPs.

In this sense, *The Sounds of Christmas* is a working musical score
and a giant readymade instrument. Its parameters are not a conventional
written manuscript; the tools for activation are provided within the installation
space. Among the rest of Marclay's work, it sits between one of his
'accumulation' pieces like *Wall of Sound* (1997) and an open-ended,

score-generating project like *Graffiti Composition* (1996–2002). It is a
working demonstration of the recombinant art of the DJ, which now has
its own history stretching back to late 1970s hip hop and disco as well as
the experimental turntable strategies pioneered by Marclay himself with
his early group, The Bachelors, Even. This legacy is reflected in the work's
ad-hoc, 'crate-digging' sourcing of materials as much as in the centrality
of the DJs' performances.

There's a delight to be had in the infinite variations milked out of the
idea of Christmas, and in the inventiveness of the musicians in further
appropriating, recombining, and distorting the content. At the London
iteration, the performances were wildly diverse. Ninja Tune DJs such as
Coldcut's Matt Black and Strictly Kev accentuated the fun, funk and kitsch
elements. Experimental musicians the Bohman Brothers focused on the
album sleeves, reading out excerpts from the liner notes while extracting
noises from the cardboard itself. And turntablist Janek Schaefer created
a hallucinatory, ringing soundscape of lushly elongated tones and angelic,
carolling sonorities that suggested the ancient provenance of the Yuletide
feast. Marclay himself tossed chopped-up portions of hymns and old-
chestnut songs into a blender, modulating and transforming them with
deft hands-on turntable manipulations and foot-switch effects.

Like Marclay's other LP collection-based work – *Incognita* and *Dictators*
(both 1990), for example, which respectively highlight the unnamed female
models used to sell albums and depict the male conductor as lonely hero
– *The Sounds of Christmas* draws attention to patterns of representation
in the packaging of these consumer objects. Instant signifiers of the season
– tinsel and baubles, roaring fires, Santa hats, gift-wrapped parcels, pinecones,
sleighs, stars and shepherds – are systematically attached to artists who,
for the rest of the year, would not dream of making any reference in their
work to a Christian festival. Christmas, after all, is the centre of gravity
in the capitalist year – the shopping period that most affects retail profit
margins. Many Christmas LPs are the product of nothing less than naked
opportunism. Others, such as the handful of albums recorded by local
choral societies, intended for sale among friends and relatives, are invested
with love and pride. In between sit the hundreds of solo-artist Christmas
celebrations – Henry Mancini, Liberace, Sting – calculated to humanize
pop idols, reminding credulous fans that on 25 December they too will
be opening presents and carving the ham. Or the myriad themed albums,

from Hammond organ carols to Tijuana brass versions of 'Winter Wonderland', which consumers might select to chime in with their own individual lifestyle aspirations. Marclay recognizes that records are more than just containers of music; they are cultural artefacts in their own right: They are repositories of memory, carriers of deep personal associations, and, in this case, bearers of entrenched cultural hegemony (surely no other world religious festival has generated so much audio product?).

Christmas LPs lie dormant for most of their lives – they're really only needed one or two days of the year. Experiencing *The Sounds of Christmas* feels like strolling round a charity shop, and in fact the piece performs an act of phonographic charity: picking out these peripheral components of the domestic record collection, DJs dust them off and give them the gift of life.

Rob Young, 'The Sounds of Christmas', in *Christian Marclay: Festival*, vol. 1 (New York: Whitney Museum of American Art/New Haven and London: Yale University Press, 2010) 30–32.

Christoph Cox
The Breaks
2010

In the early 1920s, the artist-polymath László Moholy-Nagy published
a pair of articles proposing novel uses for the phonograph.[1] In its nearly
half-century of existence, Moholy-Nagy noted, the phonograph had thus
far been used only as an apparatus of reproduction, a machine that played
recorded music and speech. Yet it could readily be transformed into an
apparatus of production, an instrument for making music, or what Moholy-
Nagy more broadly termed 'sound effects'. The surface of the record, he
suggested, could be hand-cut to generate 'hitherto unknown sounds and
tonal relations'. Graphic designs might be laid into wax to create what
he called a 'groove-manuscript score'. Such innovations, Moholy-Nagy
thought, would allow the composer to avoid the detour of musical notation
and its subsequent interpretation by musicians, and would instead reestablish
a direct, amateur experimentation with sound.

It took decades for artists to begin following these suggestions and
to realize what Moholy-Nagy had fundamentally grasped: that the advent
of the phonograph marked a key turning point in the history of music and
sound. Indeed, it was part of a fundamental shift in worldview manifested
not only in music and art but also in philosophy, science and beyond.

From his early experiments with records and turntables through
his recent photographic, video and graphic scores, Christian Marclay
has placed himself at this musical and conceptual juncture and has richly
explored its sonic and social repercussions. Marclay's work is always clever,
direct and accessible, making creative connections and drawing new
possibilities from the detritus of mass culture. Yet it also offers a rigorous
historical, conceptual and material investigation into the history of audio
recording and the fate of music and sound after the twilight of the musical
work. Before highlighting some of Marclay's key interventions, I want
briefly to rehearse this history.

Sound is a fluid and ephemeral substance that inherently resists efforts
to capture it and to forestall its inevitable dissolution and passage. For most
of human history, biological and communal memory were the only available
mechanisms for the capture – the 'recording' – of music.[2] While fundamentally

traditional and aimed at the preservation of ancestral culture, folk forms of transmission inevitably involved variant repetition and minor innovations that were amplified and passed on, ensuring that the song had no fixed or singular identity but was always in flux. Likewise, this sonic flux was essentially anonymous, authored not by a creative individual but by the entire community and its lineage.

A second mode of sound recording, musical notation, was introduced to Europe in the late Middle Ages as a supplement to memory, an *aide-mémoire* for accomplished musicians faced with complex polyvocal music. With the rise of capitalism, the written score was enlisted as the means by which to reify and commodify the ephemeral material of music. No longer the fluid production of communal authorship, the musical work became a fixed entity that was the intellectual property of an individual composer. Once merely a supplement to the sonic flux of the song, the musical score came to be, for legal and economic purposes, the musical work itself. The musical work thus paradoxically became an inaudible, mute object, and musical attention was shifted from the ear to the eye. Requiring a new form of literacy, music became the province of a specialist class.

Folk music continued to operate via oral-aural transmission. In the art-music context however, the musical score served as the dominant means of musical recording and transmission from the sixteenth century until well into the twentieth. It was the invention of the phonograph in 1877 that eventually challenged this hegemony of the visual score and inaugurated a new era. The phonograph record was able to diminish the distance between the visual score and its auditory performance. Where the score provided only a blueprint for skilled musicians to realize a musical work, the phonograph record could deliver actual performances and, to do so, required not a skilled performer but only a machine. Short-circuiting the literate culture of the score, the phonograph record could register performances of all sorts – operas and symphonies, but also folk songs and Tin Pan Alley numbers. Moreover, where the musical score was restricted to the recording of discrete pitches in a limited range, the phonograph could record and play back the entire audible universe.

An exchangeable container of music, the phonograph record intensified the reification of music that began with the score. Yet it also opened up the possibility of undoing this reification and restoring the essential fluidity of sound. As Moholy-Nagy suggested in the early 1920s, the phonograph was

capable of becoming more than merely a technology of recording and representation. It could also become an instrument for musical composition and improvisation. In the 1920s and 30s, composers such as Stefan Wolpe, Paul Hindemith, Ernst Toch and John Cage experimented with phonograph recordings in compositions and performances.[3] But the use of recorded sound did not become a prominent compositional tool until 1948, when French radio engineer Pierre Schaeffer broadcast a set of 'noise studies' built entirely from recordings – not only of musical instruments but of worldly sources such as pots, pans and railroad trains. In the years that followed, Schaeffer's Paris studio became a hive of experimental musical activity, attracting a who's who of the European avant-garde.

It's not coincidental that, at precisely this historical moment, the musical score began to fragment and dissolve. The score for Karlheinz Stockhausen's *Klavierstück XI* (1956), for example, consists of a large sheet of paper displaying nineteen musical passages amongst which the performer is invited to move at random. Similarly, the first section of Pierre Boulez's *Third Sonata for Piano* (1958) is a collection of ten pages that can be arranged in any order. More radical still is the score for Earle Brown's *December 1952* (1952), a white page sparsely sprinkled with an array of black bars of various lengths and widths. In his terse instructions. Brown remarks that the score can be read from any direction, performed by any instruments, and played for any length of time.[4]

December 1952 still looks vaguely like a traditional musical score, but one that has been largely erased. (It thus anticipates the *Erased De Kooning Drawing* produced by Brown's friend Robert Rauschenberg the following year.) Yet it also resembles the modernist drawings and paintings of Piet Mondrian and Paul Klee. These correspondences between visual art and the musical score were celebrated by the Polish-born composer Roman Haubenstock-Ramati, who suggested that the abstract picture could be treated as a musical score.[5] It was Haubenstock-Ramati who famously praised the pianist David Tudor for his astonishing ability to realize experimental scores, quipping that Tudor 'could play the raisins in a slice of fruitcake'.[6] The comment was made in jest; but it proved prescient, as Fluxus artists and other experimental composers began to treat all sorts of objects and events as provocations for sonic production.

Haubenstock-Ramati's own prodigious output of 'graphic scores' is clearly indebted to the paintings of Wassily Kandinsky, whose canvases

(many of them titled 'Composition', or 'Improvisation') aspired to the
condition of music. Indeed, like many early modernist composers and
painters, Kandinsky hoped that his paintings would approximate the
neurological condition of synaesthesia, in which different sensory
modalities merge to form a common experience. In the age of digital media
and intensive neurological research, synaesthesia has once again become
a frequent buzzword in the arts and sciences.[7] The graphic score, however,
fundamentally resists this synaesthetic condition. Instead of merging the
visual and the sonic, the graphic score pries them apart. Where the traditional
musical score aims at a one-to-one correspondence between visual symbols
and musical tones, the graphic score denies such correspondence. Hence,
faithful performances of Brown's *December 1952,* Haubenstock-Ramati's
Batterie (1969) or Cornelius Cardew's *Treatise* (1963–67), for example,
generally bear no audible similarity to one another. With the graphic
score, then, the visual and audible content of music diverge, becoming
two parallel streams.

This experience of divergence is, indeed, a general characteristic of our
contemporary intellectual condition, of which music is a microcosm.[8] The
traditional musical score emerged alongside the classical physical theories
of the sixteenth and seventeenth centuries, which construed the universe
as a closed system governed by deterministic mechanical laws and set
into operation by a transcendent creator. From such an external position,
the world was present all at once; and the experience of time was only an
illusion experienced by immanent entities such as human beings, who were
denied a God's-eye view of the whole. The classic musical score mirrors
this physical structure. A fixed, bounded totality (the score) is produced
by a creator outside of it (the composer) to be executed by musicians
who faithfully carry out its predetermined programme.

In the mid nineteenth century, the dominance of deterministic physics
was challenged by evolutionary biology, which denied the necessity of
a transcendent creator and figured the world as an open system that
was irreducibly temporal. Biological species were no longer taken to be
fixed types produced in advance; rather, they were seen as the contingent
products of countless historical events and processes that could not
have been foreseen. In the biological domain, there is no identity. No
two individuals are alike, and biological reproduction proceeds not by
repetition or replication but by variation, mutation, differentiation and

divergence. For evolutionary biology, then, time is real, and past and future are asymmetrical.

The avant-garde and experimental music of the past half century has resolutely explored these temporal processes of difference and divergence. Indeterminate compositions and graphic scores were just the beginning. John Cage's employment of chance procedures shunned the ordinary musical 'time-object' in favour of compositions that 'imitated nature in her manner of operation', which meant following 'a process essentially purposeless'.[9] Iannis Xenakis modelled his musical compositions on stochastic processes such as 'the collision of hail or rain with hard surfaces, or the song of cicadas in a summer field'.[10] The 'event scores' of Fluxus figures such as George Brecht, Yoko Ono and La Monte Young simply provided provocative verbal prompts to action and could be realized in any number of ways. Ornette Coleman, Derek Bailey and Musica Elettronica Viva inaugurated practices of free improvisation that dispensed with the score in favour of in-the-moment decision-making and responses to the sounds of fellow musicians.

Cage described as 'experimental' 'an action the outcome of which is not foreseen';[11] and indeed so much experimental music simply provides a set of initial conditions from which performances then ramify and diverge. This is manifested quite literally in Steve Reich's early tape works *It's Gonna Rain* (1965) and *Come Out* (1966), in which two tape recorders playing the same vocal fragment gradually go out of phase, generating interlocking patterns of extraordinary complexity. So much computer-driven 'generative music' celebrates the spontaneous eruption of emergent properties through feedback loops.[12] And DJ culture treats the whole history of recorded music as an archive of fragments to be endlessly sampled, mixed and remixed. All these modes of music-making, then, affirm a fundamentally complex, open, temporal and indeterminate world. Christian Marclay's work richly references and extends this history. It affirms the historical rupture through which the musical score gave way to audio recording, and celebrates the temporal, conceptual and sensory divergence that characterizes our contemporary condition. Marclay's first move was to activate the turntable and the record. Beginning in 1979, working independently from hip-hop DJs such as Kool Herc, Grandmaster Flash and Grand Wizard Theodore, who were undertaking similar experiments at the time, Marclay transformed the turntable into a musical

instrument and treated the record not as a finished product to be passively consumed but as raw material for creative manipulation.

Like any commodity, a record is what Karl Marx called 'dead labour', the congealed residue of human activity.[13] The ordinary commodity disavows or dissimulates this essence, but the phonograph record makes it peculiarly manifest. The sonic remains of past events and bodies no longer living are dug into its grooves, inscribed in a petroleum byproduct that materially consists of fossilized organic matter. The turntable momentarily revives these events and voices, but always retrospectively, as a remembrance of things past. A record collection, then, is a mausoleum that testifies both to the fixity and the fragility of the past. Within this context, Marclay's turntablism performs a temporal inversion. His 'recycled records' (LPs cut into pieces and reassembled in new configurations) reorganize the linearity of auditory history; and his multi-turntable collages and improvisations cast the fixed past into an uncertain future.[14]

In 1985, Marclay embalmed a set of his own turntable performances on a commercial LP. This would have been a paradoxical and contradictory move, were it not for the disc's title, *Record Without a Cover*, and an instruction engraved on one of its sides: 'Do not store in a protective package.' Without such protection, the records would inevitably pick up scratches and attract dust and debris. What began as all-but-identical, mass-produced objects would slowly diverge from one another, becoming unique works of art via the accumulated traces of their singular and contingent trajectories. Marclay thus submitted the prefab world of Andy Warhol's Campbell's Soup cans to Steve Reich's tape-phase procedure, allowing time, chance and the vicissitudes of commodity circulation to 'improvise', adding sonic material to his own and producing results that he could not have foreseen in advance.[15]

A more recent project, *Mixed Reviews* (1999–2010), also celebrates this divergence, in this case via metaphorical leaps across the gaps that separate sound, text and image. Vivid and bombastic sentences pulled from music reviews – efforts to translate musical experience into language – are strung together to form a horizontal wall text that cuts across the exhibition space. Each installation of the piece translates the text into the local language, increasing the distance between musical referent and linguistic sign. In a video version, *Mixed Reviews (American Sign Language)* (1999–2001), a deaf actor renders the text as a flow of wildly expressive bodily gestures.

The circuitous course of translation – from sound to texts in multiple languages to gestural signs on video – operates like the game of 'telephone', ensuring that the output will diverge substantially from the input. Even so, the text fires the aural imagination, provoking a silent experience that is nonetheless intensely musical. The video is likewise silent, but the actor's hands, arms and face powerfully capture the physicality of sound, the waves and forces it releases, and their social trajectories.

These projects are not evidence of some nostalgia for lost unity, nor are they commentaries on the incapacities or disabilities of various media. Rather, they are testaments to the generative powers of difference and translation. Forestalling the stultifying collapse of the senses and media into identity or unity and the conformist fantasy of perfect correspondence, they celebrate ingenious leaps between sensory modalities and media that produce genuine novelty. Perfect replication, we know from biology, would be a recipe for death and extinction. Life and creativity thrive on mutation, variation and divergence. Such leaps and divergences are actively cultivated by the series of photographic and video scores Marclay has produced over the past fifteen years. *Graffiti Composition* (1996) and *Shuffle* (2007), for example, are decks of photographs to be used as musical scores. Where the earlier piece documents anonymous scribbles on blank score sheets, *Shuffle* collects fragments of conventional musical notation from street signs, clothing, awnings, umbrellas, tattoos and bric-à-brac of all sorts. They may be intended as mere decoration, signifiers of 'music' in general, but Marclay takes these found objects seriously. The collection as a whole combines the Duchampian readymade with Stockhausen's *Klavierstück XI* to create a musical score of endless permutation. As in *Graffiti Composition*, anonymity plays a key role here, though in *Shuffle* it's the anonymity of a vast cadre of designers who go unnamed and uncredited in the visual culture of modern life. Marclay's photographs, then, are a form of sampling – not of musical sound, oddly, but of its visual representation. Photography and phonography approach one another and generate sparks across the divide.

Closely linked with these projects are two others. *Zoom Zoom* (2007–9) and *Manga Scroll* (2010), both of which employ onomatopoeia, that curious effort of language to imitate worldly sounds. Onomatopoeia attempts to circumvent the semantic content (the signified) that generally stands between the signifier and its referent – an effort by the word not just to *represent* the referent but to *be* it. Yet onomatopoeias turn out to be

conventional signs, not natural ones, and, moreover, signs that are culturally specific. (We say 'chirp'; the Spaniard says 'pio'. We say 'cock-a-doodle- do'; the Italian says 'chicchirichi'.) What's more, Marclay's onomatopoeias are textual and visual, not spoken or sonic: *Zoom Zoom* is a photographic compendium of onomatopoeias found on banners, trucks, champagne bottles, candy wrappers and elsewhere; *Manga Scroll* is a string of onomatopoeias lifted from English versions of Japanese comic books. Composed for a solo vocalist, both pieces ask the performer to undertake a roundabout translation: not to imitate sounds but to use their voices to re-sonify graphisms that vainly attempt to mimic the noises of the world. This proliferation of translations and leaps across various domains becomes dizzying when we consider that *Manga Scroll* pays tribute to composer-vocalist Cathy Berberian's *Stripsody* (1966), which itself alludes to *Blam* (1962), *Whaam!* (1963), and other early paintings by Roy Lichtenstein – making Marclay's piece a deferred and circuitous response to Haubenstock-Ramati's suggestion that any painting might be treated as a graphic score.

Beginning with the early turntable compositions and improvisations, Marclay's work has always followed the logic of sampling and the remix, generating new material from old, insisting that every work is a remix that is itself perpetually open to remixing. Marclay's visual scores intensify this trajectory. In the case of these works, remixing takes place not merely in a single medium – from records to records, films to films – but across media, from photographs and films to musical performances. Furthermore, like any graphic score, they are structurally incomplete. As Umberto Eco put it in an early essay on musical indeterminacy, 'they are quite literally "unfinished": the author seems to hand them on to the performer more or less like components of a construction kit'.[16]

Screen Play (2005) provides a rich example. A thirty-minute montage of short clips from black-and-white films (home movies, adventure films, westerns, documentaries, educational films, etc.) periodically overlaid with simple graphic elements (coloured lines, dots, staves and wipes), *Screen Play* begins with the basic instruction: 'To be interpreted by a small group of musicians.' But how to interpret the score? The intermittent overlay of musical staves and visual metonymies suggests that the video might be read purely formally, the placement and movement of objects on the screen taken as indications of pitch, duration or rhythm. Yet the abundant visual cues of sonic events (crashing waves, footsteps, fireworks,

and the like) seem to direct performers to become Foley artists [sound-effect creators] whose aim is to supply the missing audio. More loosely, performers might simply compose or improvise a soundtrack, following the general movement and mood of the visual flow. Any or all of these strategies is possible, and in order to amplify differences among them, Marclay generally programmes three different ensembles to play the score on any given occasion. Each time, the film is given a different soundtrack, which, in turn, produces a different film.[17]

All these elements and interests come together in Marclay's masterpiece, *The Bell and the Glass* (2003). At once a stand-alone work of art and a visual score, this double-screen video projection presents the unlikely conjunction of two objects: the Liberty Bell and Marcel Duchamp's *Large Glass (The Bride Stripped Bare by Her Bachelors, Even)*. The two screens function like the turntablist's two decks, mechanisms through which fragments of all sorts are drawn into a mix. Discs, spirals, rotating drums, pulsing dots and phonographs appear on both screens throughout the video, references no doubt to the rotating objects and devices in the lower ('bachelor's') section of the *Large Glass,* but also visual allusions to Marclay's turntablist practice, which he launched in the late 1970s in a band with the Duchampian name, The Bachelors, Even.

Arranged vertically, the two screens in *The Bell and the Glass* also operate as the symmetrical staves of the traditional musical score: the lower ('bachelor's') half functioning as the bass clef, and the upper ('bride's') half as the treble. Instances of musical notation (three interviews with Duchamp that Marclay transcribed into staff notation; Duchamp's chance composition *Erratum musical;* and a collection of songs celebrating the Liberty Bell) appear throughout the video in the manner of *Shuffle,* as found musical material to be read by musicians. Indeed, the entire video is conceived as a graphic score, all its visual elements (images, texts, score fragments, etc.) aimed at provoking musical accompaniment to the video's existing sonic elements (Duchamp's voice; the ringing of souvenir Liberty Bells; overlaid string passages, etc.).

In two interview fragments that recur throughout the video, Duchamp gleefully refers to 'the breaks' in the *Large Glass,* the cracks caused in 1926 when the work was damaged during transport. Marclay keys in on this phrase, which becomes an organizing figure of his video, referring not only to the *Glass,* but also to the crack in the Liberty Bell that rendered it at once

iconic and mute. More broadly, 'the breaks' signifies the connection and disconnection between these two objects, the conjunction and disjunction between the visual and the sonic, and, by extension, between the visual cuts of cinematic montage and the auditory cuts of the turntablist's art, which – from disco, dub and hip hop through drum 'n' bass and dubstep – has largely consisted in isolating and extending what DJs call 'the breaks' or 'breakbeats', those sections of funk and rock songs during which the melody instruments drop out and the bass and drums come to the fore.

'The break', then, is the cut, line or bar that both conjoins and disjoins the two terms of an opposition: bride and bachelor, bell and glass, sound and image, phonography and photography, mass culture and high art, staff notation and graphic score. It is also, for Duchamp and Marclay alike, the caesura between past and future, between what the artist puts into the work and its indeterminate destiny. Reflecting on the accidental cracks in the *Glass,* Duchamp remarks, 'I like the breaks [...] There's almost an intention there [...], a curious intention that I'm not responsible for, a readymade intention, in other words, that I respect and love.' For it is his principle, he says elsewhere in the video, 'to accept any *malheur* as it comes'. This openness to chance, accident and any eventuality whatsoever defines the work of Duchamp and Cage, a lineage that Marclay makes his own. From his turntablist practice through his graphic scores, Marclay takes the readymade object as raw material for the generation of new work and affirms this fate of his own work as well, acknowledging that nothing remains fixed, that the future will always diverge from the past, and that, well, those are the breaks.

1 László Moholy-Nagy, 'Production-Reproduction' (1922) and 'New Form in Music: Potentialities of the Phonograph' (1923), in *Moholy-Nagy,* ed. Krisztina Passuth (London: Thames & Hudson, 1985) 289–90, 291–2, excerpted in *Audio Culture: Readings in Modern Music,* ed. Christoph Cox and Daniel Warner (New York: Continuum, 2004) 331–3.

2 My capsule history of audio recording draws substantially from Chris Cutler's helpful essay 'Necessity and Choice in Musical Forms', *File Under Popular: Theoretical and Critical Writings on Music* (New York: Autonomedia, 1993) 20–38.

3 The history of these experiments is helpfully chronicled in Cutler's 'Plunderphonia', *Audio Culture,* op. cit., 138–56.

4 Earle Brown, *Folio* (1952–53) and *4 Systems* (1954) (New York: Associated Music Publishers, 1961).

5 Roman Haubenstock-Ramati, 'Music and Abstract Art: Remarks on 'Constellations'' (1971), *Konstellationen* (Vienna: Galerie Ariadne, no date).

6 Quoted in John Holzaepfel, liner notes to *David Tudor and Gordon Mumma* (New World Records, 2006).

7 See my 'Lost in Translation: Sound in the Discourse of Synaesthesia', *Artforum* (October 2005) 236–41.

8 For different but related accounts of this correspondence between music and science, see Umberto Eco, 'Poetics of the Open Work' (1959), *The Open Work*, trans. Anna Cancogni (Cambridge, Massachusetts: Harvard University Press, 1989) 1–23; and Brian Eno, 'Generating and Organizing Variety in the Arts', *Studio International* (November/December 1976) 279–83. Both essays are reprinted in *Audio Culture*. My scientific account is also indebted to Ilya Prigogine and Isabelle Stengers' *Order out of Chaos* (New York: Bantam Books, 1984) and Prigogine's *The End of Certainty* (New York: The Free Press, 1997).

9 See John Cage, 'Composition as Process: Indeterminacy', in *Silence: Lectures and Writings by John Cage* (Hanover, New Hampshire: Wesleyan University Press, 1961) 35–40, and the introduction to *Themes & Variations* (Barrytown, New York: Station Hill Press, 1982), both reprinted in *Audio Culture.*

10 Iannis Xenakis, *Formalized Music: Thought and Mathematics in Composition* (Bloomington: Indiana University Press, 1971) 9.

11 John Cage, 'History of Experimental Music in the United States', *Silence*, op. cit., 69.

12 For a helpful overview, see David Toop, 'The Generation Game: Experimental Music and Digital Culture', *Audio Culture,* op. cit., 239–47.

13 Karl Marx, *Capital,* Volume I, trans. Ernest Mandel (New York: Penguin, 1990) 322–42, and passim.

14 '[R]ecorded sound is dead sound, in the sense that it's not "live" anymore', Marclay once told an interviewer. 'The music is embalmed. I'm trying to bring it back to life through my art.' Quoted in *Audio Culture, op. cit.,* 327.

15 For an exhibition at Exit Art in 2001, Marclay produced a companion piece to *Record Without a Cover*, a wall grid of 200 record covers, all copies of Herb Alpert's *Whipped Cream and Other Delights*. Another variation on Warhol, the display revealed not only production differences among the various copies but also differences due to wear and tear. See Christian Marclay, 'Herb Alpert's *Whipped Cream and Other Delights*', 'The Inner Sleeve' column, *The Wire*, no. 308 (November 2009) 77.

16 Umberto Eco, 'Poetics of the Open Work', op. cit., 4.

17 See 'Conversation between Christian Marclay and David Toop', *Arcana III: Musicians on Music,* ed. John Zorn (New York: Hip's Road, 2008) 144.

Christoph Cox, 'The Breaks', in *Christian Marclay: Festival*, vol. 3 (New York: Whitney Museum of American Art/New Haven and London: Yale University Press, 2010) 8–14.

Jean-Pierre Criqui
Image on the Run
2010

Music. – Makes one think of a great many things.
– Gustave Flaubert, *Dictionary of Received Ideas*

It would appear that 4 July 2005 was a rather fine, sunny day in the Hudson
Valley. Or at least, this is one of the banally circumstantial thoughts that come
to mind when looking at the photographs taken by Christian Marclay with
a 35mm camera on that particular day in Hyde Park, a small town known,
among other things, as the place where Franklin D. Roosevelt was born
in 1882. But even before they can begin to indulge in such inconsequential
remarks, the first thing to strike viewers of these images is their primary
characteristic: that they are not so much photographs in the traditional –
that is, rectangular – sense of the term, as fragments of torn photographs.
Never the sort to cultivate mystery where his working methods are
concerned, Marclay readily explains how he proceeded. He chose eight
of the views he had recorded at Hyde Park and made them into large-
format prints. He then tore these up, taking care to ensure maximum
variety in the size, configuration and figurative content of the fragments
thus obtained. One image was torn into four pieces, another into six,
two into seven and the last four into five, resulting in a total of forty-four
elements constituting the ensemble entitled *Fourth of July*. Two pieces
of one of the images torn in five are currently missing and should reappear
in the near or more distant future. Be that as it may, the current ensemble,
with the incompleteness due to these two lacunae echoing the dispersive
principle of the work itself, comprises only forty-two elements. That is
the ensemble being discussed here, and in relation to which I shall address
a number of questions touching on Marclay's art in general but also on
the considerable intertextual field in which *Fourth of July* is inscribed.

To tear is to unmake, to detach, separate and distance. In this sense,
the tear is a literally 'diabolical' act (*diabolos*, in Greek, means 'that which
disunites'), although this does not prevent it – when deliberate and applied,
moreover, to objects such as photographs – from carrying an obvious
symbolic charge that warrants further discussion. Another immediate

effect is that tearing makes something partially or wholly unintelligible. The torn object is to some extent constantly eluding meaning: its lack of unity is what keeps us at a distance, prevents us from 'being one' with it, as if we too had been pushed away by the tear. In the first of his *Blue Octavo Notebooks,* dated November–December 1916, Franz Kafka gives the title 'A Disjointed Dream' to a short paragraph in which each sentence, each proposition, although perfectly clear in itself, heightens the obscurity of the micro-narrative that they collectively adumbrate. The reader in turn feels torn: between different hypothetical readings, between different attempts to restore what may have been hidden from him. In *Fourth of July* Marclay rejects this kind of implicit rending and its misleading contiguity. On the contrary, he seeks to prevent any linking of the work's fragments, which he presents in highly scattered form in order to prevent the viewer from mentally stitching together any of these tatters of images that have been cut loose. From this point of view, the logic of the work is contrary to that of a jigsaw puzzle, which is all about putting the pieces together (a piece from a jigsaw is of no interest in itself; its semantic and visual autonomy is nonexistent). Assembling, recomposing the original unity, which is the basic principle of the jigsaw puzzle, and is what ensures the eventual satisfaction of the person doing it, has no place in *Fourth of July,* for even if by some acrobatic process one managed to recompose some of the initial images, the result would not produce any significant augmentation. Marclay does not offer us the chance to 'put the pieces back together': no, his aim is not reconciliation, but very much destruction.

To tear, then, is of course to destroy, which in modern art has often represented another way of creating. Assuming the role of a kind of Dante of the Negative, Stéphane Mallarmé wrote strikingly in a famous letter to his friend Eugène Lefébure, dated 27 May 1867, that in his work 'Destruction was my Beatrice'. From Mondrian to Giacometti, and on to Gustav Metzger and Michael Landy, many artists have, in a thousand different ways, taken this salutary path of destruction, and it is clear that Marclay, if only because of the neo-punk roots of his early days, is very much a part of this tendency.[1] However, before examining more precisely the way in which this destructive impulse runs like a powder trail throughout his work, we should first consider the role it plays in *Fourth of July.*

What makes someone tear up a photograph? Much more than a common artistic procedure (which it is not, even in the context of the different

iconoclastic strategies adopted by the avant-gardes), this action is usually
linked to renunciation, to some personal upset: a betrayal of friendship,
heartache or another form of personal disappointment. This tearing
therefore implies that the person who performs it is himself torn, while
at the same time giving vent to a kind of anger or protest, or even desire
for revenge – and here the symbolic dimension comes fully into play,
touching on the almost magical character that the photograph has always
had as a fetish (even if this quality cannot be and is not acknowledged).
However minimal it may seem, such an action still testifies to a potential
violence that might become extreme, a violence to which it serves as
substitute or outlet. (With his usual irony, Jules Renard noted this in his
Journal on 29 December 1888: 'So many people wanted to kill themselves,
but made do with tearing up their photograph!'). In the case of *Fourth of
July,* in which the size of the prints surely implied a very deliberate form of
violence when tearing them to pieces, Marclay, it seems to me, is attacking
three main targets.

The first, which is evident even in the title of the work, is a certain kind
of American patriotism that, back in 2005, was embodied at the summit of
the state by figures one might hesitate to describe as glorious. By choosing,
on that national holiday, to travel to the birthplace of an American president
(and a rather distinguished one, at that), a town located in a region that
itself played a decisive role in the War of Independence, and by then
tearing up the images of the celebrations that he had just witnessed,
Marclay – who, we should remember, was born in California – was taking
a perfectly explicit political position, one that in some sense resonates with
the attitude of those people who, in other times, tore up their passport or
burned the flag. The second target aimed at by this work is music. Not only
'God Bless America' or 'This Land is Your Land', the pieces played on that
particular day by the performers who are torn into fragments by *Fourth
of July,* but also music in general, as a cultural and aesthetic phenomenon,
at once an object to be destroyed and a permanent source of inspiration
around which Marclay's work has revolved ever since he first began. It can
also be noted in passing that, among all the echoes we may detect here, the
motif of the brass band brings to mind Charles Ives, that experimenter of
genius who loved popular music as much as he did high cultural innovation
(and also surprising mixtures of the two). More precisely, we may recall
the third movement of his *A Symphony: New England Holidays,* composed

in 1904–13, and entitled 'The Fourth of July'. Finally, the third target I am alluding to is of course photography itself: the photograph. The photograph as an object, first of all, that sheet of paper which is irremediably attacked and altered. And then there is photography as a medium, the reproducibility of which is unanswerably contravened by the tear. Behind this reduction of each fragment to a unique image looms a critique of a certain type of photography that emerged quite recently but is already on the wane: smooth, intact, grandiose and endlessly marketable.

Looking at the jagged images of *Fourth of July* (only three of them still have two right angles, and a good number don't have any, although all do at least have one straight side), the predominant effect is of zooming in, of incompleteness and an emphasis on detail. We can see that in tearing his images Marclay in a sense amplified or, so to speak, exacerbated the framing operation that is part of taking any photograph. A photograph can exist only on the condition that it separate itself from an out-of-frame space which it simultaneously cancels and invokes. These fragments emphasize the fact: a photograph hides as much as – if not, strictly speaking, more than – it shows. Hence the fact that, in personal, private use, it so often represents a memory or promise of happiness; hence too, perhaps, the inevitable melancholy that clings to it when the person represented is no longer with us. With all the caustic excess that is its author's trademark, Thomas Bernhardt's novel *Extinction*, which indeed features a torn photo, makes several references to this profoundly illusory joy of photography:

> I wonder why it is that when people have themselves photographed they always
> want to look happy, or at any rate less unhappy than they are. Everybody wants
> to be portrayed as happy, never as someone unhappy, always as someone who
> is completely false, never as what he is in reality, that is, the image of the unhappy
> person he is. Everybody wants to be portrayed as good-looking and happy, when
> in fact they are ugly and unhappy. They take refuge in the photograph, they
> deliberately shrink into the photograph, which, completely falsifying things,
> shows them as happy and good-looking, or at least, less ugly and less unhappy
> than they are. What they demand of the photograph is an ideal image of
> themselves, and they will agree to anything that produces this ideal image,
> even the most dreadful distortion. [...] We lived in two worlds, I told Gambetti:
> in the real world, which is sad and crude and, in the end, deadly, and in the
> photographed world, which is false throughout but, for most of humankind,

the world they wish for, the ideal world. Today, if one took photography away
from man, if one tore it off his walls, I told Gambetti, and if one destroyed it
once and for good, one would be taking away almost everything. It can therefore
logically be said that humankind cares for nothing, is interested by nothing and,
ultimately, depends on nothing except photography.[2]

Like literature, but no doubt more significantly where Marclay's work is
concerned, since he regularly takes his material from cinema (here we may
think of *Telephones*, 1995, *Video Quartet*, 2002, and *Crossfire*, 2007), a fair
number of films contain at least one scene involving a torn photograph. I
shall mention only a few dating from the 1960s and 70s, which I invoke here
because of their undeniable quality, in order to give an idea of the diversity
of the field. In Bergman's *Persona* (1966) Elizabeth (Liv Ullmann), an actress
who has suddenly lost her ability to speak and is being treated in a clinic/
convalescent home, is sent a photograph of her son, which is given to her by
the nurse who will soon become her alter ego (Bibi Andersson). She shoots
a brief glance at the nurse and then tears it in two, starting at the top. In
Model Shop (1968), the only film made in America by Jacques Demy (offering,
by the way, a magnificent sequence of drives through Los Angeles), George,
the male protagonist, played by Gary Lockwood, brings home the photographs
that he is paid to take of Lola (Anouk Aimée, here continuing the fictive life
of the Lola who gave her name to Demy's first feature film). His girlfriend
Gloria (Alexandra Hay) eventually finds them together in their bedroom. She
flies into a fit of rage, tears up the images of Lola and throws them onto the
floor before storming out. *L'Amour en fuite (Love on the Run,* 1979) is the film
that closes François Truffaut's Antoine Doinel cycle (with Jean-Pierre Léaud
in the lead role). The motif of the torn photo is deceptively repeated here,
in that spectators initially believe that it is the hero of Doinel's novel, 'The
Manuscript Found by a Nasty Kid',[3] who picks up the pieces of a torn photo
of a woman in a phone box and, having patched it together with sticky tape,
immediately falls in love with her. We later realize that this is in fact what
happened to Doinel himself, and that this is how he came to have a
relationship with Sabine (Dorothée). After various ins and outs, the film
ends in the record store where she works and we hear the song written for
the film by Alain Souchon, celebrating the victory of union over disunion:
'You can throw it all away/The moments, the photos, the books/There
is always clear tape/To put all your torments back together again.'

A long way from this soothing idyll, Samuel Beckett's *Film,* made
in 1964 with the collaboration of Alan Schneider, had already proposed
two scenes in which the theme of the torn photograph is taken to its violent,
unsurpassable extreme. Taking refuge in a gloomy room and trying to
rid himself of what we might call his 'perceptual anxiety', O – for 'object',
played by Buster Keaton – begins by tearing up a print that was pinned on
the wall (the image of 'God the Father', no less, as Beckett points out in his
script – as it happens, the reproduction of a Sumerian statuette of an 'Orant'
[a devotional figure with arms outstretched] from the Temple of Abu at Tell
Asmar). The four pieces fall to the floor; O tramples on them. A little later,
sitting in a rocking chair, he pulls out of his briefcase seven photos showing
him at different times of his life, alone or with his family, examines them
and then tears them up. Now only he is left and, as Deleuze points out,
'now he has nothing but the present in the form of a hermetically sealed
room in which all ideas of space or time, all divine, animal or human
images, all images of things have disappeared. All that remains is the
Rocking Chair in the centre of the room, because, more than any bed,
it is the sole piece of furniture that exists before or after man, that which
suspends us in the middle of nothingness (to and fro).'[4] The only thing left
for O to do is die, which he soon does.

Because its mode of figuration is based primarily on *dis*-figuring, *Fourth
of July* is related to the many iconoclastic practices that, over the ages, have
manifested their belief in the powers of art and representation in the form
of destruction.[5] That, one could say, is its anthropological, extra-artistic
or even anti-artistic dimension. Indeed, it goes without saying that such a
work inevitably evokes more or less similar actions performed by countless
artists over the last century (taking, as our conventional starting point, the
papiers collés and collages of the Cubists). Arp, Ellsworth Kelly, Sol LeWitt,
to mention only these three, used torn paper, often combined with the
workings of chance, in order to circumvent the constraints of composition.
As for *décollage,* Raymond Hains, Jacques Villeglé and others after them
took an interest in tattered posters, those sublime wrecks from contemporary
public space whose fortuitous beauty they revealed. However, as we have
noted, *Fourth of July* stands apart by virtue of the radical physical autonomy
accorded to each of its elements, which could very easily be exhibited
individually, since the ensemble no more constitutes the work as such than
do any of its subsets (Marclay even asked his galleries to ensure that no two

fragments of the same image found their way into the same collection). This trait would appear to be fairly unusual, which is somewhat surprising. (To tell the truth, although this no doubt is due only to a lack of information or of doggedness on my part, I have yet to come across another work of art that is typologically identical to this one, that is to say, a torn fragment of a photograph, with no additions, presented on its own. Having said which, in the end this is only a secondary issue.)

'Many of the works of the Ancients have become fragments. Many modern works are fragments as soon as they are written.'[6] These two sentences constitute the full text of a fragment published anonymously in 1798 in the *Athenaeum,* the short-lived journal put out by the Jena group formed around the brothers Friedrich and August Wilhelm Schlegel, and of which Novalis was also a member. The first Romantics thus inaugurated the idea of the intentional fragment, as opposed to the simply accidental one. Before them, the *disjecta membra,* the scattered limbs of a metaphorical, textual or material body, dispersed by the ravages of time and men, had been considered only in terms of a loss to be regretted, a vanished grandeur of which all that remained, from Ancient Greece and Rome, were incomplete bits – in a word, ruins. At the turn of the twelfth century Hildebert of Lavardin, the bishop of Le Mans, spoke of the lost splendour of Rome in words that have become a ritual formula: 'Roma quanta fuit ipsa ruina docet' (How great Rome was the ruins themselves tell us). In contrast to this nostalgia for the whole, the modern fragment 'designates the edges of the fracture as an autonomous form, as much as the informity or the deformity of the tear'.[7] And the whole thing, as Adorno wrote in *Minima Moralia,* itself one of the finest collections of fragments produced in the twentieth century, would end up being just the 'untrue'.[8] Hence the paean to the ruin for its own sake, and the taste of modern artists for pseudo-fragments, especially in sculpture (as in Rodin and Brancusi).

The Romantic poetics of ruins, of which Byron's poem *Childe Harold's Pilgrimage,* published in 1818, contains one of the first substantial literary examples, reaches its most striking postmodern culmination in 1967, with the 'report' made by Robert Smithson in his hometown of Passaic. Published in *Artforum* in December that same year, under the title (abridged by the magazine) 'The Monuments of Passaic', this text illustrated by the author's photographs relates, in a somnambulistic manner that we find again in Smithson's account of his journey to Yucatan,

a visit to that small town in New Jersey and a tour of its 'monuments': the bridge, the pumping derrick, the sandbox, the 'fountain monument' with open-air pipes spewing out sewage, etc. This is a landscape dotted with 'ruins in reverse', as Smithson himself puts it: 'That zero panorama seemed to contain *ruins in reverse,* that is – all the new construction that would eventually be built. This is the opposite of the "romantic ruin" because the buildings don't *fall* into ruin *after* they are built but rather *rise* into ruin before they are built.'[9] In the form of these very prosaic (very un-artistic) views, photography here backs up – and in reality rehearses the principle of – an 'entropic' conception of the contemporary monument, that is to say, of the certain failure of any aspiration to the monumental. A little later, Barthes allowed it an equivalent role when he observed that 'Earlier societies managed so that memory, the substitute for life, was eternal, and that at least the thing which spoke Death should itself be immortal: this was the Monument. But by making the (moral) Photograph into the general and somehow natural witness of "what has been", modern society has renounced the Monument.'[10]

Like Smithson, Marclay is not at all a photographer in the strict sense of the term, but an artist who ranges freely across mediums and for whom, as for anyone else, photography and photographs can perform many different functions (found object, possibly filed away for future use; an everyday personal practice a bit like a memo or notebook). His visit to Hyde Park is reminiscent of Smithson's to Passaic in that the images he brought back have no aesthetic value in themselves (Marclay would certainly not have exhibited them simply as they were). To make his images of Passaic truly effective, Smithson, the local son, had to insert them into a hyperbolic device in the form of a magazine article 'glorifying' the most dispiriting aspects of suburban life. To make his work, the author of *Fourth of July* had to tear up his prints, deliberately convert them into ruins, into anti-monuments or 'backward icons' that refused to elevate what they registered to even the slightest degree. Concerning the two artists' respective relations to photography, it is worth recalling that a little-known work by Smithson, *Torn Photograph from the Second Stop (Rubble), Second Mountain of 6 Stops on a Section* (1970) consists of a print torn into four pieces of recognizably similar sizes that have kept their external right angles – their corners. Unlike the fragments of *Fourth of July,* those of *Torn Photograph* are displayed as a unit, only an inch or two apart from each other, so that

the original image is not lost (this work is, moreover, a multiple: the artist tore up a number of prints of the same image, with the inevitable result that there are slight variations in their appearance). But the allegorical intention that appears to have been behind this work is also worth emphasizing in relation to *Fourth of July*, where something analogous can be observed. Robert Hobbs has summed it up thus: 'The ripped photograph of the "Second Stop" is a snapshot of a small section of earth blown up to life size. Symbolically, it can be equated with tearing the earth itself, and with Smithson's later sequence in the film *Spiral Jetty*, titled "Ripping the Jetty", in which the giant tooth of a plough, ominously resembling a giant phallus, gouges the earth'.[11]

Whatever their specific symbolic potential, the fragments of *Fourth of July* are evidence of Marclay's continuing attraction, observable in his earliest work, to fractures, lacunae, faults, scratches and all kinds of other forms of damage, whether deliberate or accidental. They partake of an aesthetics of the accident that consists in inverting the negative value commonly attached to a damaged object in order to make this feature the source of whatever interest it may acquire. Here, damaged or broken means 'good' (the French expression, 'ça ne casse rien' – literally, 'that doesn't break anything' – means that something is of little interest). Music, the substance of representation as well as the aural phenomenon, has provided the privileged field for Marclay's arsenal of destruction. *Fast Music,* from 1981, shows him taking big bites out of an old 33-rpm LP, the edge of which grows jagged like a geographical map. In *Record Players,* a performance given in 1982 at the Kitchen, New York, vinyl records were shaken, rubbed, scraped and hit – literally 'played' in rhythm – by the participants who thus made them produce different sounds before breaking them into pieces, throwing them on the floor and trampling on them. In the same year Marclay developed his *Phonoguitar,* a turntable that he could sling over his shoulder, enabling him to scratch records while copying the gestures of rock guitarists (such as the ones that heavy metal lovers admiringly call *shredders*). *Record Without a Cover* (1985), on the surface of which we read the words 'Do not store in a protective package', is like a portable reminder of the artist's love of scratches and all those other forms of surface damage that he exploits with great regularity in his work as a performer, sometimes even going so far as to break the records he is using (*The Spit,* Boston, in 1985). In 1990 a series of photograms on

photographic paper, entitled *Broken Record,* recorded in two dimensions the various ways of breaking and their resulting configurations. Another sign of his interest in the disc as ruin, Marclay's 'Snapshots' from the 2000s show vinyls and CDs, or rather the remains thereof, left on the ground or thrown into the gutter.

Marclay is the artist who really picked up on the endless visual richness of the record cover as a working material. Here, once again, the object is given a rough ride, but the violence of the actions is leavened by a kind of wit. In *Fire* (1990), the flames on the cover seem to have become real so as to destroy the lower edge of the sleeve, which has indeed been burned. *Mort* (1992), one of his most powerful *Imaginary Records,* sets about a Mozart cover, tearing out the central third so that the 'z' and the 'a' disappear from the name, along with most of the composer's portrait (one thinks of a kind of second, unfinished or incomplete Requiem). In 1994 it was an album by the group The Tubes that gave rise to a virtuoso visual pun: the highly effective *trompe l'oeil* of the original cover, showing two woman's hands tearing a sleeve to reveal the vinyl inside, is itself torn so as to reveal another part of the record, the real one, which extends the image. Echoing Pop art and its sources, in a recent series Marclay turned towards the cartoon and its onomatopoeias, thereby adding a new chapter to his exploration of the visual representations of sound. Once again, tearing was his key modus operandi, and a solitary fragment like *Krak!* (2007) does to some extent recall *Fourth of July* ('What was that sound?' could indeed be considered as the question put to us by nearly all his works). Finally, I cannot end this quick and very fragmentary overview without mentioning, in the register of allegory as well as destruction, *Guitar Drag* (2000), in which we witness the 'execution' of a Fender guitar plugged into an amplifier and dragged behind a truck (driven by Marclay himself) along a small road in Texas, not far from the place where an African-American named James Byrd Jr. was lynched in the same way, only two years before.

The grandeur of *Fourth of July* is bound up with the means used by Marclay to declare the independence of his photos. By tearing them up and making each of the elements thus produced an irreducible, irreconcilable fragment, he has endowed them with a symbolic power superior to any approximation of a whole that is by definition impossible and mendacious – the whole of photography, of the event that it has recorded, of the history that it commemorates. And because they always escape us along one side

or another, because they are perpetually fugacious, these images compel
us and we store them in our memory.

1 Although it doesn't mention any names, and does not even allude specifically to art, the
 short essay published by Walter Benjamin in 1931, 'The Destructive Character', remains
 an invaluable resource for thinking about this question. For example, Benjamin writes,
 'The destructive character stands in the front line of traditionalists. Some people pass
 things down to posterity by making them untouchable and thus conserving them; others
 pass on situations, by making them practicable and thus liquidating them. The latter are
 called the destructive. [...] The destructive character sees nothing permanent. But for this
 very reason he sees ways everywhere. Where others encounter walls or mountains, there,
 too, he sees a way. But because he sees a way everywhere, he has to clear things from it
 everywhere. Not always by brute force; sometimes by the most refined. Because he sees
 ways everywhere, he always stands at a crossroads. No moment can know what the next
 will bring. What exists he reduces to rubble – not for the sake of the rubble, but for that of
 the way leading through it.' 'The Destructive Character', trans. Edmund Jephcott, in *Walter
 Benjamin: Selected Writings. Volume 2: 1927-1934* (Cambridge, Massachusetts: The Belknap
 Press of Harvard University Press, 1999) 542. Regarding tearing, Georges Didi-Huberman
 has for at least twenty years now been developing a concept of the tear or rend (*la déchirure*)
 as a constitutional dysfunction of imagined representations. See, among others, his books
 Confronting Images: Questioning the Ends of a Certain History of Art (University Park,
 Pennsylvania: Penn State University Press, 2005), chapter 4: 'The Image as Rend and the
 Death of God Incarnate') and *La Ressemblance informe, ou le Gai Savoir visuel selon Georges
 Bataille* (Paris: Macula, 1995), chapter 1: 'Thèse: ressemblance et conformité. Comment
 déchire-t-on la ressemblance?')
2 Thomas Bernhard, *Extinction* (1986), trans. David McLintock (New York: Alfred A. Knopf,
 1995) 64. The episode of the torn photograph occurs early on (page 12) and concerns an
 image of the narrator's brother: 'He has a forced smile, as they say, and only his brother
 – only I – could have taken that photo. When I gave him a copy of the photo, he tore it up
 without a word.'
3 The original French title, 'Manuscrit trouvé par un sale gosse', punningly evokes the title
 of the novel *Le Manuscrit trouvé à Saragosse*, which was made into a film (*The Saragossa
 Manuscript*) by Wojciech Has in 1965. Jan Potocki (1761-1815), the author of the novel,
 was (like the film director) a Pole, but wrote in French.
4 Gilles Deleuze, 'The Greatest Irish Film' (Beckett's "Film")' (1986), trans. Michael A.
 Greco and Daniel W. Smith, in *Gilles Deleuze: Essays Critical and Clinical* (London and
 New York: Verso, 1997) 25.
5 There is an abundant corpus of texts on iconoclasm. Among recent studies, there are many
 illuminating analyses and references to be found in the following two books: Philippe-Alain
 Michaud, *Le Peuple des images. Essai d'anthropologie figurative*, chapter 2: 'Images en pièces.
 Figures du premier iconoclasme byzantin (726-787)' (Paris: Desclée de Brouwer, 2002);

and Valentin Groebner, *Defaced: The Visual Culture of Violence in the Late Middle Ages*, trans.
P. Selwyn (New York: Zone Books, 2004).

6 See 'Fragments de l'Athenaeum', in Philippe Lacoue-Labarthe and Jean-Luc Nancy,
 L'absolu littéraire. Théorie de la littérature du romantisme allemand (Paris: Éditions du Seuil,
 1978) 101, fragment no. 24 (translation by the authors in collaboration with A-M. Lang).
 Both a study and an anthology, this book is an essential contribution to understanding
 the foundations of the modern aesthetic.

7 Ibid., 62. English translation, Friedrich Schlegel, *Philosophical Fragments*, trans. Peter
 Firchow (Minneapolis: University of Minnesota Press, 1991) 21.

8 'The whole is untrue.' Theodor W. Adorno, *Minima Moralia: Reflections from Damaged Life*
 (1951), trans. Edmund Jephcott (London: Verso, 1978). This fragment reverses Hegel's
 famous formula in the *Phenomenology of Spirit*: 'The Truth is in the Whole.'

9 Robert Smithson, 'A Tour of the Monuments of Passaic, New Jersey' (1967), in Nancy Holt,
 ed., *The Writings of Robert Smithson* (New York: New York University Press, 1979) 54.

10 Roland Barthes, *La Chambre claire* (1980), trans. Richard Howard, *Camera Lucida:
 Reflections on Photography* (New York: Hill & Wang, 1982) 93.

11 See Robert Hobbs' entry on *Six Stops on a Section* (1968), in Robert C. Hobbs, ed., *Robert
 Smithson: Sculpture* (Ithaca, New York: Cornell University Press, 1981) 122. Lee Ranaldo,
 one of the guitarists of Sonic Youth, has given us a variation on Smithson's *Torn Photograph*
 entitled *Four Organs (For Steve Reich and Robert Smithson)*. It consists of a photo, clearly torn
 in four, of the Farfisa organ used by Reich for his composition *Four Organs*.

Jean-Pierre Criqui, 'Image on the Run', in *Christian Marclay: Fourth of July* (New York: Paula
Cooper Gallery, 2010) n.p.

Rosalind Krauss
Clock Time
2011

Christian Marclay is a hold-out against the eclipse of the medium. This
requires that he embed his work in what I elsewhere term a 'technical
support'.[1] (If traditional art required artisanal supports of various kinds –
canvas for oil painting, plaster and wax for bronze casting, light-sensitive
emulsion for photography – contemporary art makes use of technical
supports – commercial or industrial products – to which it then makes
recursive reference, in the manner of modernist art's reflex of self-
criticism. For Marclay, this technical support is commercial sound film,
from which he has extrapolated that process into pure synchronicity.
Earlier, this was to be found in his focus on sync-sound in the use
of mostly Hollywood films for his masterful *Video Quartet* (2002).

An anthology of film clips joined top-to-bottom, *Video Quartet* runs four
loops of clips from commercial sound films on four DVD screens, spaced
out along a wall. Sometimes the synchrony is visual, as circular forms
(phonograph turntable, roulette wheel, trumpet rim) play simultaneously
across the visual field. At other times, Marclay seems intent to contrast
sound and silence, a historical divide over which sound jumped in 1929
to turn movies into talkies. At such points, it is the very era of *silence* that
Marclay ambitiously wants his viewers to *see*. How to do this is not obvious,
but one electric moment presents cockroaches spilling onto a piano keyboard
and scurrying over it (soundlessly, of course).

The Clock (2010), Christian Marclay's latest work, is also a compilation
of film clips – fragments of commercial films, joined end-to-end. Projected
in video on a wall as a segmented twelve by twenty-one foot image, *The
Clock* selects fragments in which the dials of wristwatches and large free-
standing clocks figure prominently. Doubling this temporal focus, *The
Clock* stretches over twenty-four hours of audience and projected time.[2]

Marclay has turned to pure *synchronicity* as the undeniable support
for post-1929 film and thus for cinema itself. This is easy to see in *Video
Quartet*'s exercise in sync sound. In *The Clock*, we confront what must
be called another of the underlying conditions of film – sync time: which
is to say, projection at twenty-four frames a second, synchronized with

the psycho-physiological facts of optics, as the retinal production of the after-image from one frame's visual stimulation slides invisibly into the next. The illusion of movement overrides the film frame's appearance, creating the visual slippage we call the 'movies'.

This explanation by way of the after-image, called the 'phi-effect', has become controversial of late, making the synchronization between projected frames and the physiological optics of viewing problematic. Recent research on the 'intermittent reperfusion' on the brain supports the reality of the 'phi-effect', however, even in the relatively smooth unrolling of video.[3]

The Clock's sync-time joins audience and screen in the manner of what film scholars call interpellation, after Althusser's 'Ideological State Apparatuses', as the subject 'recognizes' himself as the addressee of a command, thus identifying with the commander himself; for Laura Mulvey, classical narrative cinema positions female viewers to identify with the male protagonist. In film, this recognition, or identification, causes the viewing subject to suffer a passivity that results in her being woven into the weft of the film's movement, as the swivelling camera or shot/reaction-shot editing lifts the viewer imaginatively off her seat to join the sides of the projected actors. At the very outset of cinematic editing, Vsevolod Pudovkin conserved scarce film stock in the post-revolutionary Soviet Union by interspersing pre-recorded scenes with cut-aways to an actor's expressionless face, thereby creating the illusion of someone acting out pity, horror, anguish. These cut-aways perform another act of interpellation, synchronizing observers in the audience with the temporal unfolding of events in the film.

Marclay's *The Clock* exploits the cut-away as its 'plot' unfolds through the sights of the dials displayed on clocks and watches, and the reaction shots of horrified characters in the film clips Marclay anthologizes into his own work. It doesn't take long before members of the audience glance at their watches and realize that the precise moment displayed on the screen matches the moment registered on their own wrists. Marclay's plot gears itself into that of the film clips he uses, in which characters anticipate a catastrophe that will be unleashed at a certain moment: a bomb's explosion, a missile's strike. We recognize Sean Connery, Charlie Chaplin, Steve McQueen, Gregory Peck, but unlike the temporal arcs that produce the plots of *Dial M for Murder*, or *Strangers on a Train*, the suspense unreeling inside the screen is not synchronized with the suspense unfolding

in the viewer's real time. In another twist on this, Annette Michelson has characterized Michael Snow's *Wavelength* (1967) as the very distillation of suspense:

> And as the camera continues to move steadily forward, building a tension that grows in direct ratio to the reduction of the field, we recognize, with some surprise, those horizons as defining the contours of narrative, of that narrative form animated by distended temporality, turning upon cognition, towards revelation. Waiting for an issue, we are 'suspended' towards resolution.[4]

Snow's resistance to editing, except for several cuts and splices, allows for an extended zoom to pass through space, ignoring the body that crashes to the floor – the presumed object of the film's 'suspense'. The near continuity of the cinematic zoom enforces the viewer's perception that *Wavelength* can only continue for the length of a 16mm reel of film, synchronizing the 'suspense' time on the screen with his own perceptual experience, in his seat.

On all of these fronts, *The Clock* explores synchronous time, a *tour de force* in the 'invention' of a technical support and, consequently, a new medium.

Post-structuralism, in the form of Jacques Derrida's *Speech and Phenomena*, a critique of Husserl's own critique of structuralism in his *Logical Investigations*, focuses on the 'now' effect of Husserl's dismissal of structural linguistics, with its division of subjective experience into consciousness and representational sign. He quotes Husserl as saying, '"consciousness" means nothing other than the possibility of the self-presence of the present in the living present', and consequently:

> In inward speech I communicate nothing to myself because there is no need of it. The existence of mental acts does not have to be indicated because it is immediately present to the subject in the present moment.

Derrida insists on this effect of 'self-presence', this indivisible 'now-effect', as pure fiction, or myth. He writes, 'It is a spatial or mechanical metaphor, an inherited metaphysical concept.'[5]

The Clock's simultaneity, enacted by the synchronous gearing of reel time into real time, flirts with Husserl's desire for the self-present instant, the revelation of self-presence in the 'now-effect'. Derrida's critique of the idea of synchrony is explored as well in 'The Double Session', where

he emphasizes the line in Mallarmé's essay 'Mimique', characterizing the mime's performance as '*the false appearance of the present*', which Derrida will celebrate as overthrowing the idea of synchronic *self-presence*, and consequently of the very specificity of an object-in-it*self*.[6] It is the strength of those contemporary artists who want to explore the dimensions of a specific medium, in *itself*, that they put Derrida's strictures behind them. Marclay manages this by turning to *suspense* as the extended dilation of the 'now effect', transforming the reel time of film into the real time of waiting.

1 See 'Two Moments from the Post-Medium Condition', *October*, no. 116 (Spring 2006) and '*A Voyage on the North Sea*': *Art in the Age of the Post-Medium Condition* (London: Thames & Hudson, 1999).

2 My thanks to Malcolm Turvey for his reading and helpful critiques of this essay.

3 Research at the Thoralf M. Sundt Jr. Neurosurgical Research Laboratory, Mayo Clinic, and Mayo Graduate School of Medicine, Rochester, Minnesota, 1995.

4 Annette Michelson, 'Toward Snow' (1971), in *The Avant-Garde Film: A Reader of Theory and Criticism*, ed. P. Adams Sitney (New York: Anthology Film Archives, 1987) 175.

5 Jacques Derrida, *Speech and Phenomena* (1967), trans. Newton Garve (Evanstown: Northwestern University Press, 1973) 62.

6 Jacques Derrida, 'The Double Session', *Dissemination* (1972), trans. Barbara Johnson (Chicago: University of Chicago Press, 1981) 200.

Rosalind Krauss, 'Clock Time', *October*, no. 136 (Spring 2011) 213–17.

Zadie Smith
Killing Orson Welles at Midnight
2011

It's two in the afternoon. No one is groaning; no one turns over in bed
or hits an alarm clock – it's much too late for that. *Love set you going like
a fat gold watch* ... But by two o'clock the morning song is just a memory.
We are no longer speculating as to what set us going, we just know we are
going. We are less sentimental in the afternoon. We watch the minute
hand go round: 2:01 becoming 2:02 becoming 2:03. It's mindless, when
you think about it. Mostly we don't think about it. We're very busy, what
with everything that's going on. The foreign schoolchildren have already
left for the day, a burly gentleman is having his tea in a glass, Billy Liar is
being asked 'What time d'yer call this?' (seventeen minutes past two), and
Charlotte Rampling is all by herself eating chocolate eclairs and smoking,
in a garden somewhere, in France, probably.

There's no slowing it down and no turning back: the day is too far along
to be denied. Though some will try, some always do. At two o'clock precisely
a man screams at a grandfather clock ('That'll be enough of that!') and
smashes it to pieces. But the day continues. It always does. The Japanese –
a pragmatic people, a realistic people – deal with the situation by having
a meeting at a long white conference table. Faced with the same reality,
we in the West tend to opt for a stiff drink instead. But people will insist
upon shooting us sideways glances and saying things like 'It's two o'clock
in the afternoon!' and so we put down our glasses and sigh. The afternoon
– free from the blur of hangover or the fug of sleep – is when our shared
predicament on this planet becomes clear.

Coincidentally, the afternoon is also the time when many people will
first go to see Christian Marclay's *The Clock*. Not too early, just after lunch.
After all, it may be good, it may be bad – you don't want to lose a whole
morning over it. But very soon, sooner than you could have imagined – in
fact at exactly 2:06, as Adam Sandler patronizes a Spanish girl – you realize
that *The Clock* is neither bad nor good, but sublime, maybe the greatest film
you have ever seen, and you will need to come back in the morning, in the
evening, and late at night, abandoning everything else, packing a sleeping
bag, and decamping to the Paula Cooper Gallery until sunrise. Except:

Christ, is that the time? Oh well. Come back tomorrow.

The things you notice on a second visit are quite small but feel necessary for orientation, like drawing an x and y axis before attempting to plot a great mass of information on a graph. In my notebook I tried to state the obvious, to get it clear in my own mind. *The Clock* is a twenty-four hour movie that tells the time. This is achieved by editing together clips of movies in which clocks appear. But *The Clock* is so monumental in intention and design that even the simplest things you can say about it need qualification. There isn't, for example, a clock visible in every scene. Sometimes people will only mention the time, or even just speak of time as a general concept. Mary Poppins does less than that; she glances at her wristwatch, the face of which we cannot see, then opens her umbrella and flies, to be replaced, a moment later, by a man, also flying with an umbrella, who soon floats past a clock tower, thus revealing the time. There are many moments like this, and when you first notice them their synchronicity and beauty are a little unnerving. They reveal a creative constraint even larger and more demanding than the one you had assumed. If *The Clock* cares to match a flying umbrella with a flying umbrella, it must have aesthetic currents passing beneath its main flow, moving in a variety of directions, not simply clockwise.

You sit in the dark, trying to figure out *la règle du jeu.* Clearly there are two types of time, real and staged. There are a few ways to say that. Accidental clocks versus deliberate clocks. Time that has been caught on film versus time that has been manipulated for film. It turns out that accidental clocks are more poignant than deliberate clocks. The actors in the street valiantly approximate reality, but the clock tower behind them has captured reality, a genuine moment in time, now passed forever, unrecoverable, yet reanimated by film. It really was 3:22. 3:22 would have happened, whether it was filmed or not, and consequently this moment feels unvarnished, unmanipulated, true. By contrast, staged time obeys certain conventions. Afternoon sex is the sexiest, probably because it often involves prostitutes. Between four and five o'clock transport is significant: trains, cars and aeroplanes. If the phone rings after one in the morning do not expect good news. Cuckoo clocks, no matter when they chime, are almost always ominous. When Orson Welles says what time it is, it lends the hour an epic sound. At two a.m. everyone's lonely.

A few clips are anticipated and people applaud when they arrive. Christopher Walken in *Pulp Fiction* with his father's watch up his ass.

Big Ben exploding. These are meta-clips, because their clocks were already notorious. Embedded in *The Clock,* all kinds of run-of-the-mill cinematic moments become profound or comic or both. A comment as innocuous as 'I just don't have the time' reduces the audience to giggles. Very unlikely people become philosophers. Owen Wilson, speaking to himself: 'You're about to die. You're on the minute hand of a clock.' Marisa Tomei, in a rowboat: 'Time is a relative thing ... an emotional thing!'

Other tendencies are more obscure and may be your own solitary delusion. Watching *The Clock* is a trance-like experience, almost hallucinogenic: you're liable to see things that aren't there. For instance, isn't it the case that the charm of certain actors is so overwhelming that they seem to step out of the time of the concept? To operate outside it? When Paul Newman lifts his foot onto the bed and ties his shoe and smiles, you find you are no longer waiting for the next clock. You settle in to watch a Paul Newman movie. And when the inevitable cut comes, a sigh passes through the gallery. Is that what people mean when they speak of 'star quality'? The ability to exist outside of time? (This side effect happened rarely, and didn't seem connected to relative fame. Nobody sighed when Tom Cruise came and went.) Repetitions occur, and appear to be meaningful. If we see a lot of James Bond and Columbo it is because time, *staged time,* is their natural milieu. Fake clocks drive their narrative worlds: countdowns and alibis, crime scenes. This may also account for the frequency of Denzel Washington.

The Clock makes you realize how finely attuned you are to the rhythms of commercial (usually American) film. Each foreign clip is spotted at once, long before the actor opens his mouth. And it's not the film stock or even the moustaches that give the game away, it's the variant manipulation of time, primarily its slowness, although of course this 'slowness' is only the pace of real time. In commercial film, decades pass in a minute, or a day lasts two and a half hours. We flash back, we flash forward. There's always a certain pep. 'Making lunch' is a shot of an open fridge, then a chopping board, then food cooked on the stove. A plane ride is check-in, a cocktail, then customs. Principles dear to Denzel – tension, climax, resolution – are immanent in all the American clips, while their absence is obvious in the merest snatch of French art house. A parsing of the common enough phrase 'I don't like foreign movies' might be 'I don't want to sit in a cinema and feel time pass.'

Given that nobody has given you the rules – given that you have imagined the rules – how can you be indignant when these rules of yours are 'broken'? But somehow you are. If Christian Marclay returns to the same film several times – a long 'countdown' scene, say, from some bad thriller – it feels like cheating. And because you have decided that the sharp 'cut' is the ruling principle of the piece, you're at first unsure about music bleeding from one scene into another. But stay a few hours and these supposed deviations become the main event. You start to find that two separated clips from the same scene behave like semi-colons, bracketing the visual sentence in between, bringing shape and style to what we imagined would have to be (given the ordering principle of the work) necessarily random. Marclay manages to deliver connections at once so lovely and so unlikely that you can't really see how they were managed: you have to chalk it up to blessed serendipity. Guns in one film meet guns in another, and kisses, kisses; drivers in colour wave through drivers in black and white so they might overtake them.

And still *The Clock* keeps perfect time. And speaks of time. By mixing the sound so artfully across visual boundaries (Marclay's previous work is primarily in sound), *The Clock* endows each clip with something like perdurance, extending it in time, like a four-dimensional object. As far as the philosophy of time goes, Marclay's with Heraclitus rather than Parmenides: the present reaches into the future, the past decays in the present. It's all about the sound. The more frequently you visit *The Clock* the more tempted you are to watch it with your eyes closed. Is that the Sex Pistols leaking into the can-can? Nostalgia is continually aroused and teased; you miss clips the moment they're gone, and cling to the aural afterglow of what has passed even as you focus on what is coming, what keeps coming.

So far *The Clock* has had few opportunities to play to audiences for its full twenty-four hours, but whenever it has the queues have been almost as long as the film itself. Naturally everyone wants to see midnight. 'Why does it always happen at midnight?' asks a young man by a fireplace, underneath a carriage clock. 'Because it does!' replies his friend. In the run-up, only Juliette Binoche in France is able to remain calm: quietly, foxily, ironing a bag of laundry, while wearing a bra-less T-shirt. In America everyone's going crazy. Both Bette Davis and Joan Crawford start building to climaxes of divadom early, at around a quarter to the hour. Jaws going, eyeballs rolling. At ten to midnight Farley Granger looks utterly haunted,

though I suppose he always looked that way. At three minutes to midnight
people start demanding stays of execution: 'I want to speak to the governor!'
And the violins start, those rising violins, slashing at their strings, playing
on our midnight angst.

This works up into a joke: Marclay can cut seamlessly through dozens
of films for the last two minutes without manipulating the sound at all:
they all have the same screeching violins, the only difference is the key.
At midnight a zombie woman pops out of a grandfather clock and gets a
big laugh, but I preferred the clip that came a moment later, when a twelve-
foot clockwork soldier, swinging out of a bell tower to mark the hour,
impales Orson Welles on his giant sword. It reminded me of Owen Wilson's
memento mori: *You're about to die. You're on the minute hand of a clock.*

Thirst, Taxi Driver, The X-Files, a lot of Kurosawa, *Fatal Attraction, The
Prime of Miss Jean Brodie,* some Woody Allen, a little Bergman – Marclay's
sources will be very familiar to his New York and London audiences. Maybe
if *The Clock* had been drawn from a more alien culture it would have a different
emphasis, but as it is, it's our film and looks at time our way: tragically. *Do
not squander time. That is the stuff that life is made of* – so reads the engraving
on an old sundial. We recognize its provenance (Ashley Wilkes' estate,
Gone with the Wind) and accept it as the gospel of our culture. Time is not
on our side. Every minute more of it means one minute less of us. Witness
Jeff Bridges in *The Vanishing* (and also some other guy, in the original Dutch
version), taking his own pulse and writing it out neatly next to the time.
We are tied to the wagon and it's going in only one direction, whether
we like it or not.

Film constantly reenacts and dramatizes this struggle with time: except
in film, time loses. We are victorious. Narrative is victorious. We bend time
to our will. We tie a man to the floor, put a gag in his mouth, and set the
clock ticking – but we will decide how fast or slow that clock moves.
ESTABLISH TIME: a note written in a thriller. And this is film's whole
challenge and illusion. Without it there is no story, no film. If we believe
Marclay, no shot in the history of cinema is as common as the desperate
close-up of a clock face. ESTABLISH TIME! But the time thus established
has, until now, always been a fantasy, a fiction. *The Clock* is the first film
in which time is real.

A lot of people speak of a crisis in the purpose and value of the fictional
realm. *The Clock* feels to me like a part of that conversation: a factual response

to the fantasies of film. It has a very poor predecessor in the TV show
24, which also promised an end to 'narrative time' but instead bent
to commercial concerns, factoring in ad breaks, and was anyway,
with its endorsement of torture, ideologically vile. With its real-time
synchronization *The Clock* has upped the ante exponentially. Honestly
I can't see how you could up it much more. It's the art object Sontag
was hoping for almost half a century ago in *Against Interpretation,* which
reminds me that this supposed crisis of the Noughties has in fact been
going on a long time: '*Transparence* is the highest, most liberating value
in art – and in criticism – today. Transparence means experiencing the
luminousness of the thing in itself, of things being what they are.' A very
long time. Plato would recognize it.

But what I love about *The Clock* is that while appearing to pass 'beyond'
fiction it also honours and celebrates it. Fiction is Marclay's material; after
all, he recycles it. What else is *The Clock* if not thousands of fictional
interpretations of time *repurposed to express time precisely.* That's why you
don't feel that you are *watching* a film, you feel you are *existing alongside*
a film. People even leave the gallery following the conventions of time:
on the hour, or a quarter past. No one can seem to stand to leave at, say,
6:07. Most wonderful is listening to people on their way out. 'How did
he do it, though? You can't Google for clocks. How did he do it then? Did
he have hundreds of people or what?'

The awe is palpable, and thrilling because it has become so unusual.
A lot of the time, when standing in a gallery, I am aware of two feelings,
one permitted, and one *verboten.* The first is boredom: usually the artist's
subject is boredom (the boredom of twenty-first-century life, etc.), and my
reaction is meant to be one of boredom, or, at the most, outraged boredom.
The second is 'wonder at craft'. I am not meant to have this feeling. Asking
how something was made, or having any concern at all with its physical
making, or being concerned with how hard the thing might have been
to make – asking any of these questions will mark me out as a simpleton.
The question is childish, reactionary, nostalgic.

But *The Clock* is not reactionary, and manages to reintroduce these
questions, without being nostalgic or childish. Marclay has made,
in essence, a sort of home-made Web engine that collates and cross-
references an extraordinary amount of different kinds of information:
scenes that have clocks, scenes with clocks in classrooms, with clocks

in bars, Johnny Depp films with clocks, women with clocks, children with
clocks, clocks on planes, and so on, and so on, and so on. You're never
bored – you haven't time to be.

Really an essay is not the right form in which to speak of it. A visual
representation of some kind would be better; a cloud consensus, or a
spectacular graph. It's hard to convey in words what Marclay does with
data, how luminous he makes it. And if this data were all lined up on
a graph, what conclusions would we draw? That life is epic, varied and
never boring, but also short, relentless and terminal. *The Clock* is a joyful
art experience but a harsh life experience, because it doesn't disguise what
time is doing to you. At 2:45 p.m., when Harold Lloyd hung off the face of
that clock, I couldn't access the delight I have felt in the past watching that
fabulous piece of fiction, because if Harold was up on that screen it meant
I had somehow managed to come at the same time again, the early afternoon,
despite all my efforts to find a different moment, between childcare and
work. I looked around the walls of the gallery where all the young people
sat, hipsters, childless, with a sandwich in their bags and the will to stay
till three in the morning. I envied them; hated them, even. They looked
like they had all the time in the world.

Zadie Smith, 'Killing Orson Welles at Midnight', *New York Review of Books* (28 April 2011) 14–16.

David Toop
Painting in Slang
2011

A scene from *Gulliver's Travels*, perhaps. We are situated within a circular piano keyboard of grotesque proportions – *piano gargantua* – and in the centre, raised on a dais and encircled by an audience, sits a tiny piano played by an equally diminutive pianist. The pianist is Steve Beresford, a human of average size (as is his piano), but in this context he is dwarfed by the immensity of his own hands. I think of Alex Steinweiss's cover design for *Boogie Woogie*, a record released in 1942. Two huge hands, one black, one white, loom over a small grand piano on which rests a cigarette its smoke rising in one elegant series of waveforms.

This is Christian Marclay's *Pianorama* (2011), created for designer Ron Arad's *Curtain Call* at the Roundhouse, North London. Arad has created a circular curtain of hanging plastic filaments for this famously circular building, then invited a selection of artists to make works which exploit the format. Marclay's response was to film Beresford's hands playing the piano, then editing the images into a seamless, circular keyboard that surrounds the audience and allows hands to appear at any point in the circle. Hands that dart and retreat like nervous birds, a single note here, a short run, an alluring hint of Cuban *montuno*; ghosts of a piano music that is as abstracted as the black and white keys of the piano itself.

Two days earlier I was standing in the same circle, this time with Marclay. He frets about sound, the way the budget always narrows when it gets to the sonic point of the wedge, the way the sound should emerge at exactly the point where each finger strikes the keys, the compromise solution that has small speakers outside the cylinder of the curtain and then a big speaker pod hanging overhead to destroy any sense of precise placement in the space. He also frets about the matching of this muffled sound with the clarity of the live piano. 'Visually, [*Curtain Call*] is extremely sophisticated and complex', he says. 'But on the opening night the sound system was so damned loud that my ear is still bothering me two weeks later, ringing. I find it criminal. People just don't understand sound, they're so careless about it.'

Of all the artists who are decidedly not careless about sound Marclay

has risen with gradual, inexorable grace to pre-eminence. In June I found him at the opening of the 'Gone with the Wind' exhibition at Raven Row gallery in London, still in shock from winning the Golden Lion as best artist at the Venice Biennale. I'm surprised that he's surprised. *The Clock*, the 24-hour video piece which won him the award, is both artful and crafted, a simple but smart concept that has proven to be nonchalantly engaging for a casual audience but as weighty as you like for cultural commentators whose deliberations on time unwind until their clock gets stopped. But later for *The Clock*: now Steve Beresford sits at the piano within his two-and-a-half-times cylindrical piano and deals, as musicians must do, with the immediate problems of improvising a response to his own playing, to the muffled sound from the speakers, and to the prospect of drawing a line that connects the repeating fragments and pauses of the video work.

A line is what seems to unfold, an exercise in concentration and poise. At one moment it feels like reverse karaoke, in which the video sound is reacting to the live playing, trying to knock its implacable invention off course. There is a hint of salsa nudges and pokes, 'follow me', 'develop me', but Beresford is too seasoned an improvisor to capitulate into cliché. He plays with clarity and care, waits, occasionally erupts, mirrors a descending scale but then next time walks it in the other direction. Certainty it's more demanding than the shorter experience of sitting within the video piece. The listener needs to remember the unfolding, the variations, yet stay with its taut outstretching. As Marclay had said, two days before: 'Live, you're in a balancing act and you can fall any minute.'

While we were talking on that occasion, Ron Arad appeared at our table wearing that funny cloche hat of his. What can you say about Christian's piece, I ask. 'There's things you can't get your head around', Arad says. 'When I thought to ask Christian to do something, stupidly I thought there's 24 columns, so we can watch *The Clock* in one hour. I regret all the hours I missed when I watched it, because I didn't stay for the whole 24 hours.' Instead, he got *Pianorama*, which has more than one relationship to *The Clock* but connects more closely to a whole other world of improvisation and ideographic scores. The imperfect nature of performance remains as important to Marclay as the fanatically precise editing exemplified in these works (and earlier examples such as *Telephones*, *Video Quartet* and *Crossfire*). From talking about the specific technical challenges of making *Pianorama*, Marclay begins to expand on similarities and differences:

cursor cuts and digital frames versus slamming a swiftly chosen vinyl
LP onto a turntable in half-darkness and hoping for the best, or the
malleability of sound against the specificity of image. 'I do enjoy editing',
he says. 'That's the fun part. With video, found footage, it is and it isn't like
DJing, mixing things, but it's definitely connected to that approach of just
dealing with what you have, what you've found, what you can do. There's
more freedom with just sound because things blend. With images you can
blend them but it'll always look like a soft dissolve, have a cheesy quality.'
There was the feeling of a vast living archive, music, art and film. One
summer in 1980, Marclay's punk/performance duo – The Bachelors, Even
– played a San Francisco dive called Club Foot. Bruce Conner would hang
out there, once inviting the group to accompany a night of films using
multiple projectors, home movies, industrial films and found footage.
'He was notoriously grumpy and paranoid toward the art world but
somehow he liked us', Marclay recalls. 'I stayed in touch. He was someone
that I really liked right away for the found footage. It was always set to
another soundtrack so he was a bit of a precursor to MTV. I remember
seeing his short film *Take the 5:10 to Dreamland* (1976) – the heat of a
radiator makes this feather go up in the air and it becomes an atomic bomb.
These beautiful transitions. Another filmmaker I liked was Maya Deren.
There's one scene in *Meshes of the Afternoon* (1943) when she's walking
and every footstep is a cut to a different landscape surface on which she's
walking, and so there's the momentum of the body, yet it's always cutting
to another thing. These are the moments that you remember because they
make you aware of what you can do with editing. It's a whole poem, going
from one texture to the next.' I suggest to him that his recent work can't
be fully understood unless you know the music back story.

'The DJing satisfies something more raw', he says, 'improvised and
direct, hands on, that incorporates mistakes and accidents. It's a live process.
The viewer/listener becomes involved and sees the process, but with video
you end up with this product that doesn't necessarily show how it's made.
It's a different experience for the viewer/listener but it's different for
me also. In the editing there's more a cerebral process. It's a struggle,
and then you have these little moments of pleasure when you get a smooth
transition, something exciting happens, you find a narrative connection,
a symbolic connection, a musical connection. It keeps you going, though
there isn't that joy of the moment that you get when you're on stage, you

lose balance, you catch yourself. I miss that because I don't do it as much anymore.' What I also feel, and this is more contentious, is that works like *The Clock* are given greater cultural weight than the unpredictability, sensuality and quick wit of improvising and turntablism. Maybe it's Pan versus Apollo all over again. At different times in history one will triumph over the other [Dionysian/Apollonian] and for the moment Apollo has Pan's face in the dirt, but I'm thinking of an album like *Moving Parts*, recorded by Marclay and Otomo Yoshihide in the late 1990s. What is implicit and distilled in Steve Beresford's *Pianorama* improvisation – a fluid, inclusive music that can move in many directions simultaneously, working with the possibilities of silence and chaos – is given its head in tracks like 'Blood Eddy' and 'Fanfare'. Untidy and splintered, they have a delirious appetite for life as it is. Or was.

'I don't know', says Marclay, 'it's maybe a different time. My reason for pulling out of DJing, or 'DJing' in quotation marks, is that I feel that records have lost their meaning in a strange way. They're not the objects that we all used to interact with and that brought us all the music we enjoyed. Now it's retro. Culturally it has a different signification. Being a DJ means something else. It doesn't have that same relevance it had in the 1980s or even the 90s.'

Something similar could be said of clocks – they are being superseded by mobile devices. Rueful, he nods and starts to tell me about a forthcoming exhibition in San Francisco in which he will use cassettes combined with cyanotypes, an obsolete nineteenth-century photographic printing process (used famously in the early 1840s by Anna Atkins, who laid various species of British algae directly onto the coated paper to produce mysterious near-abstract blueprints). There are two or three ideas here that pinpoint the themes of Marclay's work. One is circularity: the records, the clocks and now a circular piano keyboard. You might call it an instinct for design, which incidentally helps him make compelling sound work for the visual art world, or something deeper, whereby circles and cycles tell the universally understood story of loss and return. On the one hand you sense a ruthless streak – it's over, move on – but then there is a recurrent attraction to obsolescence or that which is caught only in the corner of the eye, to the salvage of peripheral, abject and transient cultural objects, scrap discarded in the inexorable churning of evolution.

'The gramophone record becomes a form the moment it unintentionally

approaches the requisite state of a compositional form.' This was Theodor
Adorno, from 'Opera and the Long-Playing Record', published in 1969.
'Looking back, it now seems as if the short-playing records of yesteryear
– acoustic daguerreotypes that are already now hard to play in a way that
produces a satisfying sound due to the lack of proper apparatus –
unconsciously also corresponded to their epoch: the desire for highbrow
diversion, the salon pieces, favourite arias and the Neapolitan semi-hits ...
This sphere of music is finished: there is now only music of the highest
standards and obvious kitsch, with nothing in between. The LP expresses
this historical change rather precisely.' Views on that gap between kitsch
and high art may have changed but the point remains still valid: technologies
shape cultural expression and mirror the politics of their epoch in ways that
can only be fully grasped when the technology becomes obsolete.

In 2003, Marclay exhibited photographs, drawings and notations
at White Cube gallery. Let's say they were all notations because they
indicated alternative methods for instructing musicians. Writing a
catalogue essay at the time I mentioned Max Ernst – a reference that
Marclay accepted – 'He found the fantastic in the ordinary', he said. I
remember a photograph of tin cans tied to the back of a marital get-away
car and thought about indeterminacy, improvising percussionists, the
charivari noise rites for domestic percussion enacted during threats to
cosmic or social order, not to mention Marclay's own *Guitar Drag*. Marclay
likened his photographs to the kind of sketches made by travellers, hasty
recordings of memorable scenes as fragile as dreams in their tendency
to slip from memory. 'It's like these little moments of recognition that we
encounter every day', he said. 'They're small and insignificant. They need
to have enough excitement to pull out the camera and press the shutter but
most people pass them by.'

In another life, Marclay might have been a professor of linguistics. He
is fascinated by the language of signs, constantly returning to ideographic
languages, semiotics, codes, translations and transliterations. The severely
abstracted, extended and enlarged piano keyboard of *Pianorama*, for
example, plugs us straight into a history of what Alfred Appel Jr called
jazz modernism – that Steinweiss design I mentioned earlier which showed
up in the record collection of Piet Mondrian – or a wonderful Walker Evans
photograph from 1935, *Sidewalk and Shopfront*, a New Orleans barber shop
where the helical stripe of the traditional barber's pole has been applied

to the entire shop front, as if blood and bandage transformed into the
ebony/ivory binary of Jelly Roll Morton's piano keyboard. 'Rauschenberg's
collaged 78 rpm record label shard of Monk's most famous composition,
"Round about Midnight" (1947) is a jagged fragment', writes Appel Jr in
his book, *Jazz Modernism*, 'a phrase that telescopes the essence of Monk
as minimalist piano player and composer, especially his dissonances, like
the nerve-wracking way the lines of the trumpet and alto saxophone refuse
to mesh in the ensemble passages of "Round about Midnight", enough to
crack or shatter a 78 disc.'

Thelonious Monk and 'Tea For Two' were nested within Steve Beresford's
performance alongside the eruptive piano styles of Charlie and Eddie
Palmieri (the cover design of Charlie Palmieri's *A Giant Step* album shows
a giant piano keyboard played by a shoe, while Eddie Palmieri's *The Sun
of Latin Music* has a disembodied red hand clawing at a cluster of vertical
piano keys). This language owes as much to the iconography of film and
cartoons as it does to Cubism, Futurism, Surrealism, Constructivism and
the De Stijl movement of Mondrian and Theo van Doesburg. Like Fernand
Léger, who wanted to 'paint in slang', Marclay makes sound works which
draw on blurred memories of vernacular culture, maybe a *Tom and Jerry*
cartoon in which Tom's efforts to perform Liszt's *Hungarian Rhapsody* are
thwarted by Jerry hammering at the same note over and over, slamming
down the lid to flatten Tom's white-gloved fingers, laying a mouse trap
on the keyboard, dancing on the hammers to play jazz or running up and
down under the keys to make a Mexican wave.

A car passes in the street outside, A-ZOOM painted on the side for some
unknown reason. He gets excited momentarily because these are exactly
the kind of signs he has collected for an improvising score – *Zoom Zoom* –
written for New York singer Shelley Hirsch and first performed by them
both in Théâtre du Grütli, Geneva, in September 2008. 'Using video
to prompt a performance is something I've been interested in', he says.
'Shelley has a certain skill, she's a great improvisor, but she has this
stream of consciousness way that she can get lost in the stories and react
to sound and image. I send these photographs that I've been taking of
onomatopoeias that I find in everyday life, advertisements, the name of
a store or a restaurant – Ping Pong, which is a London reference, or Crush.
These onomatopoeias are sound first but they become little hints at
storytelling. She embroiders them as a springboard for her own crazy

stories. I project the images one at a time. I'm on stage with my laptop –
I have this grid of images that I can click on so I'm reacting to her as much
as she's reacting to the images. The images are projected big and she stands
facing the audience but she has a monitor that shows her the image, so
she can still project towards the audience but she's reacting to the images
that the audience sees. What has always been for the private world of
the musician – the score – becomes now public. The audience is creating
relationships in their own minds which are maybe different from what
Shelley is thinking. That connection between the image there and what
Shelley's doing becomes part of the perception of the piece. These are
new experiments for me.'

What interests me in this account is what it reveals about the insistently
collaborative nature of Marclay's work. No longer in thrall to movements,
the art world now feeds on individuals who are strong and distinctive
enough to survive as international commodities without the collective and
critical mass of an 'ism', a manifesto or national identity. While this is true
of Marclay, a peripatetic Swiss-American living in London and not aligned
to any particular group or style, he also has a background in music, more
particularly in improvised music, a form which survives and develops
because it is based on interlinked and evolving communities of players
spread across the globe. Those photographs and notations mentioned
earlier, the ones exhibited at White Cube gallery in 2003, may have seeded
like *amuse-bouches* at the time; retrospectively we can see them as interim
stages, gradually developing into notations for a type of playing which has
its roots in 1970s improvisation. In New York, John Zorn's game pieces –
Lacrosse, Pool, Archery, Cobra, and so on – were innovations not just in
ensemble improvisation but as an ingenious solution to problems of
notation, organization and stylistic diversity. Marclay took part in some
of these pieces and played turntables with Zorn on tracks like 'Forbidden
Fruit' (from *Spillane*, 1987), 'Battle of Algiers' (from *The Big Gundown*,
1986), 'John Zorn Présente Godard' (*Godard ça vous chante?*, 1985), the
1986 studio version of *Cobra*, the 'Trip Coaster' section of *Filmworks VII*
(1988) and the first side of *Locus Solus* (1983). The turntables are beautifully
integrated with other instruments on *Filmworks* tracks like 'Hysteric Logo'
and 'Coaster 2' but with track timings of 0′24″ and 0′4″, the music places
extreme demands on immediacy, invention and physical dexterity. Out
of curiosity, I asked John Zorn about how players like Marclay shaped the

game pieces and how the game pieces shaped them. 'The game pieces were
a very fast operation', he says, 'with cues and signs and split-second timing.
Christian's ear was always very sharp and all the players loved working with
him. Christian has an uncanny sense of what follows what – you can see
that in his film work as well.'

'It was very important and very influential', Marclay says of his
'apprenticeship' with Zorn. 'To me it was my discovery of improvisation.
These early game pieces were liberating for me, realizing I didn't have to
try to repeat on stage what I had rehearsed. I also realized that the records
didn't allow me to do that because they were so fragile and so temperamental,
wanting to do what they wanted to do. John is a really important influence
on my development. He also introduced me to every musician I ended up
working with in the 1980s. He introduced me to a social network I didn't
know. It's through encouragements from people like John, who somehow
saw something in me that I couldn't see because I didn't have the musical
knowledge or the experience to see that what I was doing had any value.
That's one of the great things about John, how he brought all these people
from such different backgrounds together in his projects, from classical
musicians who were eager to get away from the rigidity of classical music,
jazz musicians, rockers and even amateurs and weirdoes like me.'

One of the issues Zorn was thinking about was time. In his notes for the
1981 release of *Archery* he wrote about eliminating set amounts of materials
whose completion was a requirement of a score; his compositions were
pulling 'free from the idea of Time as a linear progression of amounts
(size of information, length) to a more vertical conception: as an energy
that appears immediately everywhere, and can be collected, balanced
and regenerated in "pockets" of information/material.'

Though they are all different, Marclay compositions such as *Screen
Play*, *Ephemera*, *Shuffle*, *Zoom Zoom* and now *Manga Scroll* have grown
from this dynamic of omnipresent energy. They attack the normal
hierarchy of perception whereby what is seen is taken to be the core
reality of the event. The fluctuations of dialogue experienced during
Steve Beresford's performance of *Pianorama* – fixed and unfixed elements
seeming to exchange roles, stabilize or destabilize each other, ebb and flow
as focal points – is true of all these pieces. Sound pulls them away from the
frontal flatness of the image, its fixity in space; improvising adds that
element of unpredictability, the loss of balance, the catch.

As well as distributing the formal elements of a composition, they also distribute the composer to some extent. Last summer's 'Christian Marclay: Festival' at the Whitney Museum in New York acknowledged this blurring of identities. More of a Festschrift or carnival than a typical one-person show, the festival threw light on his musical collaborators as well as Marclay himself. Yet scores for improvisors (or improvising, to be more precise) can be a treacherous area. Who gets the ultimate credit? What about those notorious, sometimes celebrated 'composers' who ask experienced players to 'play something sustained in a high register', then walk away with the accolades and perhaps the money. Marclay's scores are different – they are highly sophisticated visually and conceptually. Audiences find them entertaining but they also open up potentialities for the musicians. For this reason I asked three of his collaborators – John Butcher, Joan La Barbara and Steve Beresford – to reflect on the question of why these pieces are stimulating to perform.

Steve Beresford has acted more or less as musical director for some of Marclay's more recent performances. For him, the scores engage parts of the brain that lie dormant in other situations. 'Playing *Ephemera* [a piano solo in which the soloist works from 28 folios that collect together musical notations printed on confectionery wrappers, clothing, record covers and other found materials] is like improvising with a great musician – you get a sense of overwhelming urgency and you don't want to miss a trick. Sometimes the difference between improvising freely and playing (or can we re-use the sixties term 'realizing') Christian's pieces is obvious: 'readable bits of simple tunes in a piece like *Ephemera* may get played very literally; over-repetitive phrases that looked good to the graphic designer might get played past the point we'd normally do them'.

'I've played a few now', says John Butcher, 'the film ones, *Screen Play* and *The Bell and the Glass* – and *Shuffle* and *Ephemera*, which are both based around photos of items or places that contain images of musical notation, ranging from a snippet of Mozart on a chocolate box, to stuff that makes little sense, like adverts with three-line staves. With the films, I think some people approach it like Foley artists, and at the other end, some play quite independently. As they're very carefully edited – he has a great sense of flow and rhythm in this – I think it works best to follow the action quite closely but keep the material pretty abstract. You can invent your own schemes corresponding to the films, but it pays to rehearse and think

through this in advance. I think it's wrong to look at it as the musicians 'interpreting' the work. The improvisation is as much the work as the visual material that's stimulating it. It's unusual to have an artist prepared to operate this way. I guess it comes from the fact that he himself values the intrinsic possibilities and meanings of improvised music, and isn't interested in just using it for colour or effect. Of course, he's a great improvisor himself, which must be why players like collaborating with him.'

In 2009 Marclay invited Joan La Barbara to perform a work for solo vocalist, *Manga Scroll*. He speaks of her with a note of awe – 'She's like the queen of vocal experimentation.' The piece has been performed by La Barbara, Shelley Hirsch, David Moss and Phil Minton and will be performed in Aldeburgh later this year by Elaine Mitchener. *Manga Scroll* is another project derived from signs, transliteration and onomatopoeia, a 60-foot long scroll of graphic sound effects lifted from North American translations of Japanese *manga* cartoons – basically a long strip of pfff, skrrrr, krak and blech.

I asked La Barbara how she approached such a daunting task. 'When we discussed it, I said that I hadn't decided where to start or which direction to go', she says, 'and Christian said that he wanted the scroll performed from beginning to end. Other than that, he gave no specific directions as he wanted to experience how each of the performers who took on the task would deal with the material. There was a great deal of motion, for me, in the visual material, and so I progressed through the score with somewhat of a sense of "urgency", moving along with the energy required to perform what I felt the score implied.

'I worked as close to real-time reading/performing as possible, spending the amount of time necessary to perform the fragments immediately in my gaze, while looking somewhat ahead to the next set of events in preparation. So, each performance was both improvised in the moment but informed by the decisions I had made about certain sounds and sets of material in my rehearsal sessions. When the visual material circles back on itself, I tried to create real-time loops without electronic support. When it splits apart and goes in several directions simultaneously, I tried to create the feeling of multi-directionality by choosing one stream, progressing along it and then leaping back and choosing another. I created complex patterns by fragmenting material and utilized some of the extended vocal techniques that are my personal vocabulary, which often sound as if there

are multiple voices performing simultaneously.'

In *The Sound and the Fury*, one of William Faulkner's characters passes on his grandfather's watch through the paternal line to his son, Quentin, describing it as 'the mausoleum of all hope and desire ... the *reductio ad absurdum* of all hope and desire'. As Quentin prepares for his suicide, he lies in bed listening to the watch: 'It was propped against the collar box and I lay listening to it. Hearing it, that is. I don't suppose anybody ever deliberately listens to a watch or a clock. You don't have to. You can be oblivious to the sound for a long while, then in a second of ticking it can create in the mind unbroken the long diminishing parade of time you didn't hear.'

Time is unmentionable, always ticking down to cliché unless you are Faulkner, Joyce, Woolf, of that calibre. But it can be shown, or better still, find its more complex, unfettered and subtle expression through music, through sound.

Marclay discusses editing and writing, yoga, the small platoon of researchers who found and delivered material for *The Clock*, this beautifully constructed timepiece of collective memory which nobody will ever, fully experience, if only because its parallel loop of time, each minute of a 24-hour period shown in real time on found film, is a constant reminder that life goes on, things to do, places to go. As Joe Hinton once sang, 'Ain't it funny how time just slips right on away.' Although developed very slowly, the concept of *The Clock* emerged from a video score. Working on *Screen Play* in 2005, Marclay realized that the musicians would need some indication of time in order to prepare for changes in the found film footage they were seeing. During a residency at Eyebeam Art + Technology Center in New York, an intern assistant researched film footage showing clocks. 'He started bringing in all these clocks', he says. 'I thought, wow, I wonder if it's possible to find every minute of every day in the history of cinema?'

Everybody is in crisis, I say. Who knows how to release work or make a living from it except by flinging some low-res giveaway out into the digital ocean and hoping for a better tomorrow? *The Clock* is something else, a media work enhanced by its limited availability, too big to download or buy in a shop, so you must go to the work, sit with it and, yes, give it time. He tells me the economics, that *The Clock* is being sold as an edition to institutions or sold jointly to museums in order to avoid the squirrelling habits of private collectors.

'I welcome the crisis', he says. It's not as if the old structures were particularly easy or helpful anyway. Marclay's work is not just about his own salvation – his collaborations uncover new audiences and strategies for a large group of musicians and the success of *The Clock* amplifies that effect. 'Sometimes it opens a door for audiences to learn about the music', he says. 'When we did the Whitney, they organized a dinner for all these funders – a crowd of uptown people who would never want to go down to Café Oto or the Knitting Factory. They're fine with Vito Acconci jerking off on the floor but going to listen to some crazy music somewhere is not acceptable. I asked Shelley Hirsch if she'd perform and people were completely blown away. They gave her a standing ovation and she was the hit of the party. It's hard to cross these borders so I'm hoping *The Clock* might help a little bit with that, but I'm not worried about it so much. I'm happy making music for people who enjoy it. If you strive toward a certain perfection or something you believe in the people will see that it's for real, it's not a joke. You can't control that. You can't even worry about it too much.'

David Toop, 'Painting in Slang', *The Wire*, no. 332 (October 2011) 41–9.

Noam M. Elcott
Untimely Detritus: Christian Marclay's Cyanotypes
2011

Christian Marclay's *Memento (Survival of the Fittest)* (2008), a monumental
blueprint or cameraless cyanotype, stretches out before us nearly four feet
tall and eight feet wide. Perfect catenaries and irregular tangles of piercing
whites and bright azures sweep across the image or recede into its Prussian
blue expanse. We are thrust into a forest of light, or, better still, a tropical
pool, from the depths of which we peer up toward the sunlight that breaks
the plane of the water. But as our eyes float down to the bottom of the image,
where broken cassettes litter the ocean floor and transform it into a dirty and
abandoned dance hall, the plunging ribbons of light transmogrify into party
streamers. And yet the ethereal light – stripped of naturalistic or supernatural
connotations – pulls itself out of the refuse and shines no less brightly for its
bathetic associations. A transubstantiation without the miracle.

Where to begin? The allusions tucked into *Memento (Survival of the Fittest)*
range from natural history to the history of art, from media technology
to popular music. Like the magnetic tape whose cameraless traces infuse
the image with lustrous debris, these allusions are freed from their sources
only to be bound into inchoate knots not easily untangled.[1]

The cassettes that make up *Memento (Survival of the Fittest)*, culled by
Marclay from the thrift stores of Tampa, Florida, represent a pop-cultural
miscellany. The work is in fact a memento to a specific media technology
that is rapidly approaching extinction in advanced capitalist countries.
And in this respect the title of the cyanotype could not be more fitting.
Today, the term 'survival of the fittest' is most closely associated with
Herbert Spencer and social Darwinism (the bunk application of evolution
to the realm of anthropology and politics). But the phrase was initially
understood by Spencer, Darwin and their contemporaries as a synonym
for 'natural selection', Darwin's equally famous term for the operative force
behind evolution.[2] Applied to the realm of media archaeology, the subtitle
Survival of the Fittest might be viewed ironically: in an age of digital music,
cassette tapes have gone the way of the mastodon.

But there is another face to natural selection, and it is expressed poignantly
– if rather disdainfully – by R. Child Bayley in his 1906 tome *The Complete*

Photographer, where he dismisses the blueprint as a printing method 'which survives, as the Darwinians tell us some of the lower forms of life survive, from the extreme simplicity of its structure'.[3] Among the insights of natural selection or the survival of the fittest is the recognition that a human is no more 'fit' than a bacterium, no more 'selected' than an ant. Blueprints survived decades longer than their more rarefied competitors not *in spite* of their extreme chemical simplicity, but because of it, in other words, the traits that enable survival are not ontologically superior to others; they are simply better suited to their environment. (In much of the so-called third world, you still get more mileage out of a cassette tape than from an iPod. Blueprints have a similar pragmatic advantage over digital scans in that they are likely to last much longer.)[4] Marclay's commitment to 'lower' forms of media and the simplicity of their structures sustains his extensive exploration of cyanotype photography and is nowhere in greater evidence than in one of his earliest cyanotype projects, the *Automatic Drawings* (2007–8), an *édition variée* that comprises 35 images.

Like all of Marclay's cyanotype projects, the *Automatic Drawings* were created collaboratively with the Graphicstudio atelier, based at the University of South Florida in Tampa. Marclay's work with Graphicstudio began several years prior, with a suite of photogravures, and continues to the present, with further photogravures as well as a variety of hand- and hanging-scrolls. The most fecund collaboration to date has been formed around the creation of cyanotypes: six separate series – altogether 117 individual works – beginning with the *Automatic Drawings*.

The *Automatic Drawings* are the simplest of Marclay's cyanotype creations, but they contain the seeds for nearly all his other series. The title references the Surrealist practice, pioneered by André Masson in the 1920s, in which the artist's hand is allowed to move without conscious purpose across the page and to create a drawing 'freed' from reason and rational constraints. (This practice was later pursued on a monumental scale and on American soil by Jackson Pollock and other Abstract Expressionists.) In Marclay's version, it is the chance meanderings and accumulations of magnetic tape that compose the automatic forms, which are then drawn by light directly onto the photographic paper.

If the compositional principle owes a debt to Surrealism, the technique – and, in many respects, the form as well – recalls the origins of cyanotype photography. Sir John Herschel, a prominent gentleman scientist (whose

work inspired, among others, the young Darwin) discovered the cyanotype process in 1842, three years after Louis Daguerre and William Henry Fox Talbot announced their inventions of photography to selected scientists and the general publics of France and England. Unlike the daguerreotype (Daguerre) or the calotype ('beautiful image', Talbot), however, the cyanotype ('deep-blue image') was not photosensitive enough to be used in cameras; furthermore, its fantastic blue was a liability for a young medium closely associated with naturalism and verisimilitude. Cyanotypes were initially taken up almost exclusively by a small elite of botanists for the purpose of plant illustration. The most prolific among these was Anna Atkins, who is often credited as being the first female photographer.[5] From 1843 to 1854 Atkins compiled multiple volumes and copies of *Photographs of British Algae;* in her images, the Prussian blue background conjures the sea – a lifelike context for the oceanic organisms.

When laid out across a table, Marclay's *Automatic Drawings* are reminiscent of pages from Atkins' *Photographs of British Algae,* as if Marclay were a natural historian of media technologies. In place of Atkins' British algae, Marclay uses a cassette tape; instead of sunlight, he employs artificial ultraviolet light. Otherwise, there are several surprising resemblances between these two bodies of work. Each of Marclay's *Automatic Drawings* is composed by placing a clear plastic cassette near the top of a piece of cyanotype paper – cut to the precise proportions of an audio cassette – and unfurling its magnetic tape into a 'tail'. The ensemble is then exposed to an artificial light source rich in the ultraviolet range of the spectrum (similar to sunlight), washed with tap water, and dried. But the comparison with Atkins' algae images has more than just a pseudo-morphological basis: the cyanotype chemistry used today is virtually unchanged from that of the 1840s – a mix of ferric ammonium citrate and potassium ferricyanide. Furthermore, no two images by Atkins or Marclay are the same; each is a unique photographic inscription of the specimen made without recourse to photographic negatives or cameras. Formally, both Atkins and Marclay manipulate the specimen to fit on the page and reveal its structure through the relative opacity and translucency of its various parts. Specimens are laid flat and movement is averted in an effort to create the clearest possible image. In both cases, the subject matter must be 'killed' in order to be represented (this will be seen again in Marclay's later series, such as *Memento*). Finally, for both Atkins and Marclay,

production is 'artisanal' (despite the photomechanical context of illustrated books and graphic prints) and the works are dispersed within intimate social circles: this is literally the case for the dozen or so known copies of Atkins' *Photographs of British Algae* (original recipients included family friends and scientific luminaries like Talbot, Herschel and Robert Hunt, a scientist and early photo-historian) – but it is also true for Marclay's *Automatic Drawings*, which were composed for Graphicstudio 'subscribers', a small circle of supporters and friends of the atelier.

The fundamental difference between Atkins' work and Marclay's is, of course, history. Atkins embarked on her cyanotype illustrations at the dawn of photography; Marclay delved into the cameraless blueprints in an era that has been dubbed 'post-photographic'. Atkins' once-living organic specimens resemble only slightly the dead media captured by Marclay. And of course, the practice of the nineteenth-century layman scientist bears little resemblance to that of the twenty-first century professional artist.

Ultimately, what separates Marclay from Atkins is the advent of modernity. Marclay's cameraless photography purposefully resurrects the history of modernism – a history that spans roughly the century from 1860 to 1960 – and its relation to the popular. *Memento (Survival of the Fittest)* is not a memento to the natural selection of algae or media, nor to the brute materiality of plastic cassettes, a once-dominant technology reduced to so much rubble today. Marclay's cyanotypes are mementos to a point in modernity when avant-garde forms laid claim to the popular imagination and borrowed from the dregs of popular culture. That point in history now appears as distant as cyanotype photography and Rolling Stones audiocassettes. And it is here, at the intersection of avant-garde art and the refuse of popular culture, that Marclay began his career.

In 1978, Marclay, who was born in the United States but grew up in Switzerland, had returned to America and was an art student living in Brookline, Massachusetts. 'At the time', he says, 'I was already thinking about sound.' So begins the artist's account of his gramophonic epiphany, more than three decades ago and almost exactly one hundred years after Thomas Edison announced his invention of the phonograph. Marclay recalls:

> I was living in Brookline; while walking to [art] school on a heavily trafficked
> street a block away from my apartment I found a record on the pavement. Cars
> were driving over it. It was a Batman record, a children's story with sound

effects. I borrowed one of the turntables from school to listen to the record. It was heavily damaged and skipping, but was making these interesting loops and sounds, because it was filled with sound effects. I just sat there listening and some kind of spark happened ... Just the fact that I picked it up was significant of that cultural difference. If I had grown up in the US, I wouldn't have thought twice about seeing a record on the street. That's what surprised me about American culture: its excess, the prevalence of so much waste. When I first came [back] to the United States [in 1977], it was a common sight to see broken records on the street. It took away the preciousness of the object.[6]

Marclay pursued these skips, loops and sounds through orchestrated and improvisational manipulations of the gramophone – a technique made popular through parallel developments in hip hop. His may be the only music career ever launched by a broken record.

Marclay has revisited the scene of destruction in a number of installations – notably in *Footsteps* (1989) and *Echo and Narcissus* (1992), for which he covered a gallery floor with thousands of twelve-inch vinyl records and compact discs, respectively. At first glance, these installations would seem to be comments on the programmed obsolescence that is a driving force behind advanced capitalism. But Marclay added another dimension. The vinyl records of *Footsteps* contained the sound of Marclay's own footsteps mixed with the quick syncopations of tap dancers' pattering feet. As visitors meandered through the gallery, they added the physical marks of their own footsteps to the mix. Their treading feet imprinted the mechanically reproduced records with a unique layer of skips and loops – as if to reinforce the preciousness of the records by reminding audiences of their destructibility.[7] Each of the 3,500 individually trod-upon records from *Footsteps* was packaged and sold at the close of the exhibition; an edition of 1,000 was released, out of which 100 copies were signed and numbered.

In *Echo and Narcissus*, Marclay took advantage of the reflective surfaces of compact discs, transforming their capability for sonic regurgitation into a capacity for visual reflection. This transmutation from the aural to the optical register (alluded to in the work's title) is emblematic of Marclay's oeuvre; indeed, it is perhaps its most important structural operation. Unlike the records of *Footsteps*, the 15,000 CDs used for *Echo and Narcissus* were summarily dumped after each exhibition; they could be installed and experienced but not owned as individual *objets d'art*.

Between the 1989 exhibition of *Footsteps* and the first iteration of *Echo and Narcissus* in 1992, Marclay began experimenting with cameraless photographs (also known as photograms). Made through the interposition of objects between a light source and a photosensitive surface, photograms have been known at least since the 1830s, when Talbot placed leaves and lace on photosensitive paper and exposed them directly to light. Cameraless photography of all kinds has been practised by amateurs, children, scientists and others since the invention of photography. (The most familiar and widely disseminated form of cameraless photograph is the X-ray image.) Avant-garde artists – notably Man Ray and László Moholy-Nagy – first explored the technique in the years following World War I.[8]

The critical response to the introduction of photograms into avant-garde discourse in 1922 was split. On the one hand, Man Ray sold his first 'rayographs' (as he called his cameraless photographs) to the fashion impresario Paul Poiret; they were first published in *Vanity Fair* (November 1922); and Man Ray eventually adopted the technique for advertisement spreads in *Harper's*. In short, rayographs were utilized as a tool for the 'New Vision' that was sweeping over Europe and America, a modern view inextricably tied to the marketing and sale of serially manufactured commodities. At the same time, a limited-edition portfolio of rayographs was advertised in terms of its artistic pretensions: 'This is the first time that photography is placed at the same level as original pictorial works.'[9] The title of the *Vanity Fair* piece in which the rayographs first appeared was 'A New Method of Realizing the Artistic Possibilities of Photography'.[10] The Parisian polymath Jean Cocteau quickly understood that the artistic value of the rayographs lay not only in their suppression of overt mimesis in favour of an at least partial abstraction, but also in the fact that each print is unique and no more reproducible than a drawing or painting. 'Your prints', he wrote to Man Ray in an open letter from 1922, 'are so precious because there exists only one of each.'[11]

Marclay has always been attuned to this contradictory dimension of cameraless photography. Every photogram he has created is a unique original, indeed, his very first series – comprised of photograms of broken records – immediately invokes his early gramophonic epiphany and, with it, the desire to restore the preciousness of the object taken away not by technological reproduction so much as by wasteful consumption. As its title suggests, *Broken Record in 5 Pieces* (1990) is composed of the

fragments of a single gramophone record. But rather than attempt to make it whole again, Marclay emphasizes the preciousness of the vinyl disc through its transposition into a photogram. If in *Footsteps* Marclay succeeded in transforming 3,500 identical records into 3,500 unique recordings, *Broken Record in 5 Pieces* transforms an anonymous and disposable record into a unique composition in black and white. 'Your records', Cocteau might have said to Marclay, 'are precious because there exists only one photogram of each.'

In the same vein, Marclay has produced several dozen cyanotypes that belong to no defined series and follow no preordained compositional principle. Works like *Untitled (Sonic Youth, REM and One Mix Tape); Untitled (Luciano Pavarotti, Halo, Sound Choice and Three Mix Tapes);* and *Untitled (Guns N' Roses and Survival of the Fittest)* (all 2007–8) resemble works from the more coherent series and even recycle several of their cassette tapes; but the tension they embody is first and foremost between garbage – both physical and cultural – and its sublimation.

If Cocteau insisted that objects could be sublimated only through the poetic hand of the artist, Tristan Tzara, the irascible Dada ringleader, proposed a radically different interpretation in his introduction to *Champs délicieux* (Delicious Fields, 1922), the first limited-edition folio of rayographs. In contrast to Cocteau, Tzara had little interest in preciousness. And art? Well, as Tzara joyfully proposed: 'Let's speak of art for a moment. Yes, art. I know a gentleman who makes excellent portraits. This gentleman is a camera.'[12] Like Marcel Duchamp – who, in the same year, famously answered a questionnaire on the artistic significance of photography with the rebuke 'You know exactly what I think about photography. I would like to see it make people despise painting until something else will make photography unbearable. There we are'[13] – Tzara was impatient with questions of art and artists. He believed that the rayographs freed beauty from the hegemony of a select elite. Cameraless photographs, after all, are among the simplest aesthetic objects to produce.

Even more than his first cyanotypes, Marclay's first series of photograms are the simplest of photographs: black and white in a binary sense (that is, without tonal gradations); a layout that is neither aleatory nor composed, but bluntly documentary; literal to such a degree that the titles – like *Broken Record in Three Pieces* (1990) – provide nearly complete descriptions; a one-to-one correspondence between referent and image with regard to size and

transparency. If there is visual beauty in the work it is in the broken record itself: the contrast between its rounded and jagged edges, the fragmentary quality that makes it appear like pieces of a puzzle, its wreckage and its fragility. For Tzara, the broken record itself would clearly have sufficed. And if there is a need to record the record, cameraless photography succeeds in an artless transposition that captures the beauty of the pure material itself rather than the invention of the artist. Tzara's description of Man Ray's rayographs may be perfectly well applied to Marclay's first photograms and his first cyanotypes – as well as to *Echo and Narcissus*: 'As a mirror throws back an image without effort, as an echo throws back a voice without asking why, the beauty of matter belongs to no one: from now on it is a product of physics and chemistry.'[14] From the very beginning, Marclay's photograms straddled the line between preciousness and detritus.

The critic Douglas Crimp chronicled the shift from modernism to postmodernism in the visual arts through the work of Robert Rauschenberg: 'Rauschenberg had moved definitively from techniques of production (combines, assemblages) to techniques of reproduction (silkscreens, transfer drawings). And it is that move that requires us to think of Rauschenberg's art as postmodernist.'[15] Importantly, examples of Rauschenberg's reproductive work were among the most seminal products of the formative years of Graphicstudio; and the specific type of reproduction employed was cyanotype photography.[16] Rauschenberg's *Made in Tampa* series (1972–73) inaugurated what would become a years-long collaboration between the artist and Graphicstudio. The series marks, in retrospect, a significant link between the postwar American avant-garde and Marclay's recent cyanotypes. Rather than presume the unique originality of his every brushstroke, Rauschenberg utilized mass-produced images, everyday junk and other bric-à-brac – and their traces – as the basis for much of his later work. Marclay's turn to garbage and its traces – for example, broken records and their cameraless inscriptions – follows closely on Rauschenberg's lead. But where Crimp delineates a clear progression from production to reproduction in the case of Rauschenberg – and thus from modernism to postmodernism – Marclay establishes a much more complex and playful relationship between these opposing poles, one that strikes at the heart of the interwar avant-garde.

As Marclay tells it, his interest in cameraless photography began with a photograph of a gramophone reproduced in Moholy-Nagy's mid 1920s

classic *Painting Photography Film,* published as part of the Bauhaus book series.[17] While Marclay often highlights the gulf that separates visual from acoustic art, as well as their incongruous intersections, Moholy-Nagy's text unifies the two practices beneath an overarching theory of 'production-reproduction'. And it is here that Moholy-Nagy first explored the possibility of cameraless photography. Before ever venturing into the darkroom or laying his hands on photosensitive paper, Moholy-Nagy set out a theory of technological media and their place in aesthetic practice. He argues that art is an instrument in the development of the sensory faculties and that reproductive technologies must be opened up to their own *productive* ends – that is, rather than merely reproducing the sights and sounds of the world, artists must explore the expressive potential unique to each medium.

Moholy-Nagy's announced revolution in avant-garde art was a first step in a radical reconfiguration of the entire sensual world, from fashion and advertising to human perception itself. He delineates the productive uses of three media: gramophone, photography and film (the matrix in which the seed to Marclay's cameraless work was planted). In the early 1920s, Moholy-Nagy envisioned a new form of musical composition through the direct manipulation of the gramophone record grooves. An 'ABC of the groove', as Moholy-Nagy called it, would replace all other instruments, create a graphic language of composition, eliminate the need to 'reproduce' music via amateurish interpretation, and allow for the distribution of sound without cumbersome orchestras. Productive phonography, according to Moholy-Nagy, would surpass all reproductions of extant sounds. What is more, this 'alphabet' of the record groove would be enabled by photographic enlargements of gramophones.

Of the three media technologies addressed in Moholy-Nagy's early text, only photography found a productive outlet in his practice. It was time, he asserted, to employ mirrors and lenses to produce creative light effects, rather than merely reproducing images of the outside world. To do so (as Moholy-Nagy made clear in both theory and practice the following year), it was necessary to do away with the camera and experiment with the direct exposure of photosensitive surfaces. In other words, the same theoretical assertions that supported the photogram also called for a productive use of the gramophone.

Moholy-Nagy mustered no substantive attempt at productive phonography: he would never master an 'ABC of the groove'. But neither

could he have anticipated its ultimate realization, as media-theorist Friedrich Kittler observes, among 'New York disc jockeys [who] turn the esoteric graphisms of Moholy-Nagy into the everyday experience of scratch music'.[18]

In the early 1980s, Marclay was among those DJs. But in his 'turntablism' he broke out of Moholy-Nagy's binary conception of production-reproduction and set loose a whole complex of postmodernist preoccupations. Early Marclay tracks, such as 'Dust Breeding' or 'Groove' (both 1982), reference classic avant-garde notions but depart entirely from Moholy-Nagy's fantasy of a gramophonic 'alphabet'. Rather than manipulating the record grooves on a microscopic level in order to create an entirely new language of sound, Marclay manipulated multiple records on a complex turntable station in order to mix fragments of recorded music ('reproductions') with sounds that derive uniquely from the properties of turntablism ('production'). In his music, Marclay explodes the production-reproduction divide by making productive use of reproductions.

More than acoustic montage but far from an elementary language of the groove, the sonic practice that Marclay helped to initiate was thus an investigation into reproductive production – or productive reproduction. Where modernists sought out elementary properties, universal languages and the essence of a medium, postmodernists like Marclay have embraced contingent attributes, local dialects, and, as art-historian Rosalind Krauss has characterized it, the 'post-medium condition'.[19] Marclay's oeuvre is not limited to a single medium or approach. Music, performance, appropriation, collage, photography, readymades and video – along with practices and objects that defy simple categorization – are all part of his expansive approach to art. But rather than disintegrate into eclecticism, Marclay's focus on the acoustic has opened up a new set of aesthetic conventions that lend coherence to his artistic output without falling into essentialist explorations of a medium.

Without these conventions and references, a viewer confronted with *Untitled* (2004) would be at a loss (though a blissful loss) to decipher the curved pattern of lines running three feet across the surface of the image. What is the meaning of the dark band that tears across the top third of the photogram? How to explain the moiré patterns that appear at irregular intervals? To the uninitiated viewer, this untitled photogram might be read as an exercise in abstraction. To those more familiar with the history of photograms, however, the image might at first appear like an extension –

perhaps an unwitting repetition – of avant-garde photographs (made both with and without a camera). Photograms of gramophones date back at least to Man Ray's rayographs from the early 1930s. Indeed, a flyer for a 1932 exhibition at the Julien Levy Gallery in New York describes Man Ray's transposition of the inscription of sound into an inscription in light:

> His abstractions have opened a field which is far from being fully explored as yet. He has discovered that the most familiar objects can be transposed in a domain where they escape their own utilitarianism. A pair of scissors ceases to be a thing that cuts, *a gramophone record is forever silenced*, but beautiful spectrums have been made apparent.[20]

Several years earlier, Moholy-Nagy published a microphotograph of gramophonic grooves (Enrico Caruso's high C, according to the caption) in *From Material to Architecture,* his 1929 summary of his Bauhaus teaching, later translated as *The New Vision*.[21] While there is no direct influence here – Marclay was unaware of these images when he embarked on his own series of photograms – a distinct formal parallel is apparent. Of course, while Man Ray contextualizes the moiré pattern within recognizable images of records, Marclay's fragment is rendered virtually abstract. And while Moholy-Nagy still used camera-based photography, Marclay attains his close-up of record grooves without a camera. (To make these images, Marclay re-purposed traditional photographic equipment: rather than using a camera-based negative, he inserts a fragment of a broken, transparent record directly into an enlarger.) But these formal and technical differences seem inconsequential in light of the dramatic formal similarities and underlying shared fascination with the attributes of a specific medium. It appears that the many hands in Marclay's photograms are not those of the artist but the hands of a DJ mixing his favourite tracks from the historical avant-garde. Rather than break with modernism, Marclay is replaying it.

In Marclay's version, however, there is a difference. And that difference, again, is history. New Vision photography helped shift modern tastes from the artisanal and unique to the industrial and mass-produced. Artists like Man Ray helped to inculcate new desires in modern consumers. Moholy-Nagy framed his discussion of advertising much as he did his discussion of art: in terms of medium-specificity, visual literacy, the embrace of the new. Marclay revisits the materials,

techniques and forms of the historical avant-garde under markedly
different economic and technological conditions. While the technological
reproducibility of photography once dovetailed perfectly with the
technological reproducibility of commodities, both photochemical
photography and industrial production are today on the wane in the
West. Similarly, photographic abstraction – which once marked the
radical frontier of formal experimentation in art – is now securely
established in galleries, museums and the critical literature. Most
important of all, where abstraction once struggled with the socio-economic
and technological conditions of modernity, it has become a style utterly
divorced from those conditions. Marclay revisits this early moment
of the avant-garde in order to (re)unite formal, sociological and
technological concerns.

Marclay's *Grids* series of cyanotypes (2009), his most recent
cyanotype collaboration with Graphicstudio, evinces the strife inherent
in this complex merger. One is tempted to find allusions to the countless
grids present throughout twentieth-century art, from Piet Mondrian
to Agnes Martin and Sol LeWitt. Over a century ago, the grid signalled
modern art's will to silence, its hostility to literature, narrative and
discourse. 'As such, the grid has done its job with striking efficiency',
argues Krauss. 'The arts, of course, have paid dearly for this success
because the fortress they constructed on the foundations of the grid
has increasingly become a ghetto.'[22] Works such as Marclay's large
Cassette Grid No. 7 (2009) betray the fine tracery and rigid geometry
evident in works by Frank Stella, Agnes Martin and countless more
recent painters of geometric abstraction – rather than the perfection
of truly industrial products. From this art-historical vantage point, each
cassette box (a redundant appellation: *cassette* derives from the French
for *little box* or *case*) adds another brick to the walls of modernism's grid
ghetto. But if the power of the modernist grid lies, in part, in its capacity
to articulate the very properties of the canvas – its flat rectangularity –
Marclay's grids seem to operate in reverse. Consider, for example, Stella's
seminal stripe painting *Die Fahne hoch!* (1959).[23] The ratio of the work's
width to height – five to three – ostensibly derives from that of the Nazi
flag referenced in its title (recalling Jasper Johns' famous American flag
series inaugurated only a few years prior), and the content – black enamel
stripes divided by thin lines of unpainted canvas – applies an extremely

basic geometric system to the inflexible parameters of the frame.
Marclay's *Large Cassette Grids* are nearly the precise inversion of Stella's
stripe paintings: he begins with standard-size cassette boxes. (4 by 2.5
inches), which he assembles into columns and rows until he has attained
a nearly perfect square (38.5 by 39 inches). Where Stella's frame determines
the content, Marclay's content strictly governs the frame. But the precise
(and rigorously consistent) dimensions of Marclay's content are a product
of a particular industrial logic. Records vary in size: not only are they
available in a gamut of 'standard' sizes (including seven, ten and twelve
inches), but each 'standard' format allows for a great deal of variation:
so long as the hole is punched in the centre (a convention Marclay
challenged in earlier works), the diameter and thickness are irrelevant.
This is not the case with the audiocassette. Regardless of manufacturer,
length, quality or special features, every audiocassette must fit into the
same size audio deck and, by extension, into the same size cassette box.
The result is an audiocassette whose near-golden proportions are an
iron-clad industrial norm. *Large Cassette Grid No. 1* evinces a perfect
grid only because every cassette box is manufactured to the same size
specifications. Accordingly, every one of Marclay's *Large Cassette Grids*
has the same dimensions and the same number of cassette boxes – within
which there is room for infinite minor variations based on the relative
translucency of the plastic, the precise manufacture of the boxes, and
the presence or absence of tapes within the boxes. Whereas so much
contemporary abstraction struggles unsuccessfully to escape whimsy,
Marclay's geometric abstraction adheres to a standard – a standard rooted
in the industrial design of an industry on the brink of collapse.

Technique and style correspond closely in the early experiments
Marclay did with cameraless photography around 1990 and both relate
to avant-garde precedents of the 1920s and 30s. His newer cyanotypes,
however, simultaneously turn back the photochemical clock to the
nineteenth century and allude to more recent art, creating strong
dissonances between content and form. One recent reviewer likened
the work to 'X-rays of Cy Twombly or Jackson Pollock canvases' in
an attempt to bridge the cameraless technique and the art-historical
allusions.[24] But the warring parties will not be reconciled so easily.

Marclay's recent cyanotypes of cassette tapes grew out of a 2001 series of
twenty-five photograms, each almost exactly one square foot, where ribbons

and knots of magnetic tape pulled out of audiocassettes leave white, weblike patterns on a matte black ground. Like his earlier series, the new works consist largely of unspooled reams of cassette tape. But the two bodies of work are ultimately more different than similar, in material, colour, orientation, scale and historical references. Recent pieces such as *Untitled (Guns N' Roses, Sonic Youth and Two Mix Tapes)* and *Mashup (Two Cassettes Diptych)* (both 2008) are composed not only of magnetic tape but also of the cassette containers from which they are pulled. In place of the black ground of silver gelatin, Marclay turns in these works to the striking Prussian blues of cyanotype. Moreover, where Marclay's black-and-white photograms of tape lack any clear orientation, the recent cyanotypes strongly imply the force of gravity and the attendant horizontality or verticality of their fabrication. Marclay's 2001 black-and-white photograms may be most readily comprehensible when considered in terms of avant-garde cameraless photography; by contrast, the recent cyanotypes – in particular works like *Memento (Hüsker Dü)* and *Allover (Kenny Rogers, Rod Stewart, Jody Watley and Others)* (both 2008), which measure approximately four by eight feet – are clearly in dialogue with post-World War II American painting.

The series title *Allover* is borrowed directly from the critical terminology introduced in the 1950s to describe the paintings of Pollock and his Abstract Expressionist cohorts: with the advent of 'allover' painting, suddenly every part of the canvas was given equal weight; traditional compositional notions such as foreground and background, periphery and centre were all but abandoned. For the painter, the canvas became an arena for action (per Harold Rosenberg). For the viewer, it was a consummately optical space, traversable only with the eye (per Clement Greenberg).

These qualities are present in abundance throughout Marclay's *Allover* series. A close comparison of his *Allover (Kenny Rogers, Rod Stewart, Jody Watley and Others)* and Pollock's *Number 1A* (1948) bears this out. To begin, the two works are roughly the same size (the cyanotype measures 51.5 inches high and 100.125 inches wide; the painting is 68 by 104 inches). Even more important – in terms of both process and product – is the manner in which both Marclay and Pollock lay down, or 'drip', the lines of colour onto the material support. Photographs of the two artists at work are highly revealing. In Hans Namuth's famous photographs from 1950, Pollock is seen traversing the perimeter of the recumbent canvas, pouring or flinging paint onto its surface. Marclay works in a similar fashion,

dispensing magnetic tape across the cyanotype paper. In each case, the result is an intricate web of comingling lines and forms in which whites advance and darks recede without forming traditional figures and ground. There is continuous movement but no clear 'up' or 'down', 'left' or 'right', Both works evince especially tight choreography near the edges, which are respected in the whole but transgressed in the particular.

To achieve the visual qualities evident in *Allover (Kenny Rogers, Rod Stewart, Jody Watley and Others)* Marclay lays out rectangular cassettes, circular bobbins, irregular plastic shards and many feet of magnetic tape all over the paper – after which he makes the first of roughly three or four exposures. So long as these materials do not move (rare in the case of the wispy tape), they appear shockingly white in the final print. Before each exposure, Marclay adds additional materials, whose blue traces range from an extraordinary lightness (in the case of minimal exposure) to a depth that rivals those portions of the paper that were fully exposed to the artificial sun. In a perceptual inversion, the materials most proximate to the paper during the exposures tend to be brightest and thus appear closest to the viewer upon perusal; the reverse holds true for materials layered later and higher: they appear fainter, darker, blurrier and more distant from the viewer. A very few objects float untethered from their surroundings (consider the broken cassette above and to the left of dead centre, or the bobbin just beneath and to the left of that same central point). On the whole, however, our eyes are led through a network of lines and forms without beginning or end. We are left to sweep the surface of the image or traverse its purely optical depth in an endless, rhythmic dance. Pollock would be impressed.

Whether Marclay could convince mid-century critics Rosenberg or Greenberg that his cyanotypes constitute 'serious' painting is another matter. Does *Allover (Kenny Rogers, Rod Stewart, Jody Watley and Others)* bear the traces of a dramatic dialogue between 'canvas' and artist? Does it perform a Kantian critique of its very means? Or is it little more than 'apocalyptic wallpaper', thus realizing Rosenberg's greatest fears?[25] These questions – once so urgent – seem utterly negligible – merely distractions – today. Pollock's more vital legacy lies in the collapse of the serious, formal rigour expected of 'high art' and the seemingly wanton adoption of quotidian materials (metallic house-paints, sticks in place of brushes) and bestial traces (handprints, clustered at the top right of *Number 1A,*

cigarette butts), and the refusal of studied composition in favour of intuitive
or automatic traces. The impression of *Number 1A* is as sublime as the
means are abject – the latter magnifying rather than diminishing the former.

The tension between the sublime and the abject was developed
by Pollock and his immediate followers not only in the materials they
employed but also in the orientation of the canvas. Critics and champions
alike regarded the floor as an unsavoury place for art – and either sublimated
it in favour of the works' eventual vertical position on the wall or
emphasized this 'base' dimension in order to desublimate art by contrast.
Krauss tracks the legacy of Pollock's horizontality through Andy Warhol's
Piss Paintings (1961), *Dance Diagrams* (1962) (schematic renderings
of dance steps exhibited on the floor), and *Oxidation Painting* (1978)
(here again, it was urine that oxidized the metallic paints): 'It is in this
convergence between the footprints and the urine that Warhol's formal
reading of Pollock's act of branding his work as "horizontal" is made
wholly explicit.'[25] Where Morris Louis and other Colour Field painters
elevated Pollock's drips into veils of transcendent colour, Warhol and
others grounded his drips in excrement.

Marclay's two monumental cyanotype series, *Mementos* and *Allovers,*
appear neatly separable into the vertical and the horizontal registers.
No documentary photographs are needed to identify the work of gravity
in the *Memento* series – produced at a slight angle to the perpendicular,
but with a primary vector that is clearly vertical. Similarly, the *Allovers*
are inconceivable except in their horizontal extension. On the walls
of a gallery, however, these orientations are little inclined toward the
transcendent or the abject. Photographic paper is a poor substitute for
the magical, even spiritual powers so often attributed to paint and canvas.
At the same time, magnetic tape is perfectly respectable compared
to handprints and cigarette butts, let alone bodily excretions. Where
Pollock's immediate followers tended toward the extremes, Marclay
seems to channel the Pollock described by art historian T.J. Clark as
'a petty-bourgeois artist of a tragically undiluted type – one of those pure
products of America'.[27] According to Clark:

> what is special about Abstract Expressionism – what marks it off from all other
> modernisms – is that the engagement is with the vulgar, as opposed to the
> 'popular' or 'low'. I think we should understand the 'popular' in nineteenth-

and twentieth-century art as a series of figures of avoidance of the vulgar, that is, figures of avoidance of art's actual belonging to the pathos of bourgeois taste; a perpetual shifting and conjuring of kinds of simplicity, directness, naïvety, sentiment and sentimentality, emotional and material force, in spite of everything about art's actual place and function that put such qualities beyond its grasp. Abstract Expressionism does little or no such conjuring. That is what makes it hard to bear.[29]

We have largely lost touch with the 'vulgarity' of Abstract Expressionism (which, when compared to more recent cultural vulgarity, appears positively aristocratic). One would be hard pressed to gather a set of cultural references more closely aligned with 'petty-bourgeois' (aka lower-middle-class) American vulgarity than those inscribed in the cameraless traces and titles of Marclay's cyanotypes: Rod Stewart, Celine Dion, Antonin Dvorak, Britney Spears, and so on. (It is said that one collector passed on *Memento (Britney Spears)* (2008) lest he be tainted by the pop diva's vulgarity.) Marclay's monumental cyanotypes – and this is among their great virtues – restore to visibility the vulgarity of mid twentieth-century American painting.

If Pollock, Abstract Expressionism, Colour Field painting, and mid century America are the points of departure for Marclay's *Mementos* and *Allovers,* we are in need of an intermediary other than Warhol's *Piss Paintings* and Louis's *Veil Paintings* to deliver a Pollock less torn between the abject and the transcendent. That intermediary is Rauschenberg. Around 1950, shortly after Pollock completed *Number 1A,* Rauschenberg embarked on a series of *Blueprints* in which his then-wife, Susan Weil, and their friend, Pat Pearman, lay sprawled across mural-sized sheets of cyanotype paper strewn with leaves, lace and other bric-a-brac that would have suited Anna Atkins' circle quite well. Exposing the paper with a sun lamp – much as Pollock had dripped his house paints and Marclay scatters his magnetic tape – Rauschenberg collapsed together the horizontal, the corporeal, the automatic, the vernacular and the industrial. This was not a desublimation of art so much as a defiance of its potential 'seriousness'. Photographs of Rauschenberg and Weil at work were published In *Life* magazine in 1951, where the accompanying text explains: 'Although the Rauschenbergs make blueprints for fun, they hope to turn them into screen and wallpaper designs.'[29] (They had already been used

as window displays at the department store Bonwit Teller.) Conservative critics beware: wallpaper designs? ('apocalyptic wallpaper'!). Fun? ('Fun is a medicinal bath', as Theodor Adorno and Max Horkheimer wrote. 'The pleasure industry never fails to prescribe it.')[30] If, barely two years prior to the story on Rauschenberg, Pollock appeared ill at ease in the pages of *Life* magazine ('Is He the Greatest Living Painter in the United States?' the headline asked famously and ambiguously), the younger artist made the pages of magazines like *Life* – as well as radios, television and other mass media – the very substance of his work. Art historian Leo Steinberg understood Rauschenberg's canvases to be flatbed picture planes similar to 'tabletops, studio floors, charts, bulletin boards – any receptor surface on which objects are scattered, on which data is entered, on which information may be perceived, printed, impressed'.[31] Neither transcendent nor abject, Rauschenberg's canvases do not avoid popular culture by rising above it or escaping it from beneath; they are simply surfaces on which mass culture collects – the way paint once pooled on Pollock's canvases. How is this 'cultural receptacle' evident in Rauschenberg's early *Blueprints?* Initial impressions provide conflicting evidence. On the one hand, the *Blueprints* were produced in a resolutely horizontal position. On the other hand, the traces they bear are of the female nude, leaves and other objects that link the works more closely with natural history than industrial culture.

A resolution of the conflict may be approached through a consideration of the cyanotype process itself. After its initial exploration by Atkins and other botanists, cyanotype photography was largely forgotten.[32] Thirty years of near oblivion paved the way for the reinvention of the process: entrepreneurs suppressed John Herschel's name and formula as well as his appellation for the procedure. Instead of remaining a gentleman's (or gentlewoman's) scientific hobby, the 'ferroprussiate process – as the cyanotype process was redubbed – was employed for photocopying plans of any kind: in a word, blueprints. By the end of the nineteenth century, blueprint paper was manufactured industrially: in England in 1918, a 30 by 3 foot roll of cyanotype paper cost as little as one pound sixpence. Plans for a battleship required some 11,000 square feet of the paper. (Already in the eighteenth century, Prussian blue was the first widely manufactured artificial dye; its history is indivisibly bound up with industrialization.) Cheap and easy, blueprints remained the dominant industrial reproduction process for decades. This widespread mode of reproduction – though

already in decline in the face of competing technologies like diazo prints (also known as whiteprints or bluelines) – was the medium of Rauschenberg's *Blueprints*. Atkins conjured the ocean with her Prussian blue nature prints; Rauschenberg secured nature – in the form of the female nude and botanical elements – in terms of industrial reproduction. In other words, here even nature is rendered under the sign of mass media: a signal moment of 'productive reproduction'.

This is where Marclay takes up the mantel from Pollock and Abstract Expressionism: industrially produced house-paints are replaced with industrially produced magnetic tape; the canvas as an arena for action is exchanged for blueprint paper as an arena for photographic reproduction. But rather than capture vestiges of the existential self (Pollock) or nature (Rauschenberg), Marclay records the residues of industrialized culture: cheap audiocassette reproductions produced on the nineteenth century's cheapest mode of photographic reproduction: blueprints.

Art historian Thomas Crow argues that culture in the context of capitalism displays moments of negation and an ultimately overwhelming accommodation: 'Modernism exists in the tension between these two opposed movements. And the avant-garde, the bearer of modernism, has been successful when it has found for itself a social location where this tension is visible and can be acted upon.'[33] Marclay's cyanotypes do not necessarily negate the cultural products of advanced capitalism. Quite the contrary: rarely has Pollock looked so fresh; never has Britney Spears appeared more interesting. Visually seductive and formally enchanting (approaching, perhaps, even apocalyptic wallpaper), Marclay's cyanotypes succeed not in direct negation – base materialism, desublimation, political criticism, or any other now-familiar strategy employed by modernist and postmodernist avant-gardes – but in rendering modernism's overwhelming accommodation to capitalism uncomfortably visible. Rather than an oscillation between the transcendent and the abject, Marclay fuses the beautiful and the vulgar.

1 The title derives from John Krishak's *Big Beach Outreach*, a 2006 Evangelical Christian album featuring such tracks as 'Children of Promise', 'Overwhelming Power', 'Nothing but the Blood of Jesus', and 'Survival of the Fittest'. This last song layers missionary lyrics above synthetic sound and 1980s beats. Its inclusion in Memento (Survival of the Fittest) testifies

first and foremost to the mixed bag of pop culture available in the thrift stores of Tampa, Florida, where Marclay collected the cassettes with which he executed the work.

2 See Diane B. Paul, 'The Selection of the "Survival of the Fittest"', *Journal of the History of Biology*, vol. 21, no. 3 (1988) 411-24.

3 R. Child Bayley, *The Complete Photographer* (New York: McClure, Phillips & Co., 1906) 396.

4 Media archaeologist Siegfried Zielinski has adopted a related approach – that of the geologist and zoologist Stephen Jay Gould – in order to de-emphasize technological progress in favour of diversity: 'excellence', in this model, is a measurement of diversification events and the spread of diversity. See Siegfried Zielinski, *Deep Time of the Media: Toward an Archaeology of Hearing and Seeing by Technical Means*, trans. Gloria Custance (Cambridge, Massachusetts: The MIT Press, 2006) 5. As digital scans replace blueprints and digital music replaces cassette tapes, there may be a net increase in the reproducibility and transmissibility of information, but a net loss of excellence, as all information is reduced to a common binary base. Excellence is an apt criterion by which to judge Marclay's vast and diverse output in music, performance, video, installation, assemblage, sculpture, photography and other media and practices. But excellence runs the risk of becoming to media archaeology what social Darwinism is to anthropology: namely, bunk science. After all, media are not organisms and media technologies are not naturally selected.

5 As Carol Armstrong has demonstrated, Atkins' cyanotypes are best understood as a type of nature print, drawing or illustration. See Carol Armstrong, 'Cameraless: From Natural Illustrations and Nature Prints to Manual and Photogenic Drawings and Other Botanographs', in *Ocean Flowers*, ed. Carol Armstrong and Catherine de Zegher (Princeton: Princeton University Press, 2004).

6 Christian Marclay in Douglas Kahn, 'Christian Marclay's Early Years: An Interview', *Leonardo Music Journal*, no. 13 (2003) 19.

7 Thomas Y. Levin argues that the twofold indexicality in *Footsteps* – namely, a vinyl record's recorded sounds and 'the vagaries of its subsequent performance history' – is a component of all records as soon as they are played. Thomas Y. Levin, '*Indexicality Concrète*: The Aesthetic Politics of Christian Marclay's Gramophonia', *Parkett*, no. 56 (1999) 166. Interestingly, this is precisely the definition Walter Benjamin gives to an artistic original as distinct from the reproduction (gramophonic, photographic or otherwise): 'In even the most perfect reproduction, one thing is lacking: the here and now of the work of art – its unique existence in a particular place. It is this unique existence – and nothing else – that bears the mark of the history to which the work has been subject. This history includes changes to the physical structure of the work over time, together with any changes in ownership.' Walter Benjamin, 'The Work of Art in the Age of Its Technological Reproducibility', in *Walter Benjamin: Selected Writings*, Volume 3, 1935-1938, ed. Howard Elland and Michael W. Jennings (Cambridge, Massachusetts: Harvard University Press, 2002) 103.

8 The best available overview of twentieth-century photograms is Floris M. Neusüss and Renata Heyne, eds, *Das Fotogramm in der Kunst des 20. Jahrhunderts* (Cologne: Dumont, 1990). A comprehensive survey, curated by Tim Roth, of artists who employ cameraless techniques is available online at www.photogram.org

9 'Bulletin de souscription: Champs délicieux', *Les Feuilles libres* (1922).

10 'A New Method of Realizing the Artistic Possibilities of Photography', *Vanity Fair* (November 1922) 50.

11 Jean Cocteau, 'An Open Letter to M. Man Ray, American Photographer' (1922), in Christopher Phillips, ed., *Photography in the Modern Era* (New York: Metropolitan Museum of Art/Aperture, 1989) 2.

12 Tristan Tzara, 'Photography Upside Down' ('Photographie à l'envers', 1922), in *Photography in the Modern Era*, op. cit., 5.

13 Marcel Duchamp in 'Special Issue: Can a Photograph Have the Significance of Art?', *MSS (Manuscripts)*, vol. 1, no. 4 (1922) 2.

14 Tristan Tzara, 'Photography Upside Down', op. cit., 6.

15 Douglas Crimp, 'On the Museum's Ruins', *October*, no. 13 (1980) 56.

16 See Ruth Fine and Mary Lee Corlett, eds, *GraphicStudio* (Washington, DC: National Gallery of Art, 1991) 232-37.

17 László Moholy-Nagy, *Painting Photography Film* (1925/27); trans. Janet Seligman (Cambridge, Massachusetts: The MIT Press, 1969).

18 Friedrich Kittler, *Gramophone, Film, Typewriter*; trans. Geoffrey Winthrop-Young and Michael Wurtz (Stanford: Stanford University Press, 1999) 50.

19 See Rosalind Krauss, '*A Voyage on the North Sea': Art in the Age of the Post-Medium Condition* (London: Thames & Hudson, 1999). For her more recent reflections on Christian Marclay and the 'post-medium condition', see Rosalind Krauss, 'Two Moments from the Post-Medium Condition', *October*, no. 116 (2006) 55-8.

20 Emphasis added. The exhibition was held 9-30 April 1932 at the Julien Levy Gallery (602 Madison Avenue, New York).

21 László Moholy-Nagy, *Von Material zu Architektur* (From Material to Architecture), Bauhaus Book 14 (Munich: Langen, 1929); trans. Daphne M. Hoffmann, *The New Vision - From Material to Architecture* (New York: Brewer, Warren and Putnam, 1932).

22 Rosalind Krauss, 'Grids', in *The Originality of the Avant-Garde and Other Modernist Myths* (Cambridge, Massachusetts: The MIT Press, 1986) 9.

23 'Die Fahne hoch!' (The Flag on High!), also known as the 'Horst-Wessel-Lied' was the anthem of the Nazi party from 1930 to 1945.

24 Michael Wilson, 'Christian Marclay, *Cyanotypes*', *Time Out New York*, no. 679 (2008) 62.

25 See Harold Rosenberg, 'The American Action Painters', in *The Tradition of the New* (New York: Horizon Press, 1959) 34. The Kantian model of modernism was proposed by Clement Greenberg in his 1960 essay 'Modernist Painting', in *Clement Greenberg: The Collected Essays and Criticism*, vol. 4, ed. John O'Brian (Chicago: University of Chicago Press, 1993) 85-93.

26 Rosalind Krauss, *The Optical Unconscious* (Cambridge, Massachusetts: The MIT Press, 1993) 275. See also Rosalind Krauss, 'Horizontality', in Yve-Alain Bois and Rosalind Krauss, eds, *Formless: A User's Guide* (New York: Zone Books, 1997) 93-103.

27 T.J. Clark, 'The Unhappy Consciousness', in *Farewell to an Idea* (New Haven and London: Yale University Press, 1999) 300.

28 T.J. Clark, 'In Defence of Abstract Expressionism', in ibid., 379.

29 'Speaking of Pictures', *Life* (9 April 1951).

30 Max Horkheimer and Theodor W. Adorno, *Dialectic of Enlightenment* (1944); trans. John
 Cumming (New York: Continuum, 1988) 140.

31 Leo Steinberg, 'Other Criteria' (1972), *Other Criteria: Confrontations with Twentieth-Century
 Art* (Oxford: Oxford University Press, 1972) 84.

32 The following account of the history of cyanotypes relies on Mike Ware, *Cyanotype* (London:
 Science Museum, 1999).

33 Thomas E. Crow, 'Modernism and Mass Culture in the Visual Arts', *Modern Art in the
 Common Culture* (New Haven and London: Yale University Press, 1996) 37.

Noam M. Elcott, 'Untimely Detritus: Christian Marclay's Cyanotypes', in *Christian Marclay:
Cyanotypes* (Zürich: JRP/Ringier, 2011) 1–10.

There's always a sense of nostalgia in something that records the passing of time. You can't escape that, but you can have a critical look at things that seem nostalgic. We assume, because we're able to capture sounds or images, that they will exist forever, when in fact obsolescence makes you feel the limit of those assumptions

In Conversation with Frances Richard, 2013

Selected Bibliography of Illustrated Catalogues,
Books and Monographs. Selected Discography

1989
Christian Marclay. Texts by Dennis Cooper and Harm Lux (Zürich: Shedhalle)
1990
Christian Marclay: Directions. Text by Amada Cruz (Washington, DC: Hirshhorn Museum and Sculpture
 Garden, Smithsonian Institution)
1992
Christian Marclay: Masks. Text by Wayne Koestenbaum (Rome: Galleria Valentina Moncada)
1994
Christian Marclay. Texts by Michael Glasmeier, Douglas Kahn (Berlin: DAAD Galerie/Fribourg:
 Fri-Art Kunsthalle)
1995
Christian Marclay: Amplification. Text by Russell Ferguson (Venice: Chiesa San Stäe/Zürich: Verlag
 Lars Müller)
1997
Arranged and Conducted by Christian Marclay. Interview with Bice Curiger. Texts by Dan Cameron,
 Simon Maurer, Catherine Quéloz, Philip Ursprung, Birgit Wiens (Zürich: Kunsthaus Zürich)
Christian Marclay: Pictures at an Exhibition. Text by Eugenie Tsai (New York: Whitney Museum
 of American Art at Philip Morris)
1999
Christian Marclay. Text by David Frankel (San Antonio: Artpace. Foundation for Contemporary Art)
2000
Christian Marclay: Cinema. Text by Ben Portis (Ontario: Oakville Galleries)
Christian Marclay: Video & Fotografi. Text by Rhea Anastas (Roskilde, Denmark: Museet for
 Samtisdskunst)
2003
Christian Marclay. Texts by Russell Ferguson, Douglas Kahn, Miwon Kwon, Alan Licht (Los Angeles:
 UCLA Hammer Museum/Göttingen: Steidl)
The Bell and the Glass. ed. Susan Rosenberg. Conversation with Christian Marclay, Thomas Y. Levin,
 Ann Temkin and Thaddeus A. Squire (Philadelphia: Philadelphia Museum of Art/Relâche)
2005
Christian Marclay. Texts by Jennifer González, Matthew Higgs, Christian Marclay. Interview with Kim
 Gordon (London and New York: Phaidon Press)
2007
Christian Marclay: Replay. ed. Jean-Pierre Criqui. Texts by Jean-Pierre Criqui, Rosalind Krauss, Emma
 Lavigne, Philippe-Alain Michaud, Peter Szendy. Interview with Michael Snow (Paris: Cité de la
 Musique/Melbourne: Australian Centre for the Moving Image/Zürich: JRP/Ringier)
Shuffle. Artist's edition, box of 75 cards. Text by Christian Marclay (New York: Aperture)

Christian Marclay: Crossfire. Text by Tom Morton (London: White Cube)
> **2008**

Christian Marclay: Stereo. ed. Christian Marclay (San Francisco: Fraenkel Gallery)
> **2009**

Christian Marclay: Snap! ed. Valérie Mavridorakis, David Perreau. Texts by John Armleder, Bruno Bossis and Frédéric Dufeu, Nathalie Boulouch, Clément Chéroux, Noam M. Elcott, Marianne Massin (Rennes: Galerie Art & Essai/Geneva: Musée d'art moderne et contemporain de Genève/Dijon: Les Presses du Réel)
> **2010**

Christian Marclay: The Clock. Text by Darian Leader (London: White Cube)

Christian Marclay: Festival. ed. Christian Marclay, with David Kiehl, Limor Tomer and Claire Barliant (3 magazine-format issues in slipcase). Texts by Steve Beresford, Christoph Cox, Jean-Pierre Criqui, Noam M. Elcott, Kenneth Goldsmith, Shelley Hirsch, Nicole Lanctot, Alan Licht, Arto Lindsay, Liz Kotz, Damon Krukowski, Ingrid Schaffner, Elliott Sharp, Susan Tallman, Rob Young. Interview with Russell Ferguson (New York: Whitney Museum of American Art)

Christian Marclay: Fourth of July. Text by Jean-Pierre Criqui (New York: Paula Cooper Gallery/PJC)
> **2011**

Cyanotypes: Christian Marclay. ed. David L. Noor. Texts by Noam M. Elcott and Margaret A. Miller (Tampa: GraphicStudio/Zürich: JRP/Ringier)

Christian Marclay: Scrolls. Text by Tom Morton (Tokyo: Gallery Koyanagi)
> **2013**

Christian Marclay: Things I've Heard. Interview with Christian Marclay (from discussion at University of Rennes) (San Francisco: Fraenkel Gallery/New York: Paula Cooper Gallery/PJC)

Selected Discography

> **1985**

Record Without a Cover (New York: Recycled Records) LP
Re-released in 1999 (Tokyo: Locus Solus) Picture disc
> **1987**

Untitled (Record Without a Groove) (Geneva: Ecart Éditions) 12-inch LP, limited edition of 50
> **1988**

More Encores (Würzburg: No Man's Land) 10-inch LP
Re-released in 1997 (London: ReR Megacorp) 10-inch LP and CD
> **1989**

Footsteps (Zürich: RecRec Music) LP
> **1994**

Christian Marclay & Günther Müller: Live Improvisations (Lupsingen, Switzerland: FOR4EARS records) CD
> **1996**

Untitled (Greenville, Ohio: Robert J. Schiffler Collection and Archive) 7-inch
> **1997**

Records: 1981–1989 (Chicago: Atavistic Records) CD

1999

Untitled: Christian Marclay / Yoshihide Otomo (Chicago: Gentle Giant Records) Split 7-inch

The French Diplomat's Office. Barbara Bloom, Christian Marclay (New York: Blumarts, Inc.) CD

2000

High Noon. Christian Marclay, Elliott Sharp (Zürich: Intakt Records) CD

Bouquet: Live at the Knitting Factory, with William Hooker, Lee Ranaldo (New York: Knitting Factory Records) CD

Fuck Shit Up. Thurston Moore, Lee Ranaldo, Christian Marclay (Victoriaville, Quebec: Les Disques Victo) CD

2002

CCMC + Christian Marclay, 2000–2001, with John Dutton, John Oswald, Michael Snow (Toronto: Art Metropole/Non Musica Rex) CD

2004

djTRIO, with Toshio Kajiwara, DJ Olive, Erik M., Marina Rosenfeld (San Francisco: Asphodel Records) CD

2005

Okkyung Lee / Christian Marclay / My Cat is an Alien. From the Earth to the Spheres series, vol. 7 (Turin: Opax Records) Split CD

2006

Guitar Drag (soundtrack to the video *Guitar Drag*, 2000) (Sydney: Neon Records) LP

2007

Ghost (I Don't Live Today) (Geneva: Eight & Zero/Cabinet des estampes) LP

2008

Sounds of Christmas (Geneva: Villa Magica Records) LP

2010

Graffiti Composition, with Elliott Sharp, Melvin Gibbs, Mary Halvorson, Lee Ranaldo, Vernon Reid (New York: Dog W/A Bone) CD

2012

djTRIO – 21 September 2002 Hirshhorn Museum, with Toshio Kajiwara and DJ Olive (Silver Spring, Maryland: Cuneiform Records) LP

2013

Fred Frith / Christian Marclay – Live at Cafe Oto, 2012 (London: Otoroku) LP

Groove (London: The Vinyl Factory) EP

Index